Collage & Altered Art

Visual®

by Roni Johnson

WILEY

Wiley Publishing, Inc.

Library of Congress Control Number: 2009928172

ISBN: 978-0-470-44719-2

Printed in the United States of America

10 9 8 7 6 5 4 3 2

Book production by Wiley Publishing, Inc. Composition Services

Praise for the Teach Yourself VISUALLY Series

I just had to let you and your company know how great I think your books are. I just purchased my third Visual book (my first two are dog-eared now!) and, once again, your product has surpassed my expectations. The expertise, thought, and effort that go into each book are obvious, and I sincerely appreciate your efforts. Keep up the wonderful work!

—Tracey Moore (Memphis, TN)

I have several books from the Visual series and have always found them to be valuable resources.

—Stephen P. Miller (Ballston Spa, NY)

Thank you for the wonderful books you produce. It wasn't until I was an adult that I discovered how I learn—visually. Although a few publishers out there claim to present the material visually, nothing compares to Visual books. I love the simple layout. Everything is easy to follow. And I understand the material! You really know the way I think and learn. Thanks so much!

—Stacey Han (Avondale, AZ)

Like a lot of other people, I understand things best when I see them visually. Your books really make learning easy and life more fun.

—John T. Frey (Cadillac, MI)

I am an avid fan of your Visual books. If I need to learn anything, I just buy one of your books and learn the topic in no time. Wonders! I have even trained my friends to give me Visual books as gifts.

—Illona Bergstrom (Aventura, FL)

I write to extend my thanks and appreciation for your books. They are clear, easy to follow, and straight to the point. Keep up the good work! I bought several of your books and they are just right! No regrets! I will always buy your books because they are the best.

—Seward Kollie (Dakar, Senegal)

Credits

Acquisitions Editor
Pam Mourouzis

Project Editor
Donna Wright

Copy Editor
Marylouise Wiack

Editorial Manager
Christina Stambaugh

Publisher
Cindy Kitchel

Vice President and Executive Publisher
Kathy Nebenhaus

Interior Design
Kathie Rickard
Elizabeth Brooks

Photography
Matt Bowen

Special Thanks...

I would like to thank the following artists whose work appears in the book. I appreciate your willingness to share your art and soul with us all.

- **Bonnie Brock**
- **Jen Crossley**
- **Kim Curry**
- **Lisa Dixon**
- **Robyn Fergeson**
- **Nanette Higney**
- **Shannon Horch**
- **Mindy Lai**
- **Dawn Miller**
- **Betty Oliver**
- **Nancy Summers**

About the Author

Veronica (Roni) Johnson (Albion, Indiana) is a lifelong artist and the author of the daily rubber stamping and altered art blog—InkStainswithRoni. She designs for various manufactures and retail companies in the rubber stamping and altered art fields. Her works have been published in several rubber stamping and altered art magazines, used in product advertisements and as online projects, and placed on display at national craft and hobby conventions. In addition, her work has also been previously published in two Wiley Publishing books, *Teach Yourself Visually Scrapbooking* and *Paper Crafts Visually Quick Tips*. When she isn't creating projects for her blog or design teams, she enjoys teaching others about the joys of ink, paper, and altered art.

Acknowledgments

Special thanks go out to my husband (Eric Johnson) and my boys (Ben and Bob Johnson) for their love, support, and encouragement. Art has always been my passion, and you have allowed me the freedom to follow its path wherever it leads.

I also want to acknowledge some key people who have influenced me along the way: Mom and Dad (Dixie and Albert Vance) who allowed me to dream, create, and be what I wanted to be; Grandma (Marie) Vance for introducing me to a variety of arts and crafts at a very early age; Shannon (Horch) who loved the first greeting card I ever made; Mindy (Lai) who encouraging me to branch out and helped me find my altered self; and finally, Tim Holtz for making it okay to love the grungy side of life. You are all part of the reason why I do what I do and for that I dearly thank you all!

For additional product information, an appendix can be downloaded from www.wiley.com/go/tyvcollage.

Table of Contents

 chapter **1** An Introduction to Collage and Altered Art

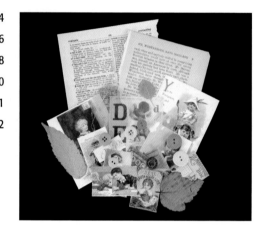

 chapter **2** Getting Started

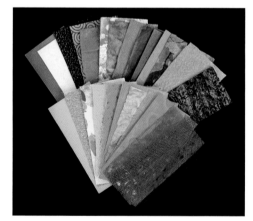

chapter 3 Aged and Distressed

chapter 4 Paper Collage Techniques

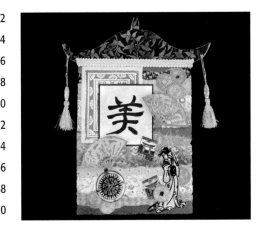

chapter 5 Paint, Ink, and Rubber Stamping

chapter 6 Image Transfer Techniques

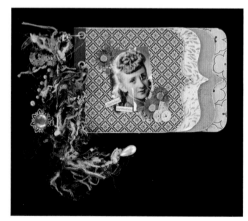

chapter 7 · Altered Charms

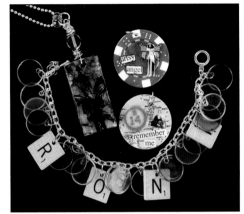

chapter 8 · Fabrics, Fibers, and Trim

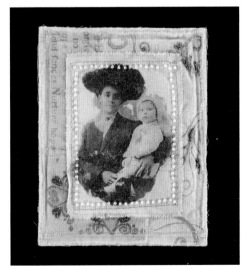

chapter 9 Assemblage Art

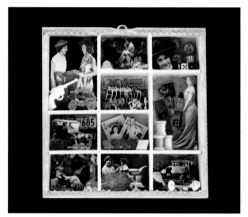

chapter 10 Altered Books

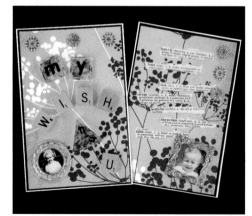

chapter **11** **Inspiration Gallery**

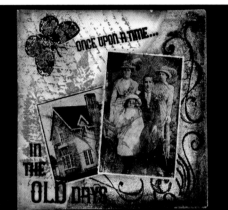

chapter **1**

An Introduction to Collage and Altered Art

The term *collage* is derived from the French word *coller*—to glue. Collage, basically stated, means to glue or paste paper onto a base. Today, the term collage encompasses so much more than simply "to glue." This chapter explores the basic process of creating a collage, discusses the design principles that collage artists use to create their pieces, and introduces you to alternate versions of the collage art form.

Collage Basics

Traditionally, collage involves simply building layers with a variety of media. The most common and basic type of collage is made by binding together various types of paper, images, and text with glue or paste. This is where we will begin. As you move through the book, you will learn techniques to build on this basic collage process.

Collage: Easy as 1, 2, 3

Supplies

- Collage images, rubber stamps – Alpha Stamps
- Specialty papers – PaperArts.com
- Pattern paper, buttons – Basic Grey

- Dried leaves – Nature's Pressed
- Glue, Aleene's Collage Pauge Instant Decoupage Glossy – Duncan Enterprises
- Foam brush

- Non-Stick Craft Sheet, Adirondack Dye Inks, black embossing powder – Ranger Industries
- Sealer (optional) – Krylon Crystal Clear or Patricia Nimocks Clear Acrylic Sealer

1 Select a theme for your collage. Inspiration can come from anywhere and everywhere. Begin by looking through magazines, books, photographs, poems, song lyrics, nature, etc. In this example, Alpha Stamps vintage school images inspired this fun and whimsical design.

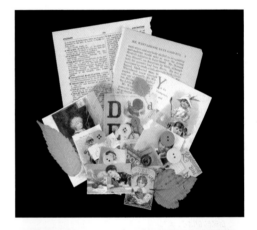

2 Select the proper foundation or base material for your collage. The base should be substantial enough to hold up under repeated applications of glue, and later on paints, ink, and embellishments. To determine which type of materials work best for your application, see the "Paper" section in Chapter 2.

③ Gather materials to be used on your collage, keeping your theme in mind. These items can include decorative and textured papers, photographs, images from magazines, text, and more. Tear or cut these images and papers into smaller pieces.

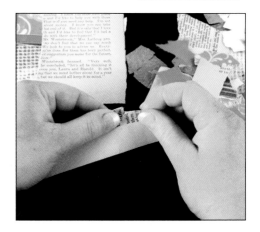

④ Place your base on a protected surface from glues, paints, and more. Ranger Industries' Non-Stick Craft Sheet can be used for protecting your work surface and making it waterproof, heat resistant, and quick and easy to clean up. Begin arranging the torn or cut pieces of paper on the collage base until you are satisfied with the placement. Paste the individual pieces onto the base using white collage glue and a foam brush.

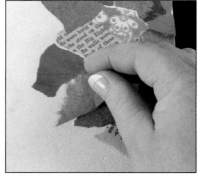
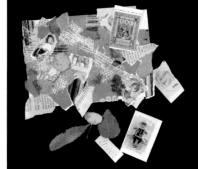

Note: *Apply a thin layer of adhesive to both the base and back of the image. Doing so will ensure that all the pieces adhere properly.*

⑤ Smooth down these pasted pieces as you go to ensure that all the edges have been properly secured by applying an additional layer of glue. Continue layering the remaining pieces of paper until your collage is complete.

⑥ At this point, you may choose to preserve your work with a spray or brush-on sealer. For additional information and options on sealing your finished collage, see Chapter 2.

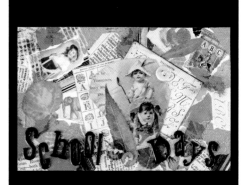

Design Principles

Design principles are basic guidelines that some artists consider when creating a collage. Keep in mind that every artist approaches the art of collage in very different ways. What works for one artist does not necessarily work for another. Also, the pure nature of collage is free and flowing without rules. You may or may not choose to follow these guidelines.

FOCAL POINT

A *focal point* is the main area of interest on a collage work. Some artists choose to emphasize a particular image, piece of text, or key word. The artist then builds the remainder of the collage around this central piece. Choosing a good focal point helps the viewer understand the mood or feeling you wish to convey.

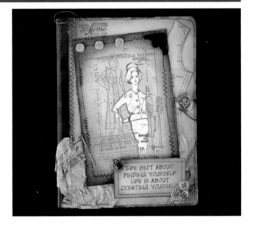

SYMMETRY

Symmetry is creating harmony among all parts of your collage. This can be achieved with the theme or color palette selection, or by adding a unifying medium to the finished collage, which is discussed in Chapter 2.

Some artists choose to ignore symmetry on purpose to make a statement about their subject or feelings.

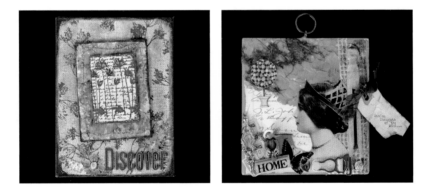

BALANCE

Balance refers to the arrangement of elements (textures, colors, shapes, etc.) on each side of your collage. There are three basic types of balance commonly referred to in art:

- **Symmetrical balance (or formal balance):** This is created when the same or similar items are mirrored on each side of your collage. The wings of a butterfly are a perfect example of symmetrical balance.

- **Asymmetrical balance (or informal balance):** This is achieved when items are positioned unevenly on your collage but work together to produce a harmonious outcome.

- **Radial balance:** Just as it sounds, your collage is arranged around one central image, and additional elements in the composition radiate from this image.

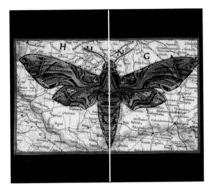

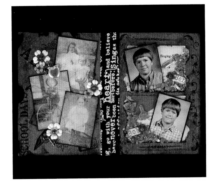

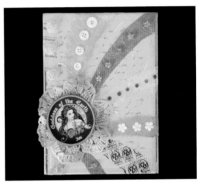

RULE OF THIRDS

This basic rule of photography can be applied to the art of collage as well. The idea behind the Rule of Thirds is that your collage can be divided by two evenly spaced vertical lines and two evenly spaced horizontal lines, thus creating a grid of nine equal parts. Important elements in the collage can be placed where the imaginary lines intersect. Many artists believe doing so adds energy and interest, and makes the finished piece of art more aesthetically pleasing.

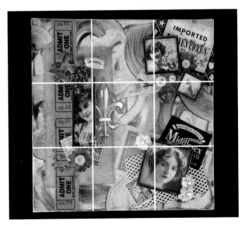

Assemblage or Altered Art

What is altered or assemblage art, you might ask? That is a tricky question because, depending on whom you ask, the answers you receive may vary greatly. The following are the top three responses to this question among altered artists, in no particular order.

To some, the term *altered art* means incorporating "found objects" into their artwork. What is a found object? It is an object used in some form other than what it was originally intended for. In this example, the bingo card is an example of a found object. Originally intended to be used as part of a game, the card has become the stepping stone for the "Lucky Me" collage.

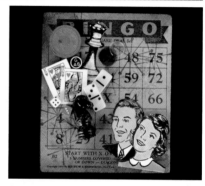

Others might say *altered art* means transforming an everyday object into a work of art. This altered shoe is a perfect example. Transformed from a mundane article of clothing, it now holds the artist's inspiration of "Spring in Your Step."

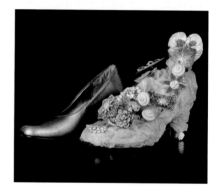

Still others say that *altered art* is a way of pulling several unrelated objects or materials together in a cohesive and pleasing fashion. Notice how the various blue elements work together despite the variety of tones, textures, and materials used.

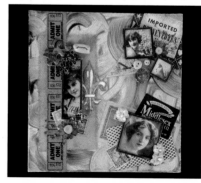

Items to Alter from A–Z

A–G

Address book; Altoids candy tin; apron; banner; basket; belt buckle; binder; birdhouse; board book; book; bookmark; bottle; bottle cap; bucket; calendar; candle; canvas; cardboard box; CD; CD case; checkbook cover; ceramic tile; Christmas ornament; cigar box; clipboard; clock; coaster; coffee can; coin book; composition book; cookie baking sheet; cork board; cutting board; domino; door hanger; dress form; envelope; file folder; flower pot; frame; game board; game piece; gift bag or box.

H–N

Hatbox; jar; jewelry; jewelry box; journal; juice can lid; keychain; lampshade; luggage tag; lunchbox; magazine holder; magnet; magnetic board; magnifying glass; mailbox; Mason jar; Mason jar lid; matchbook; matchbox; memo board; message center; microscope slide; microscope slide mailer; milk can; mirror; monogram letter; mousetrap (new, of course); movie reel; muffin tin; nightlight; notebook; notepad.

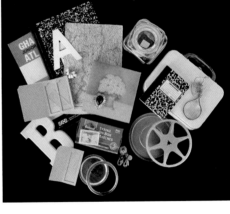

P–Z

Paint can; paper-mâché item; paperweight; paperclip; pen; pencil; pencil case; pencil holder; photo album cover; photo box or cube; piggy bank; pizza box; place mat; planter box; plate; playing card; playing card box; poker chip; postcard; purse; puzzle piece; recipe box; record (vintage LP) or album cover; Rolodex file; serving spoon; serving tray; sewing box; shadow box; shipping tag; shoe; silverware; slide mount; stamp case; stencil; switchplate cover; takeout container; tin can; tissue box holder; tongue depressor; toolbox; tote bag; trading card; travel case; vase; VCR box; wall clock; wall hook; wastepaper basket; watchmaker's tin; wooden block; wooden box; wooden letter.

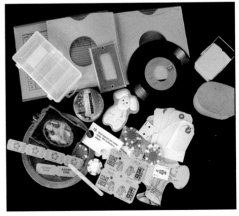

Artist Trading Cards (ATCs)

Trading cards have been around since the early 1800s, beginning with tobacco manufacturers and later, candy companies. The cards really took off when baseball followed suit with its own set in 1887. Their popularity has since grown by leaps and bounds. Why should artists be left out? The concept of the artist trading card originates with Swedish artist M. Vänçi Stirnemann. In 1997, he exhibited and traded 1,200 of his works. Since then, artist trading card (ATC) groups and networks have popped up all over the world.

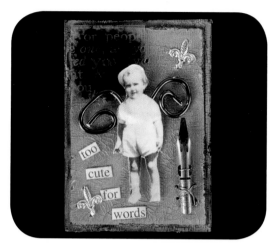

The golden rules for ATCs are easy to remember, and just as easy to follow, as there are only two:

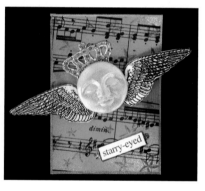

- ATCs must measure 2½ × 3½ inches. The card may be used in portrait or landscape orientation.
- ATCs must be traded, not sold.

Beyond these two rules, you are limited only by your imagination. Artists are free to incorporate virtually any medium on any surface they care to work with. You're free to embellish your cards as you choose.

Art Cards, Editions, and Originals (ACEO) are an offshoot of ATCs. These types of cards are created specifically to be sold, not traded. It has created a sore spot among true ATC enthusiasts.

ACEOs do allow for non-artists to collect and give cards as gifts.

Gothic Arch cards are a fun alternative to artist trading cards. Coming in all shapes and sizes, these cards have only one real requirement: They must be created on an arch-style base. There are many basic Gothic Arch patterns available on the Internet to get you started.

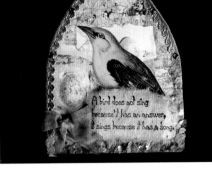

While there are no set rules and regulations concerning themes of Gothic Arch cards, you will find that most are vintage or shabby in nature. The stately architecture of the cards' base lends well to this style.

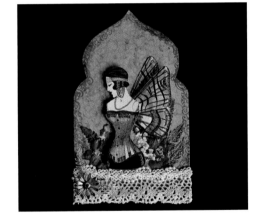

Take the Gothic Arch card one step further by turning it into a shrine-like triptych and adding two half panels to the arch base on either side. As you can see, the addition of these panels expands on the original theme. For more information on triptychs, see Chapter 9.

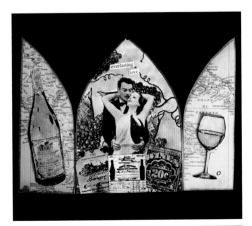

In addition to altered art objects, artist trading cards, and Gothic Arch cards, there has been an explosion of alternate art forms in the last few years. All stem from and expand on the classic collage ideal. Usually the only variation is in size requirements. Other techniques, media, and inspirations are left up to the individual artist's discretion.

INCHIES

An inchie is a miniature collage contained in the required 1 × 1-inch foundation. These challenging little works of art pack all the punch of larger pieces. They're a great way to express your artistic mind when you are short on the time or space needed for larger collage pieces.

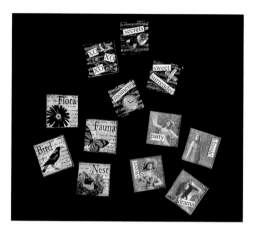

MOO CARDS

Moo cards originated as a fresh alternative to conventional business cards. Artists quickly grabbed hold of this idea and ran with it. Moo cards test your ability to design and create in a confined area. The size requirement is 28 × 70mm.

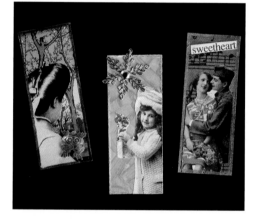

TAG ART

Tags are one more way to incorporate creative thoughts and ideas into an object of everyday life. There is no specific size requirement.

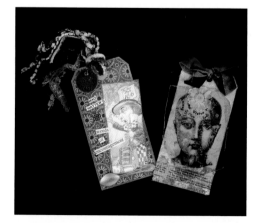

SKINNY CARDS

Sometimes referred to as ATCs on steroids, skinny cards offer up a larger working surface for various collage themes. The size requirement is 3 × 5 inches, usually in portrait orientation.

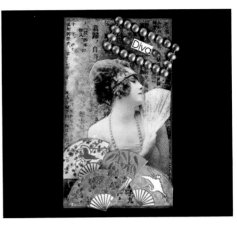

CABINET CARDS

Cabinet cards offer an artistic twist on vintage portraits of the middle to late 1800s. All cabinet cards incorporate an image of a person from this period embellished with paints, ink, and collage ephemera. Wings and crowns are popular additions to these types of cards. The size requirement is 4¼ × 6½ inches.

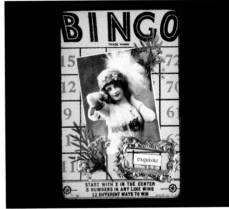

FAT BOOK PAGES

Fat book pages incorporate the freedom of collage into a shape that's familiar to scrapbook enthusiasts. If you're a scrapbooker unsure of where to begin with collage and altered art, fat book pages are a great jumping-off point. The size requirement is 4 × 4 inches.

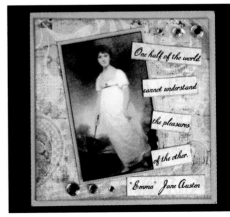

Getting Started

Start your collage and altered art journey on the right foot by understanding the supply choices that are available to you. Having a firm grasp of the materials used in collage and altered art will enable you to spend more time on art and less time deliberating on which tool to purchase and use.

Paper

The key ingredient to collage and altered art is the correct choice of paper. Understanding the differences between the various paper products that are available guarantees a fun and memorable result.

We'll start off by discussing the various forms of paper foundations you might choose to begin a design with, then move on to specialty and other forms of paper bits to incorporate into your collage or altered art projects.

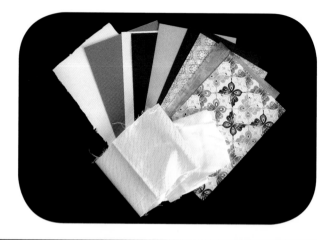

FOUNDATION MATERIAL

You must take into consideration the following when deciding on the correct foundation for your collage:

- Types of mediums to be used—paint, ink, glaze, etc.
- Number of layers and types of adhesives used.
- Weight of embellishments added to the collage.

The most commonly used foundation materials are:

- **Cardstock:** Excellent for lightweight or small collages. However, it does not tolerate excess liquid or heavy embellishment applications well.

- **Watercolor paper:** Excellent for liquid applications; it accepts several layers and is suitable for medium-weight embellishing.

- **Chipboard, wood, and canvas:** Best overall for universal applications; it tolerates liquid mediums, many layers, and heavyweight embellishments very well.

- **Fabric and leather pieces:** Great for "soft collage"; they accept paint and ink readily, and are excellent for image transfers, quilting techniques, and more.

DECORATIVE AND SPECIALTY PAPERS

Decorative and specialty papers are widely used on backgrounds, in layers, and as embellishments. They are available in an ample variety of weights, textures, and colors; these papers can be worked into an extensive array of designs.

Examples include printed pattern papers, vellum, handmade papers, mulberry and natural-fiber papers, embossed papers, and tissue paper (both printed and plain).

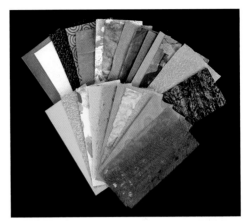

EPHEMERA

A popular paper embellishment for collage and altered art is called *ephemera*. You may be asking yourself, what is ephemera? It is an item that was designated for one-time or limited use.

Ephemera can be vintage or brand new. Either way, ephemera offers a way to convey meaning, incorporate textures and colors, or add interest to your finished project.

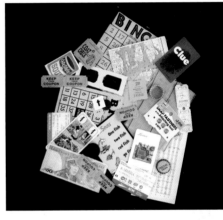

Examples include bank checks, bottle caps, cards, cigar labels, clothing tags, decorative napkins, fliers, game pieces, invitations, napkins, pamphlets, playbills, postage stamps, political or sales literature, sewing patterns and supplies, sheet music, seed catalogs, ticket stubs, and watch parts.

If you don't have the time to collect modern-day ephemera, there are many alternatives. Ephemera can be found and bought at flea markets, estate sales, second-hand shops, and even through online auctions. In addition, an alternative to using genuine ephemera is to use reprints. Many collectors and merchants now offer compact discs composed solely of vintage ephemera and images.

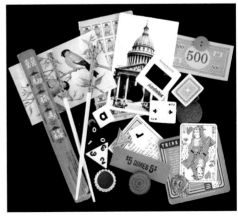

 TIP

Most "found" ephemera are not acid-free. This may or may not be a concern in your design, but products such as Make It Acid Free by Krylon will neutralize the acids in papers.

Text

The written word has been incorporated into art for as long as it has been around. Text has been used to emphasize the artist's point of view, to share some insight into the vision behind a piece, and even as the main focal point of a project.

No matter how or why you incorporate text into your collage or altered art, remember that it is an important tool at your disposal.

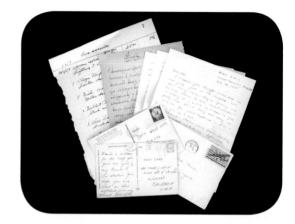

HANDWRITTEN TEXT

Handwritten text is a highly personal way to convey your message to the observer in a way that no other person can. The handwritten word is also a gift to future generations. In a world where e-mail and text messaging have taken the place of writing letters and notes, the handwritten word is quickly becoming a work of art in itself—something to be treasured almost as much as a photograph of days gone by.

PRINTED TEXT

Another way to convey your message is through printed text. Many artists incorporate text, in part or whole, from books, newspapers, or other printed materials. Available for little or no cost at thrift stores or garage sales, books and newsprint can be used to randomly piece together thoughts and ideas in your collage. Dictionaries and encyclopedias are excellent sources for both printed text and images.

COMPUTER-GENERATED OR STAMPED TEXT

Rubber stamps offer up a wide variety of alphabets, words, and phrases in a multitude of fonts and sizes. They are excellent when multiples of a single piece of artwork are desired.

Text generated from a computer allows for limitless options of fonts, sizes, and amount of text. You may print the exact text or lettering you need so that it fits the space allowed on the piece of art.

Images are essential to collage and altered artists. Images can be used as the primary focal point of your artwork, but the use of additional images may allow you to enhance and enforce the thoughts and ideas behind your creation.

PHOTOGRAPHS AND PRINTED IMAGES

Photographs, postcards, or printed images cut from out-of-date books or magazines are one of the easiest and most inexpensive ways to incorporate images into collage. Vintage or modern images can both be successfully combined into one piece. Readily available, these images can be found virtually everywhere. Discarded photos found at auctions can become adopted families just waiting for their stories to be told. Boxes of old books and magazines can be bought for very little and yield mounds of images simply waiting to be useful once again.

STAMPED IMAGES

Image rubber stamps come in a variety of sizes, shapes, and styles. With hundreds of rubber stamp companies on the market today, there are sure to be multiple images available for a focal image, embellishment, or finishing touch.

COLLAGE SHEETS

Collage sheets are images gathered together, resized, printed, and sold on one sheet of paper for your crafting convenience. Most collage sheets are printed on cardstock, vellum, or transparencies to accommodate various applications. Collage sheets range from 4 to 125 images per sheet, depending on image size. The types of images available on collage sheets encompass photographs, works of art, advertisements, line drawings, and much more.

This form of imagery is a real time-saver, as it eliminates your having to search through books and magazines for that special image. A few companies now offer CDs of their image collections for a fraction of the cost, allowing you to print individual images as needed.

Embellishments

A large part of collage and altered art are embellishments. These items help finish off your ideas and pull a piece together. Embellishments are, in a sense, the icing on the cake. What can you use to embellish your creations? Just about anything! Let's explore some of the options that are available.

PAPER EMBELLISHMENTS

Readily available and inexpensive, paper embellishments are perfect for both beginners and advanced altered artists. These embellishments may be attached to your project effortlessly, unlike some 3-D embellishments.

Paper embellishment ideas include advertisements, clothing patterns, collage sheets, ephemera, game pieces, German Scrap images (vintage or vintage-looking die-cuts with raised reliefs), greeting card images, labels, map pieces, napkins, photographs, postage stamps, postcards, stickers, tissue papers, trading cards, and vintage calling cards.

METAL EMBELLISHMENTS

Metal embellishments can be used to enhance your collage in a number of ways, from highlighting a particular phrase to adding movement when joining two pieces of your collage together. Some metal items can even be used as the foundation for your collage or altered art.

Metal embellishment ideas include buttons, brads, ball chain, charms, children's metal toys, eyelets, frames, jewelry and jewelry findings (new and old), keys, label holders, leafing flakes or foils, foil tapes, nuts and bolts, paper clips, sewing notions, sheet metal, silverware, washers, and wire.

Note: *A strong, quick-bonding adhesive may be necessary, especially when working with heavy or bulky metal items.*

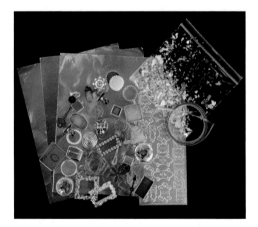

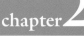

NATURAL EMBELLISHMENTS

Natural elements have the ability to create a wide and distinct range of emotions. The delicate petals of pressed flowers can soften even the harshest color palette. Sand may bring to mind a soothing day at the beach or the harsh environment of a desert. No matter what your intent, natural embellishments are always a welcome addition to collage and altered art.

Natural embellishment ideas include bones, dried leaves, feathers, mica (sheet or flakes), minerals, preserved insects, pressed flowers, rocks, rose hips, sand, seed pods, shells, skeleton leaves, and twigs.

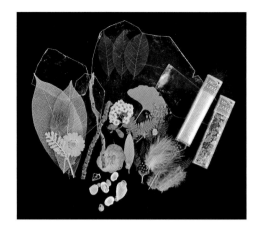

FABRIC AND TRIM EMBELLISHMENTS

Often referred to as "soft" embellishments, fabric and trims are versatile and very easy to work with. Fabric can be molded to virtually any shape, and it can be die-cut, run through a printer, used for image transfers, and much more. Ribbons, fibers, and trims are just as adaptable. Most soft embellishments can be easily dyed to complement the existing color palette of your collage.

Fabric and trim embellishment ideas include fabrics (both prints and plain), jute, leather, raffia, ribbon, rickrack, rope, string, thread, twine, twisted papers, velvet, woven material, and yarn.

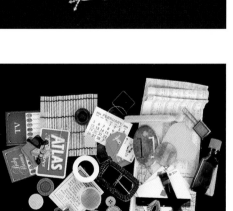

FOUND OBJECTS

Found objects are basically anything and everything. Simply stated, found objects are items not originally intended as art. Integrating found objects into collage adds a sense of realism, depth, and dimension. Some artists choose to work exclusively with found objects.

Found objects can be summed up with the old saying, "One man's trash is another man's treasure." Or, in this case, another man's art!

Found object ideas include bottle caps, bottles, buttons, clothespins, coins, corks, ephemera, game pieces, hardware, maps, paper money, puzzle pieces, sea glass, sewing supplies, tin cans, tokens, and watch parts.

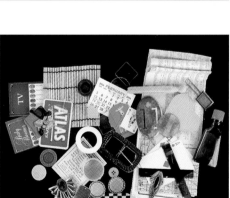

Adhesives

There are a multitude of adhesives on the market today. This section defines the various types and helps to clear up some of the confusion.

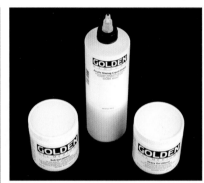

PVA OR WHITE GLUES

Polyvinyl acetate, or PVA, glues are water-based synthetic adhesives. While white glues all look the same, they are not. Some of the less expensive white glues contain large amounts of water, which, when used on collage or altered art items, causes excess warping and buckling of paper. Some also include acids, which, over time, damage paper and photographs. PVA or bookbinder's glues cost a bit more but contain less water and offer a better finished product. These glues are pH neutral and are of archival quality.

Glue sticks and Yes! Paste are also examples of white glues. These products contain very low water content, reducing buckling in thin paper. Both have been known to break down over time, though, causing items to separate and fall off.

ACRYLIC ADHESIVES, MEDIUMS, AND GELS

Many crafters believe that these types of adhesives are the best for collage and altered art. Acrylic-based adhesives, mediums, and gels contain a water-soluble polymer (plastic). The difference between each variety is viscosity. Acrylic adhesives and mediums are thin enough to pour. Gels have a thick consistency and are measured by strengths: soft, regular, and heavy. In addition to being used as an adhesive, they may also be used as a paint medium when mixed with acrylic paints or a finish sealer. This type of adhesive comes in various finishes—usually matte, semigloss, and glossy.

HEAVY-DUTY ADHESIVES

There may be times when you need a stronger adhesive to attach heavier items to your projects. Options include E-6000, Gorilla Glue, Glue Dots, and various "super"-type glues.

DIMENSIONAL ADHESIVES

Dimensional adhesives do just that: add dimension in addition to being glue. The two most common types are double-stick foam tape and a clear-liquid dimensional adhesive that holds its shape when dry.

Double-stick foam is basically a piece of thin foam that has an adhesive layer on each side. It is used to lift a particular piece off the background, making it pop into the foreground.

Liquid dimensional adhesives are thick, clear adhesives that dry to a glass-like finish. These adhesives are the perfect solution when glass isn't practical or desired on your art piece. Ranger Industries offers sepia and matte dimensional adhesives in addition to the clear variety.

DECOUPAGE MEDIUM

This type of adhesive is a water-based, nontoxic medium that can be used as a glue, sealer, or finish. When used as an adhesive, it causes more buckling than an acrylic gel or medium, but it has a longer drying time, which most collage artists prefer. It's available in three finish types: glossy, matte, and sparkle. If you use Mod Podge, you must also use an acrylic sealer to eliminate lingering tackiness.

SPECIALTY ADHESIVES

There are many other specialty adhesives on the market that can be used for a number of different techniques. Examples include:

- **Streuter's GlueFilm:** Heat-sensitive adhesive sheets.
- **Beeswax:** An ancient form of adhesive/sealer.
- **Packing tape:** Yes, that clear, sticky tape used to seal packages.

These and other specialty adhesives are discussed later in this book where they appear in a technique.

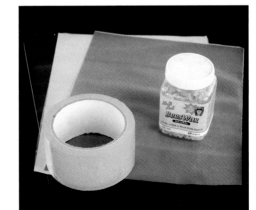

Paint, Ink, and Pigments

Paint, ink, and pigment products enhance collage and altered art projects by injecting color, texture, and at times, a bit of shimmer. Adding color to your projects can intensify emotions and heighten awareness both directly and indirectly.

PAINTS

Acrylic paints are among the most common paints used by collage and altered artists. These paints vary greatly, depending on the level of pigment concentration and viscosity. Craft acrylics have lower concentrations of pigment, making them an affordable option. Artist and fluid acrylics cost a bit more but contain high concentrations of pigment, causing them to last longer. There is a major difference between artist and fluid acrylics, however. Artist acrylics have the look and feel of oil paints, while fluid acrylics are much thinner, which allows them to be mixed with a variety of acrylic mediums, gels, and pastes.

Watercolor and *gouache* paints are another popular choice. Where watercolor paints are translucent, gouache paints are opaque and have a higher concentration of pigments. Both dry to a matte finish.

Oil, chalk, and pastels are additional color options that are available.

INKS

Inks can be incorporated into art either alone or paired with rubber stamps. Here is a basic guide to the most common inks on the market:

- **Dye:** This is a water-based ink that dries quickly and tends to fade over time.

- **Pigment:** This is a thicker, rich ink that has a very long drying time. It will not fade and is waterproof after it has been heat-set.

- **Walnut inks:** These inks are produced from the bark of walnuts. They are not normally acid-free.

- **Solvent inks:** Solvent-based inks work well on slick surfaces such as glass, metal, and acetate.

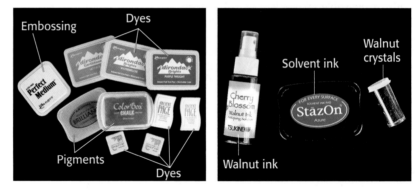

METALLIC EFFECTS

Leafing pens, leafing flakes, metallic rub-ons, and metallic acrylic paints are just a few of the products available to crafters to lend a realistic metallic flair without the bulk or weight of using real metal in your projects.

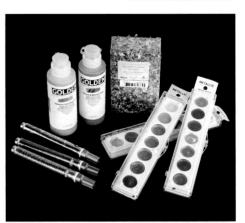

MICA AND PIGMENT POWDERS

Another option for adding color and sometimes sparkle to your collage is mica and pigment powders. Pigment powders add color. In addition to color, mica powder contains tiny flakes of mica, which produce a fine shimmer when dry.

Both are available in powder and cake forms. Some can be mixed with water, while others must be mixed with a binder. Be sure to read the manufacturer's recommendations prior to use.

SPRAY DYES

Spray dyes are a great way to add a translucent layer of color to your projects. Color intensity varies by manufacturer, so always test the spray on a scrap piece of paper before applying.

If you'd like a bit of shimmer, many spray dyes have mica powder incorporated right into the mix. Again, test on scrap paper, as the mica is not fully visible until dry.

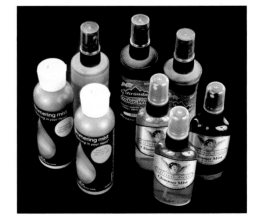

TIP

Practice using these types of dyes on scrap paper. You will notice a change in the spray pattern by varying the distance at which you spray. Movement also makes a difference in the pattern. Moving slowly yields a concentrated pattern, while quicker movements produce a lighter, airy result.

Finishes and Sealers

Finishing off your works of art properly is an essential part of the artistic process. Protecting your designs from the elements ensures that they will be around for future generations to explore and enjoy.

PAPER FINISH SPRAYS

Oftentimes in collage, you incorporate many items that may not blend together like you had hoped. Paper finish sprays are an excellent fix for such dilemmas. These sprays are ultra-transparent and create a soft iridescent or pearl sheen while sealing and protecting your work. Examples include Krylon Make It Pearl! and Krylon Make it Iridescent!

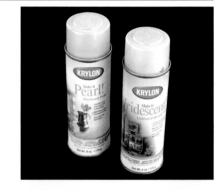

ADHESIVE SEALERS

Many collage adhesives are excellent sealers as well. The types of adhesives shown in the first photo have sealant properties that don't require any additional top coat protection. Examples include Aleene's Collage Pauge and USArtQuest PPA Adhesive.

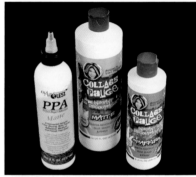

DIMENSIONAL ADHESIVE SEALERS

Like adhesive sealers, many dimensional adhesives also act as sealers for your finished pieces. Their thick coating protects everything that it encases. Examples include Ranger Glossy, Matte and Sepia Accents, JudiKins Diamond Glaze, and Aleene's Paper Glaze.

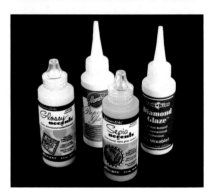

ACRYLIC SPRAY SEALERS

This type of sealer is readily available, inexpensive, and easy to use. It's usually a quick-drying, low-odor spray available in gloss and matte coats. It should be applied in several thin layers to avoid runs in the finish. Use it in a well-ventilated area to avoid breathing in the fumes.

Examples include DecoArt Americana Spray Sealer, Krylon Crystal Clear Acrylic Coating, Plaid Patricia Nimocks Clear Acrylic Sealer, Krylon Triple Thick Clear Glaze, and Triple Thick Gloss Glaze Spray.

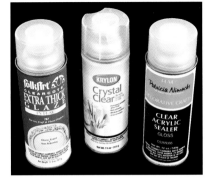

BRUSH-ON SEALERS

Brush-on sealers are desirable when fumes from aerosol sprays are a concern. Examples include DecoArt Triple Thick Gloss Glaze and DecoArt DuraClear Varnish.

SPECIALTY SEALERS

There are several special finishes on the market that yield a variety of effects.

- **Ultra Thick Embossing Enamel (UTEE):** A specially formulated large-particle embossing powder. When items are coated in this powder and heated, it yields a thick, glasslike finish. UTEE Flex, which is a resin additive, may be added for extra durability to a finished product.

- **JudiKins Micro Glaze:** A thin, clear, easy-to-apply wax protects projects from air, moisture, and oxidation. It is an excellent choice to keep inked or painted altered book pages from sticking together. This glaze does not change the appearance of your work.

- **Beeswax:** Artists have used this natural sealer for hundreds of years. It not only can be used to protect and waterproof a wide variety of materials, but it has also been used as art itself. Encaustic painting is a mixture of beeswax and pigments heated and applied to canvas or board. It can be molded and shaped, collaged, and carved.

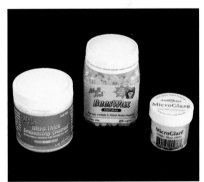

Tools

If you ask ten artists what their favorite tool is, you will likely end up with ten different answers. While we all have our favorites, there are basic tools that we all need. This section identifies these essential tools and provides information about specialized tools.

CUTTING TOOLS

Cutting tools are the most important items in your arsenal of tools. Because you will be dealing with a variety of materials in collage and altered art, you will need the correct tool for the job. You should have a general pair of shears for routine cutting, a micro-tip pair of scissors for detailed cutting jobs, and a craft knife with extra blades. I also like to have a retractable utility knife with extra blades for tougher cutting jobs. Keep in mind that you may need special cutting tools if you choose to work with materials such as wood, metal, or glass.

Remember: *For safety's sake, always use the appropriate tool for the job at hand to avoid accidents.*

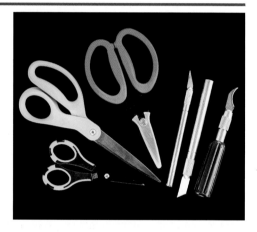

BRUSHES

Another important tool for any artist is a nice selection of brushes. Just like cutting tools, certain brushes work well for individual applications. For example, you wouldn't use a sable paintbrush to apply collage adhesive to your piece. In general, you should have a nice set of artist brushes for paints; foam-head brushes for applying collage mediums and adhesives; and larger brushes for applying finish and sealers. One additional type of brush I like to keep on hand is a waterbrush. This brush has a reservoir that can be filled with water or other solutions. It is handy when you are working with pigment powders, watercolors, or ink. You don't have the hazard of a dish of water sitting around your work area, nor do you have to constantly rewet your brush.

Note: *Clean your brushes immediately after use. Paints and other mediums dry very quickly and can ruin brushes if left unattended. Keep in mind that some mediums may require special cleaning solutions to completely remove them from your tools.*

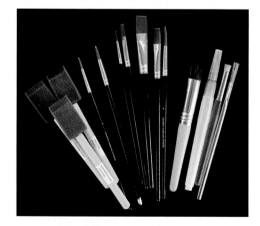

WRITING INSTRUMENTS

Pens, pencils, markers—no matter what your instrument of choice is, it's always wise to have several on hand for various applications. Graphite pencils are handy for temporary markings and sketches. Ink or gel pens are essential, especially when incorporating handwritten text or lettering in your collage or altered art projects. Depending on the application, you may want to make sure that the inks you use are acid-free and fade-resistant.

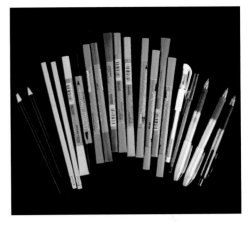

ESSENTIALS

The essentials are an assortment of tools that you will find yourself reaching for time and again. They are not only handy but are real time-savers, too.

- **Bone folder:** Use to crease, score, burnish, and smooth.
- **Ruler:** Use to measure, as a straightedge, and for spacing.
- **Paper piercer:** Use to pierce holes, as well as for scratching and scraping.
- **Brayer:** Use to smooth, and for various ink or paint techniques.
- **Heat gun:** Use to speed up drying times, for embossing, melting wax, and on shrink material.
- **Cork/cutting mats:** Use to prevent damage to your work surface.
- **Squirt bottle filled with water:** Use to mist paper or fabric, as well as with inks or paint; also use it for diluting mediums and distressing.

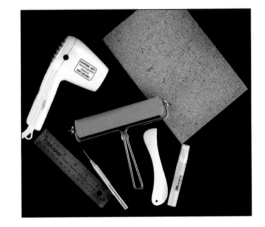

EXTRAS

You may not use the following specialized tools constantly, but without them, some jobs would be impossible.

- **Jewelry tools (pliers and wire cutters):** Use for working with wire and small hardware, as well as handling hot items.
- **Rotary tool:** Use for cutting, drilling, sanding, buffing, grinding, polishing, etching, and more.
- **Soldering iron:** Use for jewelry making, soldering metals, and glass slides.
- **Melt pot:** Use for melting various mediums, and curing polymer clay.
- **Travel iron:** Use to smooth, and for speed drying; you can also use it in ink and paint techniques.

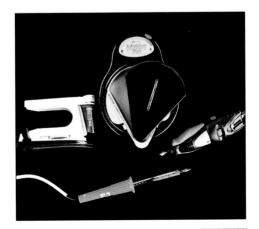

chapter 3

Aged and Distressed

Tattered papers, vintage images, shabby pieces of fabric—what do these items have in common? They are all aged and distressed. It doesn't matter if the items you incorporate into your collage and altered art are one day or one hundred years old. Simply use one or more of these easy techniques and your piece will have a uniform, cohesive look.

Distress by Hand

You can use these methods to distress paper and images without adding ink, paint, or other mediums. The existing color of your piece will remain the same, but have a worn, distressed feel.

You can see what a difference this makes in the following examples: sandpaper distressed pattern paper, torn edge photo, and wrinkled distress collage image.

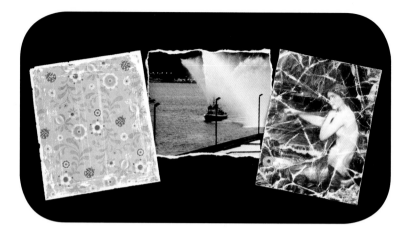

Tearing

Tearing paper is one of the easiest ways to achieve a distressed and shabby edge to papers, photos, and other items used for collage. When using paper or images with color, there are two methods that leave either a white edge (as shown in the first photo) or plain edge (as shown in the second photo).

WHITE TORN EDGE

1. Determine where you want the torn edge.
2. Grasp each side of the paper between your thumb and forefinger.
3. Slowly pull the edge you wish to be removed *toward* you. This exposes the core of the paper, leaving a ragged and frayed edge. If you choose to tear all four sides, it creates a worn, ragged frame around the entire piece.

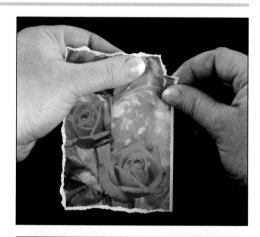

PLAIN TORN EDGE

1. Determine where you want the torn edge.
2. Grasp each side of the paper between your thumb and forefinger.
3. Slowly pull the edge you wish to be removed *away* from you. This again yields a ragged edge, but the color, image, or text extends to the very edges of the paper.

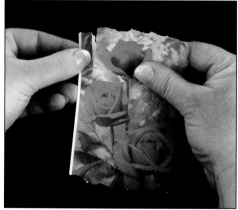

Wrinkled Distressing

Wrinkling is one of the easiest ways to distress your paper. In just a few short steps, you can add several years of wear-and-tear with just water and an optional iron.

Supplies

+ Paper or photo to distress – Retro Café Art
+ Mini Mister (filled with water) – Ranger Industries
+ Non-stick Craft Sheet – Ranger Industries
+ Heat tool (optional) – Ranger Industries
+ Craft iron (optional) – Clover

1 Place your paper on a protected work surface. Mist with water and let the water soak in for 20–30 seconds.

2 Gently crumble the paper into a small ball. Open the ball and crumble again in a different direction.

3 Unfold the paper and place it on your work surface. Gently smooth out the paper. Let it dry naturally or speed up the dry time with a heat tool.

4 **Optional:** If you want a smoother finish than what hand-pressing offers, press with a warm craft iron while the tag is still wet. This also quickly dries the tag for immediate use.

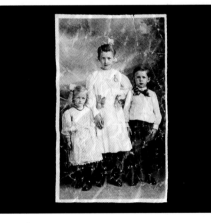

CONTINUED ON NEXT PAGE

Sandpaper Distressing

Sandpaper isn't just for wood anymore. Give it a try on pattern paper, white core cardstock, photos, and more. You will be amazed at the texture and depth created in a few short strokes.

Many types of sandpaper are available. The "roughness" of sandpaper is measured by its number (60, 100, 220, etc.) or by "grit" (coarse, medium, fine, extra fine, etc.). Larger numbers indicate finer abrasive particles. Medium-grit (60 or 80) sandpaper is a good general-use paper to have on hand for most jobs. Finer-grit papers (180 to 220) should be used when the application calls for a smooth finish.

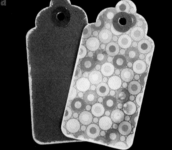

- **Sanded edges:** Hold your paper or photo in one hand while holding the sandpaper in the other. Lightly run the sandpaper along the edge. Repeat until the desired effect is achieved (a).

- **Sanded background:** Place the sandpaper on a protected work surface. Randomly sand small areas of the background, giving a worn, aged look. This is often used to highlight a particular area of an image or text (b).

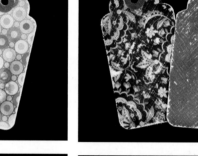

- **Crumble and sand:** Crumble your paper or tag. Unfold and flatten it back out with your hand. Sand the high spots. This process may be repeated until the desired effect is achieved (c).

- **Embossed sanding: (Note:** This works only with white core papers.) Emboss the paper that is to be sanded, or select a pre-embossed paper for this technique. Place the paper on a protected work surface. Lightly sand the raised designs, exposing the inner white layer (d).

TIP

If you run out of sandpaper, try using an emery board or nail file in a pinch.

There are a variety of tools on the market to help make distressing paper a breeze. Let's take a look at a few of them.

Paper piercer: A handy tool for creating scratches and scribble marks on your paper. It can also be used to peel layers of paper apart or to poke holes in multiple layers of paper or cardstock.

Tonic paper distresser: Tiny, sharp metal blades hidden inside this tool enable it to distress the edges of paper and cardstock safely and efficiently. The distresser adds an authentic worn edge to any paper. This tool does not work well on thicker materials such as chipboard or fiberboard.

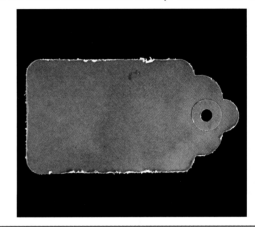

Tonic scratcher tool: Retractable wire bristles enable you to create several tiny scratches at one time. This tool creates a finely scratched surface to mimic years of wear-and-tear. It can also be used to create texture on polymer-clay pieces.

Dremel rotary tool: Sanding bands, sanding disks, brushes, grinding stones, buffing wheels, and several other attachments are available for this tool. It makes quick work of distressing paper, wood, metal, glass, stone, clay, and many other surfaces.

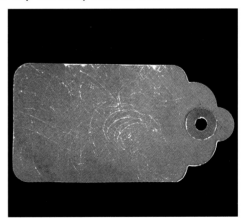

Stain with Tea and Coffee

The technique of using tea and coffee to stain paper and fabrics has been around for hundreds of years. Essentially, the processes for making and using both stains are exactly the same, with the exception of the dye agent. Both work extremely well in creating a lovely vintage patina. When you use these or other stains, you can blend paper, photos, and ephemera of all ages into one, creating harmony and uniformity in your collage.

Supplies

- ✦ Instant coffee or tea
- ✦ Hot water
- ✦ Glass bowl or pan
- ✦ Sponge brush
- ✦ Ziplock bag
- ✦ Newsprint or brown bags (to protect work surface)
- ✦ Mini Mister (optional) – Ranger Industries
- ✦ Craft Iron (optional) – Clover

MIX THE STAIN

1. Carefully pour the hot water into a glass bowl.
2. Add instant coffee or tea bags to the water.
3. Let the tea steep for several minutes before removing the teabags. Your stain is now ready for use.

 Remember: This solution isn't for drinking, so the stronger the brew, the better.

Once you have the stain to the desired shade, you have several options on how to apply the stain to your project. The following are just a few of these options.

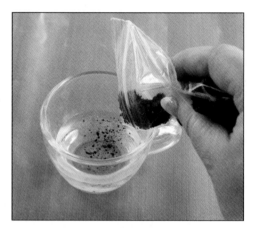

PAINT WITH STAIN

One of the easiest ways to apply the stain is to paint the stain onto your paper with a paintbrush, sponge, or foam brush. This ensures that the entire piece is tinted with the stain and yields a nice, even coverage.

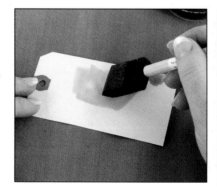

ZIPLOCK BAG STAINING

Another simple technique for staining paper, material, or ephemera is to use a ziplock bag. Applying stain in this way creates light and dark areas for a natural appearance.

1 Pour a small amount of the stain into a bag.

2 Add the items to be stained in the bag and seal it. This is *very* important. If a leak occurs, wipe it up immediately, as the coffee or tea will stain material, carpets, etc.

3 Shake, squeeze, and knead the paper or material inside the bag until you are satisfied with the coverage.

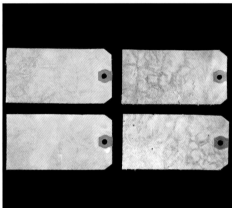

4 Remove the articles from the bag and lay them flat on several sheets of newsprint to dry. You can speed drying time by using a heat gun or craft iron.

Note: *This is an excellent way to stain several pieces at one time.*

An alternative process is to crumble your paper prior to applying the stain. The creases retain more stain than the surrounding areas, adding depth, dimension, and a natural, authentic feel to your finished piece.

SQUIRT BOTTLE STAINING

When you apply the stain by filling a squirt bottle or mister with the brew, this technique offers up a unique splatter effect. Try various spray bottles or nozzles to achieve a wide variety of patterns. Speed up the drying time by using a heat gun.

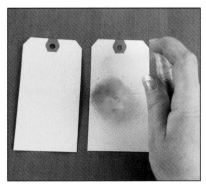

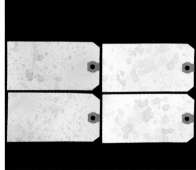

Always place your paper or material on several layers of newsprint prior to misting to protect the surrounding area.

Note: *There may be a lingering scent of coffee or tea once the item has dried. This may or may not be a factor on your project.*

Dye with Walnut Crystals and Inks

Black walnuts have been used to create dyes and inks for hundreds of years. We are fortunate to have crystal and diluted forms of the ink available for purchase, avoiding the long and arduous process of making the ink ourselves. This type of ink, while applied in much the same fashion as coffee or tea stain, adds a deeper, richer dimension.

Note: *Always protect your work surface and wear gloves. Walnut inks' staining abilities are very powerful and will last for days on skin and may be permanent on other surfaces.*

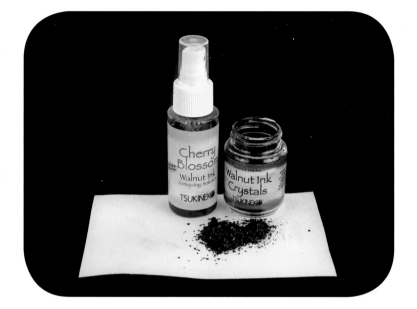

Dilute Walnut Ink Crystals

Supplies

- Glass bowl
- Warm water
- Walnut ink crystals – Tsukineko
- Metal or disposable spoon (the ink will stain plastic and wood utensils)
- Rubber gloves and an apron
- Newsprint (to protect the work surface and surrounding area)

Diluting walnut ink crystals is an easy process, similar to the dilution of instant coffee.

1. Sprinkle a teaspoon of walnut ink crystals into the bowl.
2. Slowly pour the warm water over the crystals and stir.
3. Test the ink for color. If a deeper tone is desired, add a few crystals a little at a time. If a lighter tone is needed, add a few drops of water, testing the color frequently. Once you are satisfied with the color, the walnut ink is ready for use.

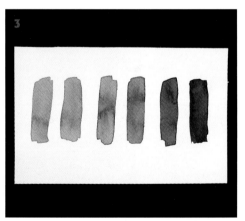

Apply Walnut Ink

There really is no wrong way to apply this ink. Below you will find several ideas to get you started. Always remember that experimentation is half the fun of art. Play around and see what you can come up with!

Diluted walnut ink crystal mixture and premixed walnut inks can be applied in the same fashion as coffee and tea stains.

Note: This ink works on uncoated cardstock, specialty, printed papers, or fabric. Glossy papers resist the ink and do not work well unless they have been manually distressed in some form.

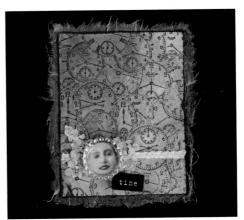

- Drip the ink onto paper and use a straw to blow the ink around.
- Paint the ink onto paper or material with a sponge, paintbrush, stipple brush, or foam brush.
- Fill a waterbrush with walnut ink. Use the waterbrush to write, draw, or scribble on the paper or fabric.
- Pour the diluted walnut ink into a ziplock bag. Add paper or material and shake to coat.
- Fill a mister with the walnut ink solution. Mist the paper with the ink. Try various methods of spraying the ink onto the paper to achieve a variety of looks.
- Wet paper with a light coat of water. Sprinkle walnut ink crystals over the wet paper. This produces intense, interesting stains on the paper.
- Crumble or distress your paper using one of the techniques from the "Distress by Hand" section on page 32. Apply the walnut ink to the distressed paper. The ink is naturally attracted to the distressed areas in higher concentrations, while the surrounding areas are lighter.

Note: Inked surfaces may be dried using a heat gun or craft iron. Try ironing pools of walnut ink for unique and interesting effects.

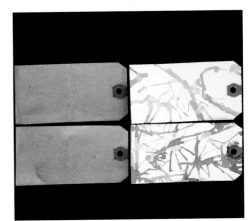

TIP

Store unused, diluted walnut ink in an airtight container in the refrigerator for future use.

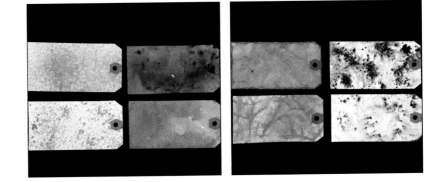

Bleaching Techniques

Instead of adding color to your collage or altered art project, take it away by using bleach. Despite the harsh chemicals and foul smell, bleach has the unique ability to create soft, diffused images.

Prior to working with bleach, always take a few precautionary measures. Wear safety glasses, rubber gloves, and an apron (as shown in the photo on the right) to protect yourself from the harmful effects of the bleach. Work in a well-ventilated area, and place several layers of newsprint on your work surface before you begin.

Supplies

- Chlorine bleach
- Water
- Shallow glass bowl
- Napkins (folded into quarters)
- Cardstock
- Applicator (rubber stamp, sea sponge, paintbrush, etc.)
- Heat gun
- Safety glasses
- Rubber gloves
- Apron
- Newsprint (to protect your work surface)

BLEACH STAMPING

1. Place the folded napkins into a shallow bowl. Pour bleach over the napkins and dilute with water (approximately a 50/50 mixture).

2. Gently press the stamp on the napkins just as you would an ink pad.

3. Stamp the image onto your cardstock. Immediately wash the rubber stamp. Heat the stamped image with a heat gun to bring out the full effects of the bleach.

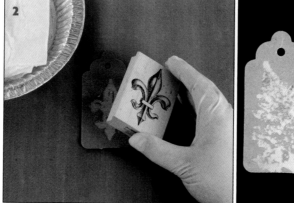

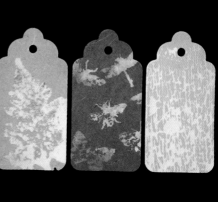

ADDITIONAL BLEACHING TECHNIQUES

- Pounce the bleach mixture onto cardstock using a natural sea sponge. This creates interesting depth and faux texture.
- Paint images or text using a cotton swab, paintbrush, or bleach-filled waterbrush.
- Fill an eyedropper with bleach mixture. Add drips, dots, scribbles, or splatters of the bleach solution to the cardstock. You can create interesting patterns by varying the way you apply the bleach.

- Pounce a stiff-bristled brush—toothbrush, old hair brush, cleaning brush, etc.—into the bleach solution and flick the bristles. This method creates a random splatter pattern on your cardstock.
- Incorporate the use of a mask as a variation on the splatter technique. Place the mask on your cardstock and then flick the bleach solution over the cardstock. Remove the mask to reveal the resulting pattern.

Note: *Some varieties of cardstock contain colorfast dyes that resist bleaching. Always test the bleach solution on a small swatch prior to attempting any of these techniques.*

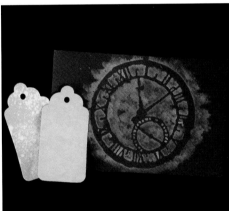

BLEACH ALTERNATIVES

If you're apprehensive about using liquid bleach, there are a few alternatives you can try:

- Gel bleach or Clorox Bleach Pens
- Lemon juice
- Balsamic vinegar

Warning: *Never, under any circumstances, place bleach or vinegar in an atomizer. Inhaling the bleach droplets may cause irritation, illness, or serious, long-lasting health issues. Be safe and always work in well-ventilated areas.*

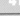

Tim Holtz Distress Inks

This specially formulated water-based dye ink from Ranger Industries was designed with aging paper and photos in mind. Its unique qualities and vintage color palette offer a versatility not found with other inks.

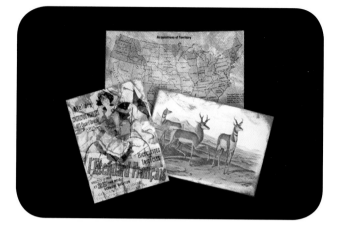

Direct to Paper

The direct-to-paper technique is just that: applying the ink directly to the paper from the ink pad. It is an easy way to achieve a worn, antique look on virtually any surface quickly and with very little mess. You can accomplish a number of effects by using the direct-to-paper technique. Here are a few to get you started.

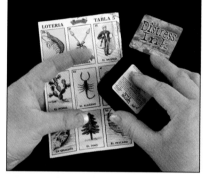

Supplies

- ✦ Tim Holtz Distress Inks – Ranger Industries
- ✦ Tag, cardstock, photo, or other item to be distressed
- ✦ Non-Stick Craft Sheet – Ranger Industries
- ✦ Craft iron – Clover
- ✦ Brayer – Ranger Industries

- Hold the tag in one hand and run the ink pad along the very edge of the tag to create a thin rim of color. I like to use this technique for modern or computer-generated items. It is a quick way to add a few years with a single stroke of the ink pad.

- Crumble the tag once or twice to create several creases in the paper. Unfold and place it on the nonstick craft mat. Rub the ink pad over the high spots of the tag. Iron to flatten it for use.

- Place a tag on the nonstick craft mat. Roll a brayer over the ink pad to pick up the ink. Immediately roll the ink onto the tag from various angles. Re-ink the brayer as needed.

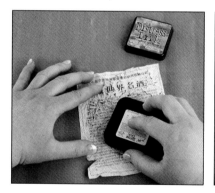

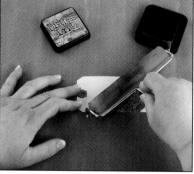

Wrinkle-Free Distressing

Who says distressed means wrinkles and creases? This quick and easy technique offers a unique distressed look without having to manually distress the paper. It is an excellent solution when you need large quantities of distressed papers.

Note: *This technique was first introduced by Tim Holtz on his DVD, "The Journey Continues." Thanks go out to Tim for allowing me to share it with you.*

Supplies

+ Tim Holtz Distress Ink – Ranger Industries
+ Non-Stick Craft Sheet – Ranger Industries
+ Squirt bottle (filled with water)
+ Cardstock (or other item)
+ Heat Tool – Ranger Industries or Craft Iron – Clover

1 Pounce the Distress Ink pad on the craft mat and mist with water.

2 Place the cardstock face down on the ink mixture and lift. Repeat until the desired color has been achieved.

3 Let it dry naturally, or speed dry with a heat tool or iron.

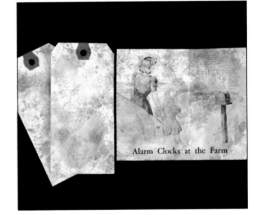

Alarm Clocks at the Farm

TIP

Wrinkle-Free Distressing Tips
- Vary the amount of water used for a multitude of looks.
- Experiment with color combinations.
- Layer one color at a time to create a feeling of depth.
- Iron the wet ink to create interesting designs in the ink.

Paint Patina

Paints applied in a variety of ways can mimic classic patinas created by years of age. By pairing modern items with one of these painted patina techniques, nobody will know that it's not a true antique. These techniques work equally well for paper, wood, and metal items.

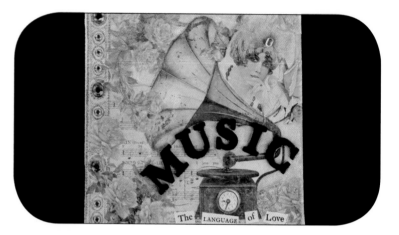

White Wash

Supplies

- ✦ Sandpaper 180–220 fine grit (optional)
- ✦ White acrylic paint
- ✦ Warm water
- ✦ Cup or bowl (to mix the paint)
- ✦ Foam brush or sponge
- ✦ Non-Stick Craft Sheet – Ranger Industries

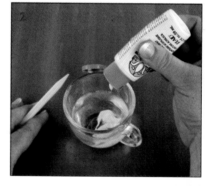

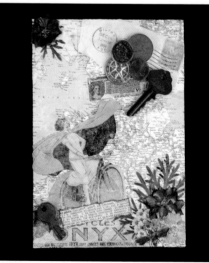

1. You need to prepare wooden or metal surfaces for this technique. Lightly sand the surface of your project using a fine-grit sandpaper. This creates a tooth for the paint to grab hold of.

2. Pour 1 part paint and 3 parts water into a container. Mix until thoroughly blended together.

3. Paint the mixture onto the prepared surface using a foam brush or natural sea sponge.

Note: *When you use this technique over a collage background, you will notice how the paint has toned down all the colors in the collage evenly. This is a simple way to create harmony and balance when one or more pieces used in the collage don't match the existing color palette.*

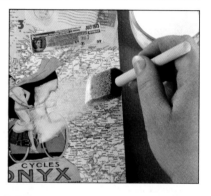

TIP

You're not limited to using white paint for this technique. Try using a variety of colors to match your mood or theme.

Faux Copper Patina

Supplies

+ Adirondack Copper Acrylic Paint – Ranger Industries
+ Adirondack Bottle Acrylic Paint (green) – Ranger Industries
+ Non-Stick Craft Sheet (optional) – Ranger Industries
+ Paintbrush
+ Sea sponge, dry cloth, or plastic baggie
+ Item to paint
+ Heat gun (optional)

1 Paint the item to be aged with copper acrylic paint. Let it dry naturally or speed dry it by using a heat gun. Your piece must be completely dry before you add the second layer.

2 Now you will add the "patina" using the green (Bottle) acrylic paint. Pour a small amount of paint onto a plate or nonstick craft mat.

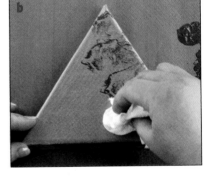

Adding the patina will be accomplished by using what is referred to as a dry brush application. Basically, that means the less paint used, the better. This layer of paint may be applied using a variety of tools.

Remember: You apply the green paint just to add a patina. You are not trying to coat the entire piece. A light coat will do.

- **Natural sea sponge:** Pounce the sponge into the paint and pat it on scrap paper until very little paint is left on the sponge. Lightly dab the sponge onto your project (a).

- **Dry cloth or burlap:** Wad the cloth or burlap into a ball. Pat the wadded cloth into the paint and dab off excess paint on scrap paper. Again, lightly dab the cloth onto the project. Notice how the wadded cloth creates a different texture from the sea sponge (b).

- **Wadded plastic baggie:** This application is basically the same as the dry cloth. The major difference between the two is that the plastic baggie tends to retain excess paint. Take extra care when applying paint using this method. Again, this method adds another textural dimension to the faux patina (c).

Crackle Mediums

Crackle mediums are an excellent way to bring that vintage feel to paper, chipboard, and wood surfaces. With a few simple steps, you can add 40 years to your project. Be sure to choose two distinctive paint colors—one for the base coat and a second, contrasting color for the top coat. If your colors are too similar, the crackle will not show very well, if at all.

Created by Shannon Horch

Supplies

- ✦ FolkArt Crackle Medium – Plaid
- ✦ FolkArt Acrylic Paints – Plaid
- ✦ Paintbrush or foam brush
- ✦ Paper, chipboard, or other item to be distressed
- ✦ Non-Stick Craft Sheet – Ranger Industries
- ✦ Acrylic spray sealer (optional) – Plaid

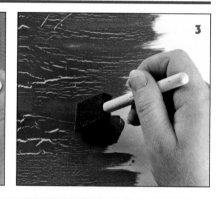

❶ Paint the foam core board using the desired base coat color. Let this coat dry completely before you proceed to the next step.

❷ Apply a layer of crackle medium over the base coat. This coat determines what the finished crackle effect will look like. Keep in mind that thicker layers of the crackle medium produce larger, well-defined cracks, while thin layers produce many fine cracks. Let this layer dry completely.

❸ Once the crackle medium has dried, it's time to apply the top coat. Brush an even, smooth layer of paint over the surface of your project. Cracks will begin forming immediately. *Do not* go back over previously painted areas, as this will destroy the cracks that have begun to form. Once the top coat has dried, the cracks should be fully formed.

❹ **Optional:** Once the top coat has completely dried, you may apply an acrylic sealer to your project.

❺ Embellish the collage as desired.

CRACKLE PASTE

Crackle Paste by Golden yields a textured crackle that can be felt as well as seen. This medium has the consistency of cake icing and holds its peaks. It can be mixed with Golden Acrylic Fluid Paints if desired, but it does have an absorbent surface and may be painted after it has dried.

To use crackle paste, apply it to your primed foundation with a palette knife or trowel. As it dries, this medium experiences extreme shrinkage, so it should be applied to projects that have a stable, rigid foundation such as wood sheets, hardboard, and prestretched canvas. Cracks will begin to appear within 24 hours, but layers ½ inch thick or more may take up to 3 days to dry completely. Heat and humidity also affect drying times.

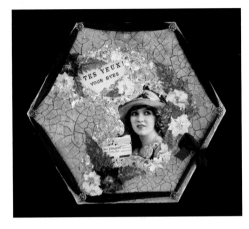

DISTRESS CRACKLE PAINT

Another alternative to crackle medium is Tim Holtz Distress Crackle Paint by Ranger Industries. This amazing paint eliminates two of the three steps associated with traditional crackle distressing. You are now able to create years of age with just one coat of this specially formulated paint.

Simply apply the paint to the project and let it dry naturally. Drying time varies, but you should begin to see cracks within the first 30 minutes. As with most other crackle mediums, thicker coats of paint produce larger crackle effects, while thin layers yield many very fine cracks.

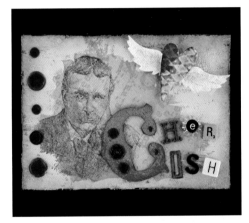

CRACKLE ACCENTS

Crackle Accents is a thick, one-step gloss medium that dries to a crackle finish. It works well on porous surfaces such as decorative or printed papers, canvas, cardstock, and chipboard.

It comes in a handy squeeze bottle with a needle-nose tip for mess-free application. Squeeze the gel where desired; cracks will begin to appear as it dries.

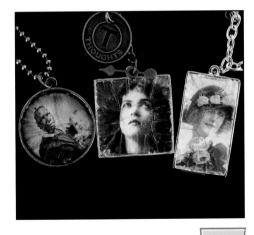

Metallic and Luster Rub-ons

Metallic and Luster Rub-ons by Craf-T Products are thick, creamy color mediums that provide you with a deep, intense vintage sheen. These rub-ons not only offer a unique way to distress your project but also help hidden textures come into focus. Rub-ons can be used as an accent, as a highlighter, or for all-over coverage.

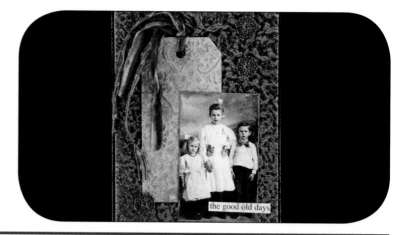

APPLICATION

Apply metallic or luster rub-ons to your project by picking up a bit of color on your fingertip and rubbing it onto your chosen project (a). The rubbing breaks down the colors to help bring out the metallic sheen.

IDEAS FOR USE

- **All-over coverage:** If you're working with a modern or computer-generated article but need it to blend in with vintage or distressed items, apply rub-ons to the entire piece (b). Vary the intensity of the rub-ons by applying lighter and darker coats of color. Try mixing rub-on colors for an interesting look and feel to the finished project.

- **Embossed or texture accent:** Apply rub-ons to embossed or textured papers and fabrics (c). By doing so, you give these items a shabby, well-worn feel in addition to adding texture to your overall finished project without adding bulk.

- **Accents:** Add metallic or luster rub-ons to the edges of a work to create an elegant Victorian charm (d).

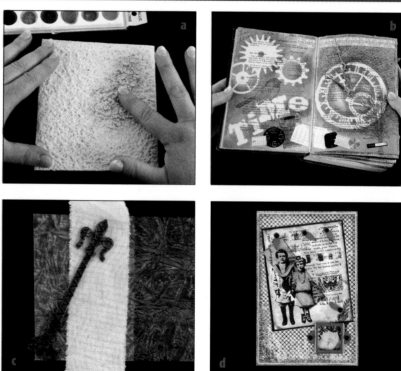

TIP

Metallic rub-ons should be sprayed with a fixative to prevent smudges.

Glazing

A *glaze* is a thin, transparent layer of paint over a finished piece of work. *Glazing* is simply building up these layers to alter how the viewer perceives the colors of the work. Glazing is an excellent option when you want to add color balance where it may not exist.

Supplies

+ FolkArt Acrylic paint – Plaid
+ FolkArt Glazing Medium – Plaid
+ Glass cup or paper plate (to mix the glaze)
+ Paintbrush or foam brush
+ Newsprint or Non-Stick Craft Sheet – Ranger Industries
+ Collage (to be glazed)

1. Pour 1 part acrylic paint and 3 parts glazing medium into a cup and mix thoroughly. You will notice that the paint becomes transparent once it has been mixed into the glazing medium. If you want the color to be more transparent, add a bit more glazing medium.

2. Paint the mixture over the collage, photo, etc. Apply additional coats of glaze where desired, to build glaze color or to tone down particular areas of the collage or image.

3. Let the glaze dry naturally. Because glazes are frequently lighter when they are dry than when they are wet, determine if additional layers are needed.

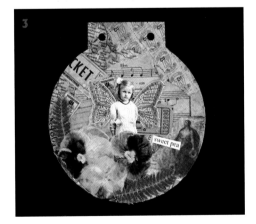

chapter 4

Paper Collage Techniques

From its humble beginnings, paper has become the cornerstone for many collage and altered art works. It has been incorporated into backgrounds, used for embellishments, or the main focus of a variety of art pieces. Since an abundance of techniques integrate paper in one form or another, we will explore the basic starting points to build from.

Mixed Paper Collage

Using the basics of making a mixed paper collage as described in Chapter 1, we'll take that basic collage one step further by adding fibers, embellishments, and glazes.

Incorporating these extras will allow you to take your art to a new level by adding bits of memorabilia and personal touches, which might not be possible in paper collages.

Supplies

+ Collage images – Retro Café Art
+ Specialty papers and fibers – PaperArts.com
+ Pattern paper, fiber, buttons – Basic Grey
+ Ephemera and found embellishments – Hannah Grey, Found Elements, personal collection
+ Mod Podge – Plaid
+ Foam brush
+ Glaze
+ Non-Stick Craft Sheet – Ranger Industries
+ Collage foundation
+ Patricia Nimocks Clear Acrylic Sealer – Plaid

1 Determine the theme, select a foundation, and assemble the required materials to be used in your collage.

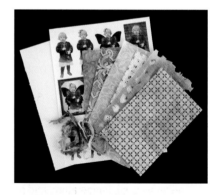

2 Arrange bits and pieces of specialty paper, pattern paper, ephemera, and collage images as desired. Begin pasting the pieces to your foundation. Remember to apply glue to both the foundation and the pieces you are adhering.

3 Smooth down any edges that may curl as they begin to dry, and continue adding various items until your collage is complete. Let your collage dry completely before moving on to the next step.

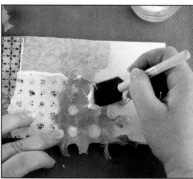

④ **Optional:** Blend acrylic paint and a glaze medium, or use a premixed glaze. Apply one or more coats of glaze to the entire collage or just certain areas.

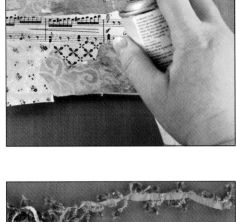

⑤ Incorporate various bits of fiber and embellishments into your collage.

Note: Some found embellishments may require stronger adhesives to ensure that they remain on your collage. See Chapter 2 for additional information.

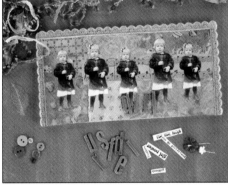

⑥ Once you are satisfied with the collage, let all adhesives dry completely. This may take several hours or a few days, depending on the amount and types of adhesive used, temperature, and humidity. Apply a brush-on or spray sealer to protect your work.

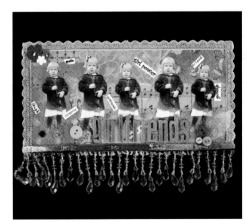

Segmented Background

When you're short on time but still want the texture and feel of a more involved mixed paper collage, try a segment collage. This type of collage can be created in a fraction of the time but still yields a wonderful foundation for your artwork.

Notice in examples how not only color plays an important role but how the type of paper adds depth, texture, and an overall appeal to the finished design.

Supplies

- ✦ Foundation material
- ✦ Specialty paper – PaperArts.com
- ✦ Cardstock – Club Scrap
- ✦ Pattern paper – Basic Grey
- ✦ Aleene's Collage Pauge collage medium – Duncan Enterprises
- ✦ Foam brush
- ✦ Non-Stick Craft Sheet – Ranger Industries

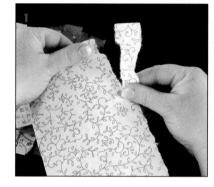

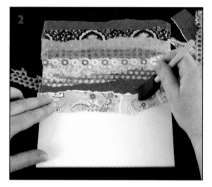

1 Tear the paper into long strips approximately 2 inches wide. If you are working with delicate specialty papers, paint a line with water prior to tearing. This will lessen the possibility of errant tears.

2 Adhere the strips of paper to the foundation using the collage medium. Apply a thin layer of glue to both the foundation and the strip of paper for the best adhesion. Begin at the top and work your way down. Vary the spacing of these strips to create added interest.

3 Once you have finished adding all the strips, let them dry completely. You may now add a glaze layer or finish off the collage as desired.

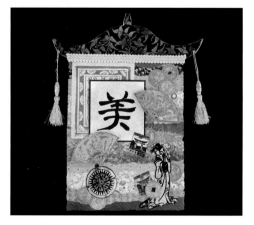

TIP

Try creating a monochromatic collage using this method for a striking background!

Notice how the theme of the collage is enhanced by the gradient color change of the segmented collage below. Now consider the variety of color combinations and themes that could work together.

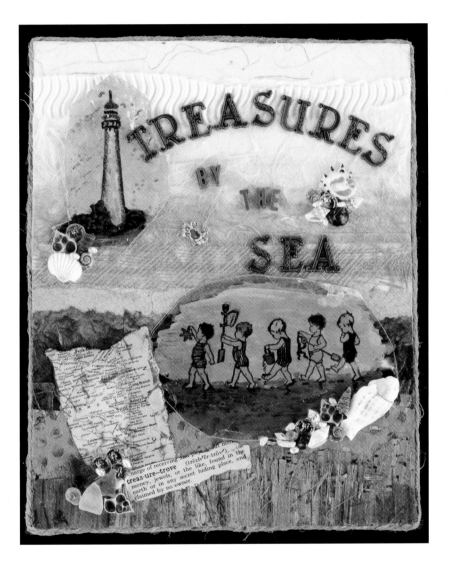

Frottage Background

Frottage is a fancy word for a technique you may have practiced as a child. Basically, frottage is making a rubbing of a textured surface. It's as simple as that! To create a frottage collage background, we'll incorporate an assortment of rubbings and textures that might not otherwise be possible. It is an excellent technique for both young and old.

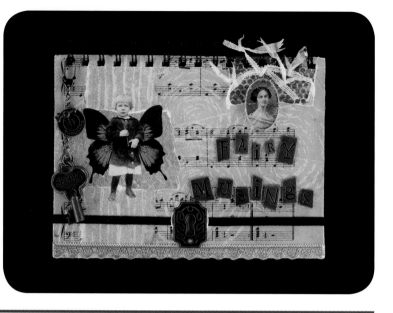

Supplies

- ✦ Copy paper
- ✦ White or black crayon or white wax candle
- ✦ Textured surfaces
- ✦ Mod Podge – Plaid
- ✦ Fluid Acrylics – Golden
- ✦ Acrylic Glazing Medium – Golden
- ✦ Foundation

① Create a rubbing by placing a sheet of copy paper over a textured surface. Rub the crayon or wax candle over the copy paper, thus transferring the texture to the paper.

② Repeat this step several times, generating a nice variety of textures to include in your collage.

 TIP

Texture Ideas

Try creating rubbings by using some of the following items: leaves, corduroy, burlap, tweed, rattan or wicker, wood, bark, concrete, stone, bricks, netting, mesh, corrugated cardboard, handmade papers, bubble wrap, rubber stamps, lace, etc.

If you're short on time or are unable to search out a variety of textured surfaces, many companies offer texture plates in a variety of patterns.

③ Create a variety of glazes by mixing the glaze medium with fluid acrylics.

You may choose to work within one color range or several. If you choose to work with a monochromatic color scheme, increase or decrease the ratio of paint versus glaze medium for a nice selection of tones.

④ Paint each of the rubbings with a different glaze. The wax from the crayon resists the glaze, highlighting the textures. Wipe away the excess paint and let the rubbings dry naturally.

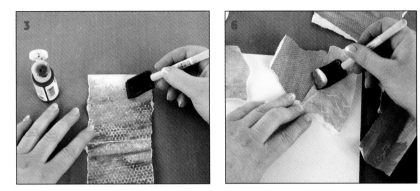

Note: *Do not speed drying by mechanical means. The heat generated by a heat gun or craft iron will melt the wax and possibly destroy the rubbings.*

⑤ Tear the dried rubbings into smaller pieces to be used in your collage.

⑥ Assemble the collage as desired by following the basic, mixed, or segmented collage directions.

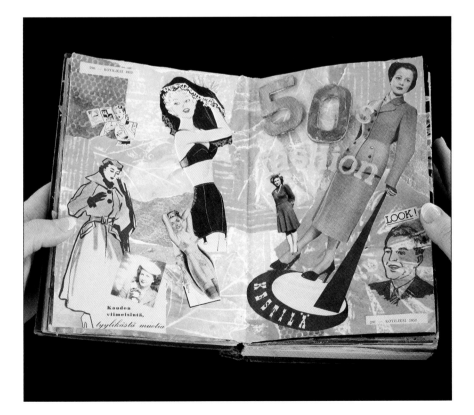

This technique is inexpensive and takes very little time to create while yielding stunning results. What makes this technique so much fun is that there are no limitations. You are free to incorporate as many of your favorite mediums and embellishments as desired. Let's create a wax paper background.

Due to the semi-translucent nature of waxed paper you have the option of mounting the finished wax paper background over other materials to enhance the overall design. For example, you might choose to layer this paper over vintage sheet music, journal entries, sections of a vintage map, and more.

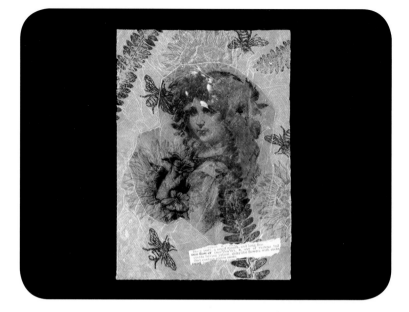

Supplies

+ Wax paper
+ Ink, paint, chalk, metallic rub-ons (any combination of these)
+ Liquid adhesive or collage medium
+ Embellishments, fibers, natural materials
+ Leafing flakes – Sepp Gilding Workshop

1 Tear a large piece of wax paper from the roll. The piece needs to be larger than what is needed for the finished project.

2 Apply various mediums to the paper. You may use paints, inks, dyes, glazes, chalks, or a combination of several mediums. It is totally freeform, and there are no limitations here. If you are using several wet mediums, I suggest that you let each layer dry between fresh coats.

Once you are satisfied with the color, let the paper dry completely.

Note: *Some people don't wait for the various mediums to dry but add the embellishments immediately. I like to let the various paints and inks dry. This way, if I drop an embellishment on the paper, it won't become covered in a wet medium.*

3 Adhere any desired embellishments, fibers, glitter, or leafing. Let the wet adhesive dry completely.

4 Crumble the wax paper several times in a variety of directions. This roughs up the appearance and adds a considerable amount of texture.

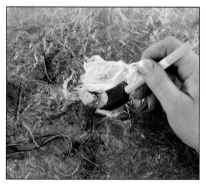

⑤ Mount the paper to your project using a collage medium or your favorite liquid adhesive.

Note: It may be necessary to weight down the paper with a book while drying to prevent the edges from curling.

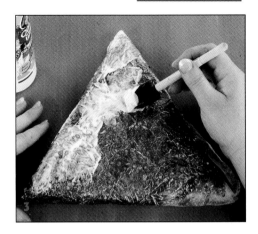

TIP

Incorporate this paper collage into altered books, canvas collages, cards, journal covers, die-cuts, etc. Leftover bits and pieces could be incorporated into jewelry, mini collages, or scrapbooks.

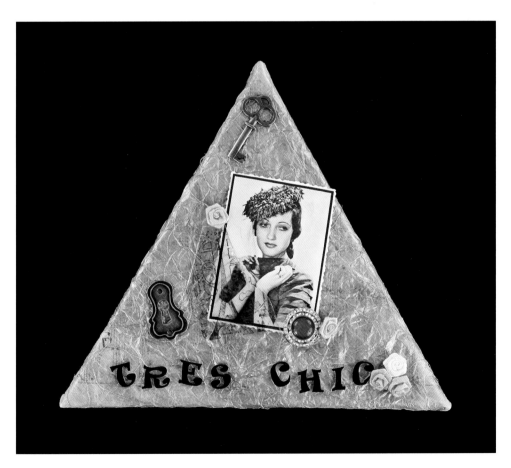

Paste Paper

Paste papers have been around for hundreds of years. Originally they were created using natural pigments and wheat paste. Today's version incorporates readily found ingredients but still yields the same amazing results.

Supplies

- ✦ Perfect Paper Adhesive (PPA) – USArtQuest
- ✦ FolkArt acrylic paints – Plaid
- ✦ Bowl or dish (to mix glue and paint)
- ✦ Foam brush
- ✦ Watercolor paper
- ✦ Newsprint (to protect the work surface and surrounding area) or Non-Stick Craft Sheet – Ranger Industries
- ✦ Texture tools (comb, bone folder, toothbrush, hair brush, foam stamps, etc.)

1. Pour equal parts acrylic paint and the PPA into a bowl. Blend the ingredients thoroughly.

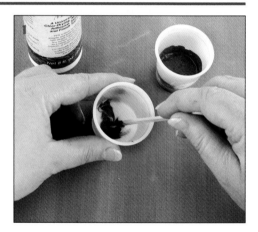

2. Apply a thick coat of paste paint to the watercolor paper using a foam brush. You need a layer of paste paint thick enough to form patterns for the next step.

TIP

Paste Alternative
If you don't have PPA on hand, you may substitute other types of white glue or a combination of Golden Glazing Liquid and Golden Fluid Acrylics.

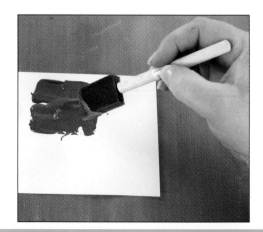

③ Form various patterns, textures, and designs in the paint by dragging or pressing a variety of implements through the paste paint.

④ Once you are satisfied with the designs and patterns on your paper, set it aside to dry completely.

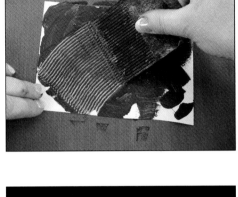

This is just a small sampling of some of the designs you can create using this technique. Look around your home for a variety of items that may be used to create texture and patterns.

Don't be afraid to mix more than one color of paint when creating your paste paper. This example demonstrates how adding multiple colors will enhance the message you wish to convey. You can almost feel the heat radiating from the blistering sun in the "Sands of Time" altered book page spread shown on the right.

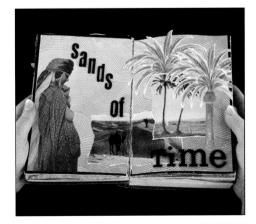

Tissue Paper Collage

Tissue paper is a readily available, inexpensive, and versatile material to incorporate into collage and altered art. It is compatible with dyes, inks, and pigments, and it can be printed with text or images, rubber stamped, and more.

An added benefit of using tissue paper in your collage is that it is a very forgiving material to work with. It conforms well to angles, crevices, and shapes as deomonstrated on the dress form "Snow Angel."

Supplies

- ✦ White tissue paper
- ✦ Glimmer Mist – Tattered Angels
- ✦ Rubber stamps – JudiKins
- ✦ Versa Fine Ink – (Tsukineko) or other permanent, water-proof ink
- ✦ Aleene's Collage Pauge collage adhesive – Duncan Enterprises
- ✦ Composition book – Mead
- ✦ Collage images – Tuscan Rose
- ✦ Studio Gesso – Ranger Industries
- ✦ Non-Stick Craft Sheet – Ranger Industries

1 Place the tissue paper on the nonstick craft mat. Mist with desired colors of Glimmer Mist and let dry.

Note: *It is very easy to scorch tissue paper with a heating tool or iron. Allow it to dry naturally.*

2 Stamp a variety of images on the dyed tissue paper. Be sure to stamp a few of the images partially off the edge. This creates a natural feel as opposed to images just floating in space.

Note: *Use a permanent, waterproof ink for this step so the images don't smear when they are glued to a collage or altered art surface.*

3 Gently crumble the stamped tissue paper several times. Unfold and smooth it out with your hand.

4 Prepare the composition book by applying a layer of gesso. Once the gesso has dried, adhere the tissue paper to the composition book using your favorite collage medium. Leave wrinkles and creases in the paper to create a unique texture.

5 Finish embellishing the cover with collage images, embellishments, and found objects as desired.

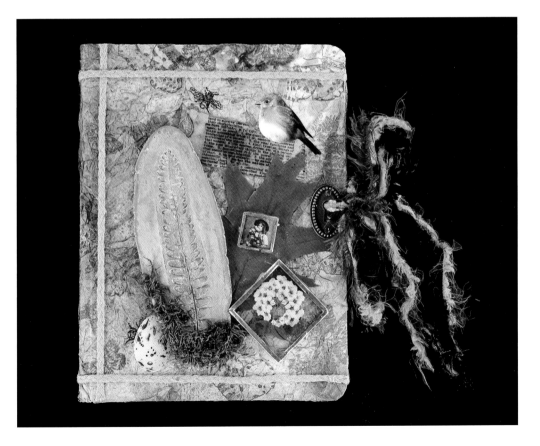

Beeswax Napkin Collage

The use of beeswax as an adhesive has been around for thousands of years. When beeswax is paired with decorative napkins, they produce a soft, vintage image of days gone by.

You can see this in the card called "Tulip." The beeswax softens the modern, bright design of the tulip, making it a perfect match for the collage image of a wistful Victorian lady.

Supplies

- ✦ Beeswax pellets (natural) – Ranger Industries
- ✦ Melt Pot and Project Pan – Ranger Industries
- ✦ Paintbrush
- ✦ Decorative napkins
- ✦ Canvas – Canvas Concepts
- ✦ Rubber stamps – Autumn Leaves
- ✦ Collage image – Tuscan Rose
- ✦ Perfect Pearls – Ranger Industries
- ✦ Specialty paper – PaperArts.com
- ✦ Non-Stick Craft Sheet – Ranger Industries
- ✦ Heat gun – Ranger Industries

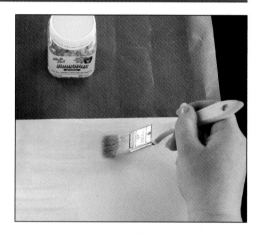

1. Remove the lid from the Melt Pot. Securely place the Project Pan into the Melt Pot. Pour the beeswax pellets into the Project Pan, turn the thermostat to the UTEE setting, and replace the lid while the beeswax is melting.

2. Once the beeswax has melted, paint a layer of beeswax over the entire canvas.

 Note: *Beeswax dries very quickly. You can use a heat gun to melt and move the wax around as needed.*

3. If your napkin consists of more than one ply, remove the white or secondary ply of tissue from the back of the napkin so you are left with only the decorative layer.

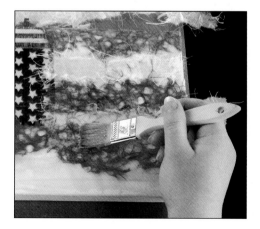

4. Tear or trim the desired sections from the decorative layer of the napkin and press the image into the wax. Heat the napkin and wax with the heat gun. You will notice that the napkin appears to sink into the hot wax. It is now secured to the canvas.

⑤ Apply a layer of wax over the napkin. Quickly press a collage image and/or specialty papers into the wax. Melt the wax with the heat gun if necessary.

⑥ Add additional images and wax as desired.

⑦ Paint a thick layer of beeswax around the outside edges of the canvas. Let the wax cool for 10 seconds. Press the rubber stamp into the warm wax. Let the wax cool for an additional 45 seconds.

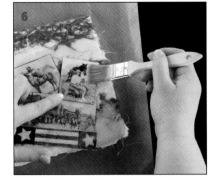 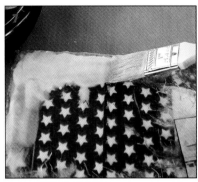

⑧ Once the wax feels cool to touch, carefully remove the rubber stamp. The stamp should leave its impression in the cooled wax.

Note: *Your impression may not be perfect. This only adds to the overall vintage, distressed feel. If any wax remains on the stamp, heat the wax with a heat gun and wipe the wax away with a paper towel. Repeat until the stamp is completely free of wax.*

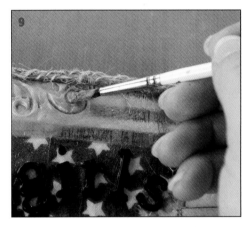

⑨ Brush Perfect Pearls over the raised areas of the wax. This not only highlights the design but also adds an elegant feel to the piece.

TIP

Beeswax is an excellent adhesive. Use it to attach a variety of materials such as pattern paper, collage images, napkins, specialty papers, photographs, tissue paper, ephemera, and more. You may also use beeswax to attach dimensional items to your projects.

Beeswax can be tinted with special dyes to add color to your collage as well.

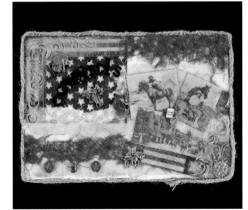

Faux Paper Casting

True paper casting can be a costly and time-consuming process. By the time you purchase molds and casting material and then blend, mold, and dry your castings, you could be looking at days of work for just a few castings. Creating faux paper castings using facial tissue and rubber stamps is an inexpensive alternative that yields amazing results for pennies on the dollar.

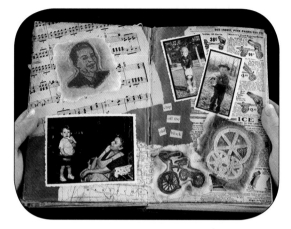

Supplies

- ✦ Facial tissues
- ✦ Paintbrush
- ✦ Bold rubber stamp – JudiKins
- ✦ Adirondack Pigment Ink (optional) – Ranger Industries
- ✦ Mini Mister (filled with water) – Ranger Industries
- ✦ Watercolors, acrylics, chalk, or other color medium

1. Place your stamp rubber side facing up on your work surface.
2. Pat the ink pad onto the stamp face for a light coat of ink.
3. Place two sheets of tissue onto the inked stamp. Mist the tissue with water and use your finger or paintbrush to gently press the tissue down into all the crevices of the stamp.

 Note: *Do not brush the tissue from side to side, as this will tear the tissue.*

 This step is very important for the first few layers of tissue. If the tissue hasn't been fully pressed in and around the rubber stamp, it may not yield a complete image.

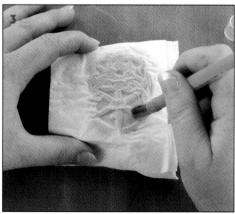

4 Continue building layers by alternately adding a layer of tissue and misting with water. Tamp down the layers as you go.

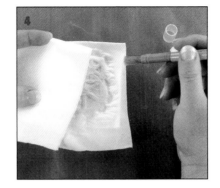

5 Once you have 5 to 7 layers of tissue, carefully remove the casting from the rubber stamp. Lay it aside to dry. If you want your finished casting to have a rough, deckled edge, carefully tear the edges away from the casting before it dries completely.

6 After your casting has dried, add color as desired. Trim off the excess paper using scissors, or, if a decorative edge is desired, trim with decorative scissors.

For a more distressed look, you may rewet the edges and gently tear away the excess tissue.

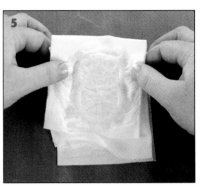

Paper castings make excellent embellishments for cards, scrapbooks, altered books, collages, altered art, and more. Because faux paper castings are lightweight, no special adhesives are necessary. You can use collage adhesive or white glues to attach the casting to your project.

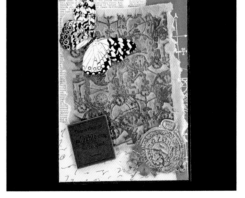

TIP

Faux paper castings can also be made using toilet tissue, tissue paper, napkins, or thin paper towels.

Paper Clay

Paper clay is a nontoxic molding compound that can be sculpted, molded, and shaped. Once dry, this clay can be sanded, carved, and painted, and it takes inks or dyes very well. This clay is an air-dry medium that does not require baking or curing like polymer clays. Its durability and light weight make it a logical choice for many collage and altered art projects.

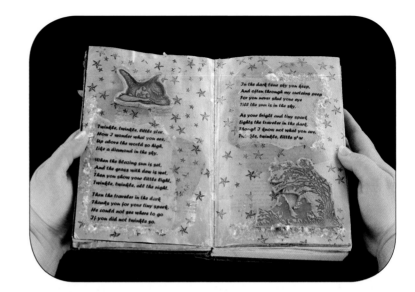

Supplies

+ Paper clay – Creative Paper Clay
+ Rolling pin
+ Parchment paper
+ Rubber stamps – 100 Proof Press
+ Perfect Pearls – Ranger Industries
+ Paintbrush (to apply Perfect Pearls)
+ Pie crust wheel or Deco scissors
+ Spray sealer – Krylon

1 Knead the paper clay, shaping it into a log approximately 3 inches long and 1 inch wide. Roll out the paper clay using the rolling pin until it is ⅛-inch thick.

2 Press the rubber stamp into the clay, applying even pressure.

Note: Ink is not necessary for this step unless desired.

3 **Optional:** While the clay is still damp, use the paintbrush to dust the pigment powders over the clay. Use one or more colors as desired.

4. Decide how you want to finish the edge. It may be torn or cut prior to drying, or it may be cut after it has dried. A variety of tools may be used to trim the edges, but some work better while the clay is still wet:

- **Hand torn:** Wet
- **Pie crust edge tool:** Wet
- **Deco scissors:** Wet or dry
- **Rotary cutting knife:** Wet or dry
- **Scissors:** Wet or dry

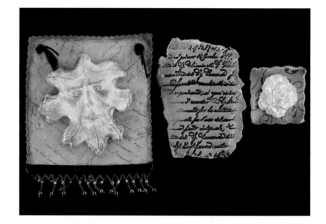

5. Let the clay dry overnight, turning frequently. You may choose to bake the clay to speed the drying time. Place the clay on the parchment paper in a 200-degree oven for 2–3 hours. Flip the clay over periodically to ensure that it dries evenly on both sides.

Note: The clay will curl as it dries. It may be pressed under a heavy book after it has dried completely.

6. After the clay has cooled, it may be painted or colored as desired. Spray it with an acrylic sealer to protect the finished work. Embellish as desired.

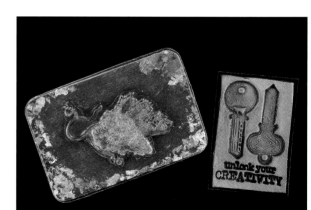

Faux Mosaic

Tera Leigh's Faux Mosaic Kit is a quick, versatile, and lightweight alternative to traditional glass or tile mosaic designs. Since it incorporates paper instead of glass tiles, it offers you an opportunity to include a mosaic design where you never would have thought it possible.

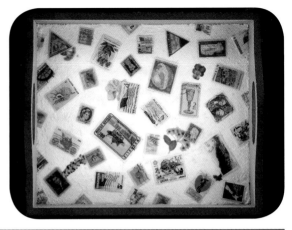

Supplies

- ✦ Tera Leigh Faux Mosaic Kit (the kit includes the grout, glue, and a glaze medium) – Ranger Industries
- ✦ Pattern paper – Basic Grey
- ✦ Wooden frame
- ✦ Disposable paintbrush

Note: *Use an inexpensive and disposable brush for the grout step. The grout is virtually impossible to remove from a standard paintbrush.*

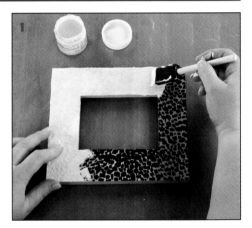

1 Use an inexpensive disposable paintbrush to apply a layer of Faux Mosaic Grout to the area of the frame that is to be "tiled." Let the grout dry completely. The grout may be tinted with a variety of color mediums.

2 Cut specialty or pattern papers into a variety of smaller shapes and sizes. These will become the tiles for your mosaic design.

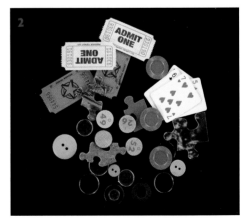

TIP

For an interesting twist, try using ephemera, buttons, or other items rather than paper for the faux tiles.

③ Glue the paper "tiles" down on the base using the Faux Mosaic Glue. Work in small sections; apply the glue to both the back of the paper tile and the frame in a decoupage fashion.

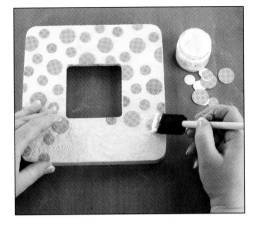

④ Cover each tile with the Faux Mosaic Glaze medium. Do so by applying the medium along the outer edge of each paper tile and then fill in the center of the tile. It's best to begin covering tiles at one end and work your way toward the other end to avoid accidentally touching glazed tiles before they have dried. Once all the tiles have been glued in place, let the glue dry to a matte finish.

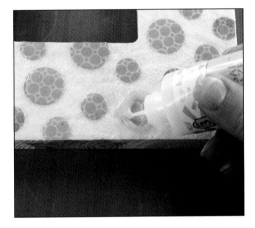

TIP

Tile Placement Tips
- Leave small spaces between paper tiles.
- Position some tiles near the edge of the project to anchor the piece. This creates a natural feel to the piece as opposed to having the tiles "floating" in space.
- Due to the rough surface of the grout medium, you may have to go back and apply an additional coat of glue to some tiles as they dry.
- Apply a light coat of Faux Mosaic Glue to the entire area when all the tiles have been applied.

chapter 5

Paint, Ink, and Rubber Stamping

Paint and inks not only bring color to your creations; these mediums can evoke a mood or feeling that can't be expressed in any other way. The techniques in this chapter enable you to enhance your collages and altered art with thoughts, feelings, and memories in color.

Embossing Resist

By combining a few basic tools—rubber stamps, clear embossing ink and power, and dye inks—you can create amazing images that seem to pop right off the page. This is a quick and easy technique to master and has a multitude of uses that can be incorporated into greeting cards, Altered Trading Cards, collage, altered books, and so much more.

Supplies

+ Light-colored paper or cardstock
+ Clear embossing ink – Ranger Industries
+ Rubber stamps – JudiKins
+ Clear embossing powders – Ranger Industries
+ Embossing or heat gun
+ Dye ink or thinned acrylic paint
+ Tool to apply inks or paint – Ink Blending Tool, paintbrush, stipple brush, brayer, etc.
+ Paper towel or rag

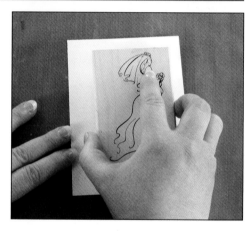

1 Pounce the rubber stamp on the clear embossing ink. Make sure the entire image has been covered with ink.

2 Press the inked rubber stamp onto the paper, applying even pressure. Do not rock the rubber stamp back and forth; this will create a blurry impression. Remove the rubber stamp.

3 Sprinkle clear embossing powder over the entire stamped image. Shake the excess powder off of the paper, returning it to the jar for use at another time.

4 Melt the embossing powder with the embossing gun until the powder has a smooth, glossy appearance.

Note: Do not over-emboss the powder! It can be scorched, causing it to melt into the paper and ruining the resist effect.

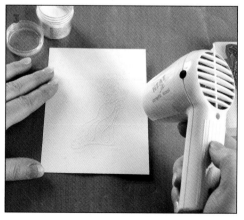

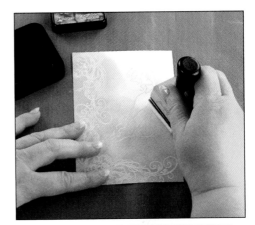

5 Once the melted embossing powder has cooled, apply one or more colors of dye ink or thinned water-based paint over the entire piece of paper. This layer may be applied with a tool or directly from the bottle or ink pad.

6 Moisten a rag or paper towel, and wipe the paint or ink from the embossed areas. If the paint has dried, rub lightly to remove it.

For a unique look, try stamping on dictionary or book pages, newsprint, or light-colored ephemera as shown below.

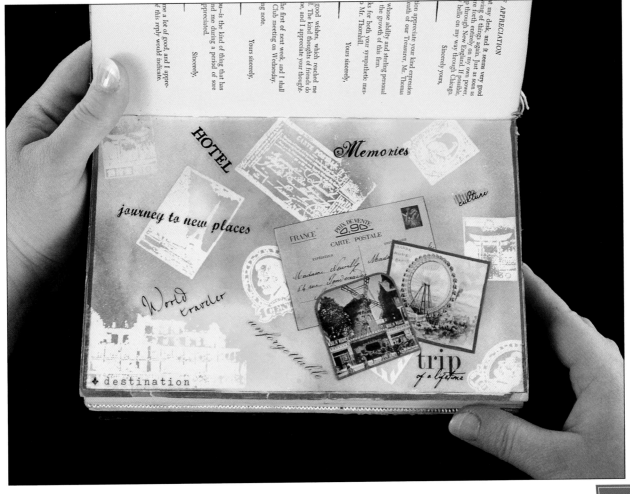

Masking Technique

This easy-to-follow technique enables you to create a complicated-looking, multilayered rubber stamp collage in a few short steps.

The altered book page "Dream in Color" used 11 different rubber stamps and looks like it took hours to create. In actuality the page took under an hour to create with very little difficulty.

It is also important to note that if you are careful about how you remove the mask from a finished project, it may be used over and over again cutting down the time it takes to make each design dramatically.

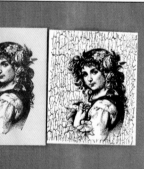

Supplies

- ✦ Rubber stamps – JudiKins, 100 Proof Press, B-Line Designs
- ✦ Eclipse Tape – JudiKins
- ✦ Archival Ink – Ranger Industries
- ✦ MatteKote cardstock – JudiKins
- ✦ Scissors

① Stamp the main image on the cardstock where desired. Then stamp the same image on a piece of the Eclipse Tape.

Note: Eclipse Tape is a low-tack art masking tape that allows you to create masks, stencils, and non-permanent stickers. It won't leave an adhesive residue after it's removed.

② Cut the stamped image from the Eclipse Tape. You can do this in one of the two following ways; either method will have an impact on what your finished collage looks like.

- Trim, leaving a ¹⁄₁₆-inch space around the outer edge of the image. This mask creates a small, white space around the finished masked image (a).

- Cut along or inside the outermost image lines. This allows subsequent stamped images to be positioned directly beside the masked image (b).

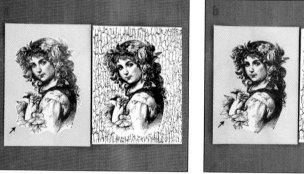

③ Position the trimmed mask over the original image, and stamp additional images as desired.

You may use more than one mask on any given collage. This enables you to build layers and add depth to your finished collage.

④ Color the images and add embellishments as desired.

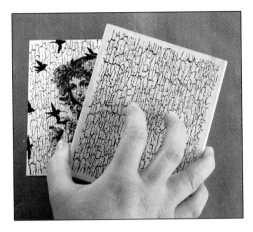

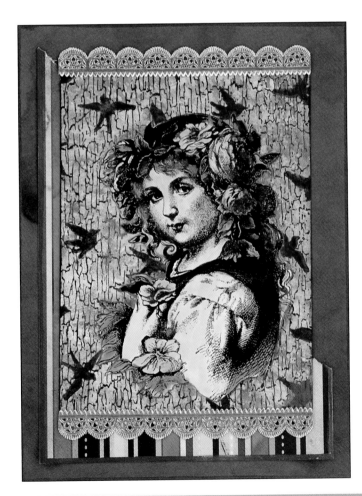

Batik is a unique silk dyeing process that incorporates the use of freehand or stamped wax designs dipped into a series of dyes. Faux batik creates similar results with rubber stamps, embossing powders, and dye inks.

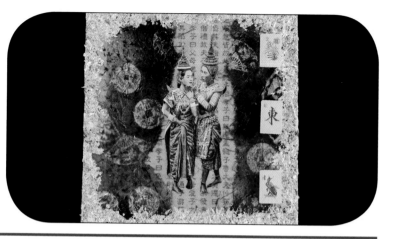

Supplies

- ✦ White mulberry paper – PaperArts.com
- ✦ Rubber stamps – Paper Studio
- ✦ Clear embossing ink – Ranger Industries
- ✦ Clear embossing powder – Ranger Industries
- ✦ Embossing or heat tool
- ✦ Spray Dye Ink, Glimmer Mist – Tattered Angels and Adirondack Color Wash – Ranger Industries
- ✦ Non-Stick Craft Sheet – Ranger Industries
- ✦ Archival Ink – Ranger Industries
- ✦ Plain newsprint or copy paper
- ✦ Craft Iron – Clover

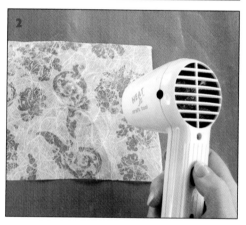

1. Pounce the rubber stamp in the clear embossing ink. Press the stamp on the white mulberry paper using firm, even pressure. Repeat stamping the images to cover approximately one-half to one-third of the paper.

2. Sprinkle the images with clear embossing powder. Shake off the excess powder and save it for later. Melt the embossing powder using a heat gun.

3. Repeat stamping and embossing until the entire piece of paper has been covered.

4. Place the embossed mulberry paper on the nonstick craft mat or protected surface. Spritz the paper with one or more colors of dye ink sprays.

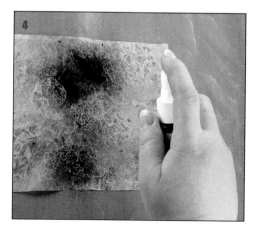

⑤ Sandwich the mulberry paper between two sheets of copy paper or plain newsprint. Do not use regular newspaper for this step. The ink from the newspaper will transfer to the mulberry paper.

⑥ Preheat the iron using the cotton or high heat setting. Iron the mulberry paper to melt and remove the embossing powders from the paper. Continue ironing until you see the images appear on the copy paper.

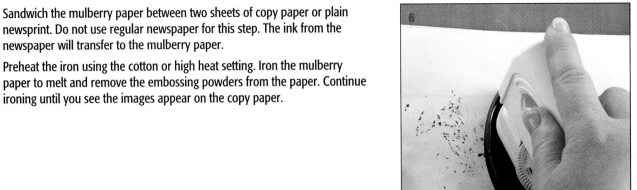

⑦ Crumble the mulberry paper two or three times, creating a lot of nice crease marks.

⑧ Roughly smooth the mulberry paper out and lightly rub Archival Ink over the paper, hitting the high spots. This creates the lines and veining that you see in the traditional Batik method.

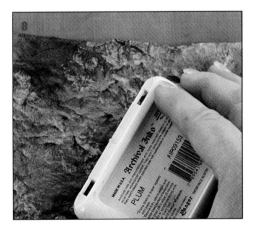

The paper is ready to be used on a variety of projects, including collages, altered art projects, scrapbooks, canvas projects, and more.

Since the foundation for this technique is tissue paper it lends itself well to various 3-D dimentional projects. With the proper adhesive faux Batik tissue paper can be used to cover gift boxes, vases, art bottles, metal or wood containers, etc.

Monoprinting

A single unique image or design is what you get each time you create a monoprint. These prints make an excellent foundation for any number of collage projects.

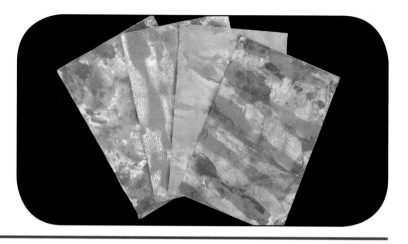

Supplies

+ Acrylic paints – Stewart Gill
+ Sheet of glass, Plexiglas, freezer paper, or Non-Stick Craft Sheet – Ranger Industries
+ Paintbrush, bone folder, popsicle stick; paint scraper for manipulating the paints
+ Mini Mister (filled with water) – Ranger Industries
+ Cardstock; watercolor, specialty, or copy paper
+ Brayer – Ranger Industries
+ Pigment powders (optional)
+ Glaze (optional)

① Drizzle, paint, or drip 1–4 colors of acrylic paint onto the nonporous work surface.

② **Optional:** The paint can be left as is, or you can create designs, swirls, or other patterns using a variety of implements such as paintbrushes, bone folders, scrapers, twigs, foam brushes, or any combination of these. Do not overwork the paint. If it is mixed too much, you will end up with a muddy brown mess.

③ **Optional:** Bring additional colors or shimmer to your monoprints by sprinkling pigment powders over the prepared paints prior to printing.

Note: Spritz the paints with water if they appear to be drying too quickly.

TIP

Instead of acrylic paints, use dye, pigment, or distress inks to create monoprints.

Create interesting designs in your finished monoprint by placing torn or die-cut shapes, fabrics, fibers, or other items into the paint prior to Step 4.

④ Place the paper on the paints, and gently press the paper into the paint with your hands or roll with a brayer. Do not press too hard because it could squeeze all the paint out of the edges, resulting in a giant smudge instead of a monoprint.

⑤ Carefully peel the paper from the paint surface in one smooth motion to reveal the monoprint. Set the paper aside to dry.

If any additional paint remains on your work surface, spritz the paint with water, and repeat Steps 4 and 5 to create a second monoprint.

Note: *Subsequent printing from leftover paint will create a different and lighter print. It will not be a duplicate of the first monoprint.*

⑥ Once dry, the monoprints can be used whole, trimmed, die-cut, and in other ways.

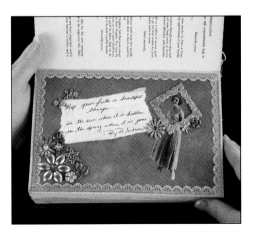

Painted Tyvek

Create unique and interesting textural effects by painting, stamping, and heating Spun-Bonded Olefin material—also known as Tyvek. The same material that protects your house from weather extremes can also be used in altered art. You don't need to head to the local home improvement store though; Tyvek envelopes are made from the same material and can be found at office and discount stores.

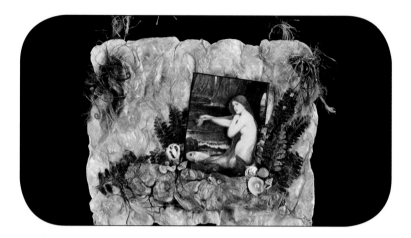

Tyvek Preparation

Supplies

+ Plain, white Tyvek envelopes (found at office supply stores)
+ Scissors, paper trimmer, or other cutting tool
+ Lumiere paints – Jacquard
+ Paintbrush

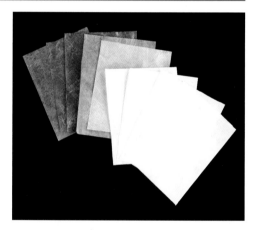

1 Cut the envelopes apart. These may be cut into a variety of shapes and sizes, but remember that they will shrink considerably once heated.

2 Paint the Tyvek pieces with one or more Lumiere paints. Set the pieces aside and allow the paints to dry completely.

Once the painted Tyvek pieces have dried, there are a number of ways they may be used, each yielding unique results:

- Melt with an embossing or heat gun.
- Heat with a craft iron.
- Cut into strips and make into beads.
- Die-cut, stitch, or stamp them.

Tyvek and Heat or Embossing Gun

Before moving on to the following steps, be aware that the paint and Tyvek give off fumes as they are being heated. Use them in a well-ventilated area and take additional precautions if you have breathing difficulties.

Supplies

- ✦ Painted Tyvek pieces
- ✦ Heat or embossing gun
- ✦ Non-stick craft sheet – Ranger Industries

1 Place the painted Tyvek on the nonstick craft mat and heat with an embossing gun.

2 Tyvek melts very quickly. Apply heat in short bursts, checking the progress frequently. Extreme care must be taken at this point.

Heat applied to the unpainted side (a).
Heat applied to the painted side (b).
Heat applied to both sides of the Tyvek piece (c).

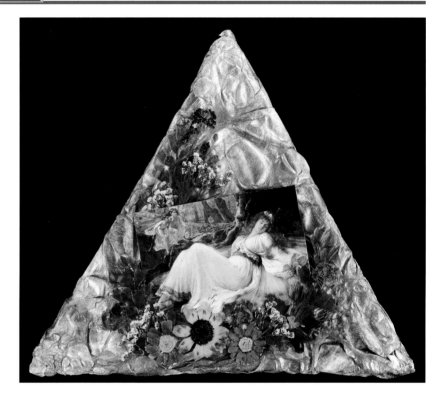

CONTINUED ON NEXT PAGE

Tyvek and Craft Iron

Supplies

+ Painted Tyvek pieces
+ Parchment paper
+ Craft Iron – Clover
+ Rubber stamps – JudiKins
+ Non-Stick Craft Sheet – Ranger Industries

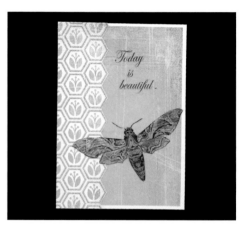

1. Put the rubber stamp on a nonstick craft mat with the rubber die facing up.
2. Place a sheet of the painted Tyvek over the stamp with the painted side facing up. Cover with a sheet of parchment paper.
3. Turn the iron to the cotton setting. Quickly pass the iron over the Tyvek. Varying the length of time that the Tyvek is ironed creates a range of looks, as shown on this page.

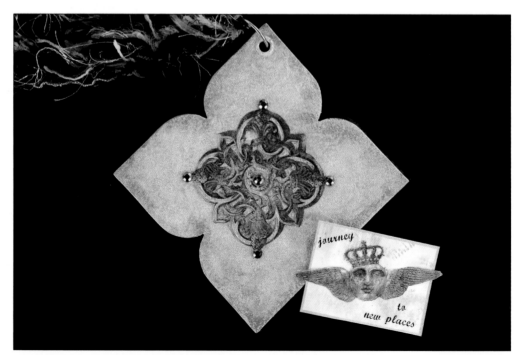

Tyvek Beads

Supplies

- ✦ Tyvek
- ✦ Lumiere paints – Jacquard
- ✦ Archival Ink – Ranger Industries
- ✦ Rubber stamps – JudiKins
- ✦ Bamboo skewers
- ✦ Aleene's Fast Grab Tacky Glue – Duncan Enterprises
- ✦ Embossing or heat gun

1️⃣ Paint the Tyvek pieces on both sides using one or more colors of Lumiere paints. Let the pieces dry completely.

2️⃣ Stamp various images onto the painted Tyvek using Archival Ink.

3️⃣ Cut the Tyvek into long strips. The strips of Tyvek can be narrow, straight cuts or tapered, creating an elongated triangle.

4️⃣ Begin with the widest point and roll a piece of Tyvek on the skewer. Use a dab of glue to hold the end in place.

5️⃣ Quickly pass the rolled Tyvek under the heat gun until you are satisfied with the look.

6️⃣ Repeat several times, making enough Tyvek beads for your project.

Washed Glaze Background

Create a foundation of rich colors and faux marble texture using the washed glaze background technique.

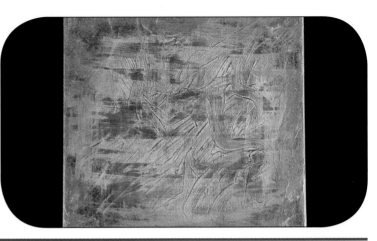

Supplies

+ Acrylic paints – Stewart Gill
+ Foam brush
+ Mixing cup
+ Water
+ Sticky back canvas (Ranger Industries) or other foundation material
+ Damp paper towel

1. Apply the base coat of paint to your canvas. Let the base coat dry completely.

2. Add water and a second darker shade of acrylic paint to the mixing cup using a 50/50 ratio. Paint this mixture, also known as a *glaze coat,* over the base coat.

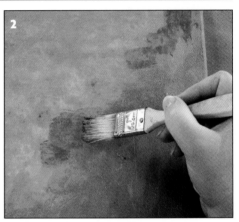

3. Use the damp paper towel to wipe off some of the glaze on various sections of the canvas. Let this coat dry completely.

4. **Optional:** You may use the canvas as is or add a second or third coat of glaze over the first. Keep in mind that each additional coat of glaze adds another layer of texture and dimension to your project.

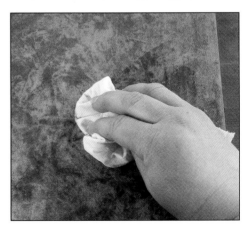

Notice in the photo below how the paints create a false sense of depth and texture. By varying the colors of paints and glazes this type of background is the perfect foundation for a variety of collage elements, techniques and themes.

Micro Glaze Resist

Micro Glaze is a specially formulated cream that was originally intended to be used as a sealing barrier to protect against dirt, stains, spills, and smears on paper, wood, metal, and plastic surfaces. Its uses extend well beyond being just a sealer, though. Micro Glaze can be paired with a variety of techniques to create effortless ink or paint resists.

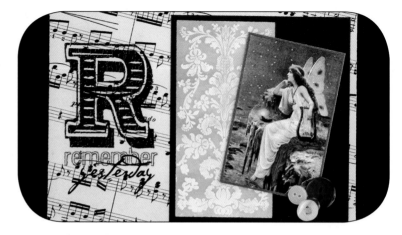

Basic Application

Supplies

- ✦ Micro Glaze – JudiKins
- ✦ Rubber stamps – JudiKins, Starving Artists, The Enchanted Gallery
- ✦ MatteKote paper – JudiKins
- ✦ Fluid Acrylics (Golden) or water-based ink
- ✦ Collage images – Hannah Grey, Tuscan Rose, Alpha Stamps, Southern Blackberry Designs
- ✦ Leaf Masks – Stampland

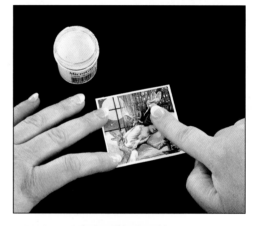

1. Micro Glaze has a soft, creamy consistency and can be applied with your fingertip. A very minimal amount covers a very large area. Simply rub it over the surface of the project and let it dry. The cream may be wiped off your fingers with a tissue.

2. **Optional:** If you'd like to create a slight sheen, buff the Micro Glaze with a soft cloth after it has dried for approximately an hour or so.

Note: You should not be able to see any streaks or fingerprints on your project after the Micro Glaze has been applied. If they do exist, then you have used too much of the cream. Simply rub off the excess Micro Glaze.

PAINT RESIST

1 Rub Micro Glaze over a single collage image or sections of a collage prior to applying acrylic paints or water-based inks.

2 Wipe away the excess paint or ink with a paper towel. The areas protected with Micro Glaze will resist the paint and ink, creating a central focal point.

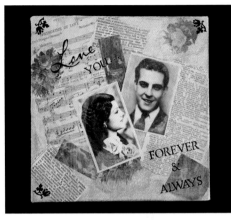

STAMPED RESIST

1 Apply a very thin coat of Micro Glaze to a rubber stamp.

2 Press the stamp onto paper as you normally would.

3 Apply an acrylic paint or water-based ink over the stamped image and wipe away the excess paint with a paper towel. Let it dry.

4 Clean any lingering Micro Glaze from the rubber stamp with a paper towel. If the cream gets into the nooks and crannies of the stamp, use a solvent-based rubber stamp cleaner to remove it completely.

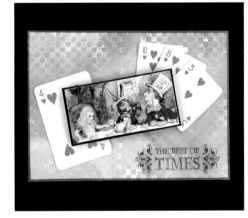

MASK OR STENCIL RESIST

1 Place a mask or stencil over your project.

2 Rub the Micro Glaze inside the stencil or around the edges of the mask. Make sure you work the Micro Glaze into and around all the corners and edges.

3 Remove the mask or stencil and apply acrylic paint or water-based ink over the entire project. Wipe off the excess paint or ink and watch the design magically appear.

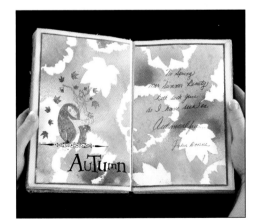

Peeled Paint Technique

Claudine Hellmuth originally shared this technique in her book *Collage Discovery Workshop*. It is an excellent technique to give virtually any project that worn and weathered look in just a few short steps.

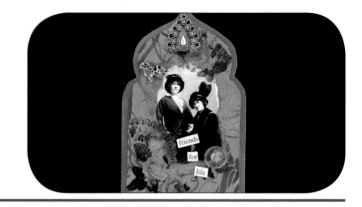

Supplies

- Fluid Acrylics – Golden
- Golden soft gel medium
- Petroleum jelly
- Paintbrush or palette knife
- Paper towels
- Wet wipe
- Canvas – Canvas Concepts
- Collage images – Altered Pages, Southern Blackberry Designs
- Ephemera – Found Elements, Hannah Grey, personal collection
- Acrylic glaze or sealer (optional)

1. Create a collage and seal the entire project with Golden soft gel medium to prevent the petroleum jelly (see the next step) from soaking into the collage.

2. Apply a very thick coat of petroleum jelly to select areas of your collage. You can apply this coat with your finger, a paintbrush, a palette knife, etc. Keep in mind that the areas where the petroleum jelly has been applied will repel the paint in the next step. These sections are what will show up in the finished collage.

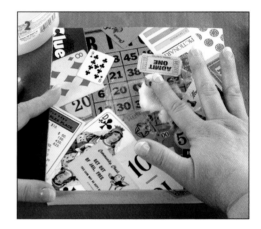

3. Paint the entire project with an acrylic paint. For the best results, use a thin-bodied paint such as Golden Fluid Acrylics. If you use a thicker, creamy paint, it must be thinned prior to application. This ensures good paint coverage without disturbing the petroleum jelly. Let this layer of paint dry completely.

④ After the paint has dried, wipe off all the petroleum jelly with a paper towel. If there is any residue left from the petroleum jelly, use a wet wipe to remove the sticky film.

⑤ **Optional:** You may choose to distress the paint further by scratching, sanding, or using another distressing method. A glaze may also be applied to the collage at this point.

⑥ Apply a sealer to protect your work.

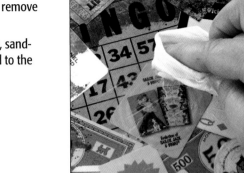

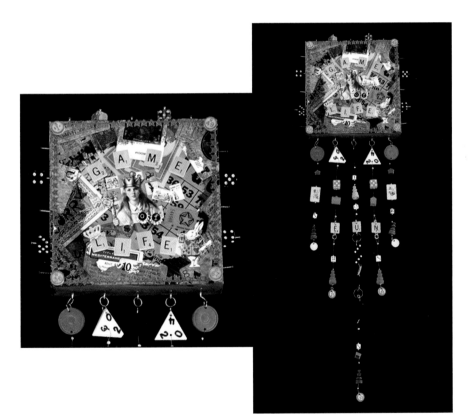

Image Transfer Techniques

"Why would you use an image transfer?" This is a common question that can be easily answered, "Because you can!" Image transfers take plain old everyday images and turn them into something special. Terms often used to describe an image that has been transferred include distressed, ethereal, shabby, vintage, and more—everything a collage or altered artist dreams of!

this is the stuff

that memories
are made of...

Transparency Transfer

This is a very basic image transfer method that requires a minimal amount of time, effort, and supplies. This technique works with both colored and black and white images and creates a clear but faded transfer.

Supplies

+ Transparency
+ Inkjet printer
+ Computer-generated image or text
+ Cardstock
+ Bone folder (Ranger Industries) or spoon

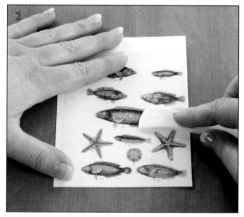

1 Print the desired image or text onto a transparency. If you are using text, you must print a mirror image for the text to be readable after it has been transferred.

2 Carefully flip the transparency onto the cardstock or other paper surface to which you wish to transfer the image. Do not touch the ink during this process or it will smear and ruin the print.

3 Hold the transparency in place and burnish with your finger, a bone folder, or the back of a spoon.

4 Remove the transparency.

Note: Backing paper left over from labels or stickers is an inexpensive alternative to transparency sheets.

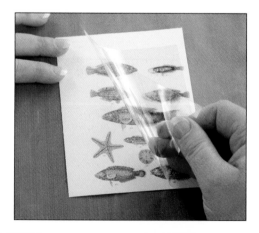

Also known as packing tape transfers, cold laminate sheets are made of a sticky-backed, clear material designed to protect documents from damage. It also makes a wonderful foundation for image transfers.

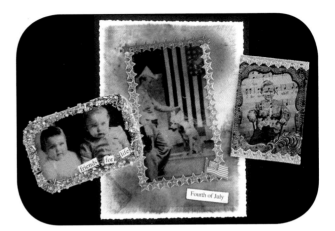

Supplies

+ Cold laminate sheets or packing tape
+ Image or text
+ Bone folder or brayer
+ Hot water
+ Decoupage medium (Aleene's) or soft gel medium (Golden)
+ Scissors

1 Place the laminate sheet, sticky side up, on your work surface.

2 Carefully lay the photo or text face down on the sticky laminate.

3 Burnish with a bone folder or brayer, making sure there are no air pockets.

4 Soak the laminate piece in hot water for 5–10 minutes so that the backing paper becomes soft.

5 Remove the image from the water. Use your finger to rub off the white backing paper. When most of the backing paper has been removed, proceed slowly. The image is delicate; too much scrubbing may remove some sections of the image.

6 After you have removed the backing paper, pat the excess water with a towel and let it dry. The finished image may be attached using a clear decoupage or gel medium.

Note: If you are working with images that have a lot of white space, keep in mind that those areas may lose their color when the paper is removed.

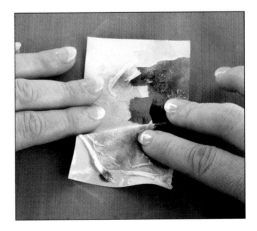

GlueFOIL (Faux Tin Type) Transfer

This image transfer technique requires the use of Streuter Technologies' GlueFOIL, which produces a vintage, grainy image just like those from years gone by.

Now it's easy to create your very own tin types without all of the harsh chemicals or fixatives used in other tin-type techniques.

Supplies

- ✦ GlueFOIL – Streuter Technologies
- ✦ Craft Iron – Clover
- ✦ Image – Hannah Grey
- ✦ Mini Mister (filled with water) – Ranger Industries
- ✦ Non-Stick Craft Sheet – Ranger Industries

1. Cut the GlueFOIL and photo to size.

2. Place the image face down on the glue side of the GlueFOIL.

3. Iron the image and GlueFOIL for approximately 10–15 seconds. If the image is larger than the bottom of the iron, lift the iron to melt the glue; don't push the iron, as it may slide the image off the GlueFOIL.

 Note: *If any of the adhesive seeps out and sticks to the bottom of the iron, carefully wipe it off using a paper towel while the iron is still hot.*

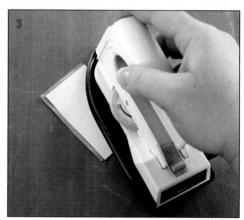

4. Squirt the back of the image with water and let it soak in.

5. Rub off the backing paper with your finger; add water as needed.

6. After the paper has been removed, let it dry completely. If the image looks cloudy after it has dried, you may try to remove the paper residue by wetting and rubbing gently.

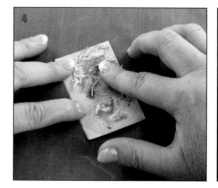

A special variety of paper enables you to create toner-based, laser, or inkjet reproductions of photos and text that can easily be transferred onto virtually any surface. This transfer technique retains all of the image color and clarity of the original.

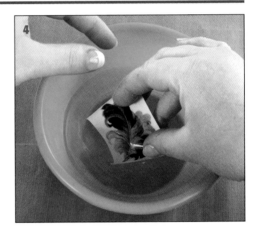

Supplies

+ Lazertran waterslide decal paper
+ Printer or photocopier
+ Hot water
+ Decoupage or gel medium (optional)
+ Crystal Clear Acrylic Sealer – Krylon

1 Print or copy the desired image onto the eggshell finish side of the paper.

> **Note:** Make sure you purchase the corresponding decal paper for the chosen printing method—toner-based copies, laser printer, or inkjet printer.

2 Allow the image to dry for 30 minutes.

3 Cut the desired image from the sheet. Soak it in hot water for 10–15 seconds.

4 Slide the image off of the backing paper. It is now ready to be applied to the desired surface. If there is not enough gum to hold the transfer to the desired nonporous surface or if you are applying it to an absorbent surface, use a decoupage or gel medium to adhere it. Allow the image to dry overnight.

5 Apply an acrylic or enamel sealer over the decal to protect it.

> **Note:** Waterslide decals dry to a white, opaque eggshell background.

Acetone Transfer

Although acetone has an unpleasant odor, it has the ability to create soft, diffused, almost ghostly images. It works well with both color and black-and-white images.

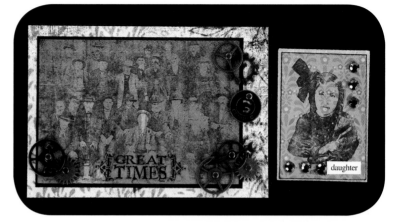

Supplies

+ Toner-based photocopy image or text
+ Cotton balls
+ Acetone or acetone-based nail polish remover
+ Cardstock base
+ Bone folder (Ranger Industries) or spoon

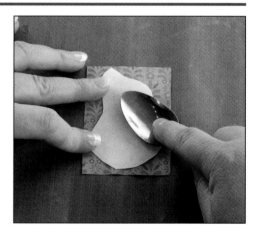

1 Make a toner-based copy of the desired image or text to be transferred. Keep in mind that the transferred image will appear as the reverse of the printed image. If text will be used, you must copy a mirror image in order to be able to read the transferred image.

2 Trim the desired areas to be transferred and place the image face down on the cardstock.

3 Saturate a cotton ball with acetone, and apply it to the back of the image. Burnish the image with a bone folder or spoon.

4 Holding the image in place with one hand, lift up one corner of the photocopy and check to see if most of the image has been transferred. If you are satisfied with the results, it's ready to use.

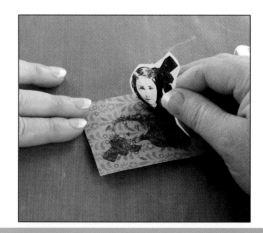

Tranz-It transfer medium is a versatile type of image transfer that can be used on metals, plastic, clay, wood, paper, fabric, and more. It works exceedingly well with color images as well as black and white.

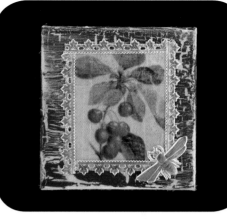

Supplies

+ Tranz-It transfer medium – JudiKins
+ Tranz-It Sheets (or transparencies) – JudiKins
+ MatteKote cardstock (JudiKins) or other item to receive image transfer
+ Bone folder, spatula, popsicle stick, or spoon
+ Micro Glaze (optional) – JudiKins

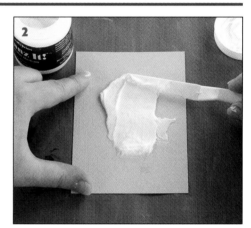

1 Use an inkjet printer to print the image to be transferred onto Tranz-It Sheets or transparencies. Let the image dry completely.

2 After the image has dried, spread a layer of Tranz-It medium over the entire image with a spatula, brush, or your finger.

3 Immediately place the wet transfer face down on the surface of the item receiving the transferred image.

4 Burnish the image with a bone folder, a popsicle stick, or the back of a spoon (a).

5 Let the transfer sit for approximately 5 minutes; then remove the Tranz-It Sheet or transparency (b).

6 **Optional:** Rub a coat of Micro Glaze over the image to protect its surface.

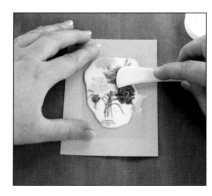

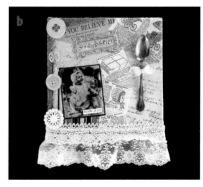

Gel Medium Transfer

Gel medium is the most common type of image transfer technique, with two distinct variations: direct transfer and gel decal or "skin." While they are not the quickest transfer techniques, they are very reliable.

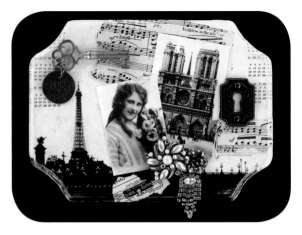

Direct Transfer

Supplies

+ Golden soft gel medium
+ Image – toner-based copy, inkjet or laser print, magazine or collage photo
+ Cardstock or other surface (to receive transfer)
+ Warm water

1 Paint a coat of the gel medium onto the surface where the transfer is desired.

2 Place the image face down in the wet gel medium and let it dry completely.

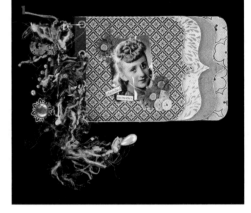

3 After the image has dried completely, wet the image with warm water. Allow the water to soak into the paper pulp. Begin rubbing off the paper; apply additional water if necessary. Let the gel transfer dry completely.

Note: The gel may turn white as it gets saturated with water, but it will dry clear after the water has evaporated.

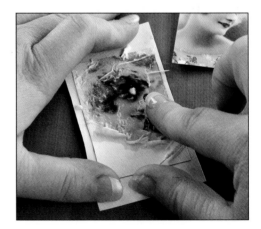

Decal or "Skin" Transfer

Supplies

- ✦ Golden soft gel medium
- ✦ Toner-based copy or laser image
- ✦ Plastic sheeting or Non-Stick Craft Sheet (Ranger Industries)
- ✦ Warm water

1 Place the toner-based image face up on the plastic sheeting or nonstick craft mat.

2 Pour or brush on a layer of gel medium over the entire image and let it dry completely.

3 Place the image into a pan of warm water and allow it to soak for 3–5 minutes.

> **Note:** The longer the image soaks in the warm water, the easier it will be to peel off the paper. However, do not leave the image submerged for longer than 15 minutes or it will disintegrate.

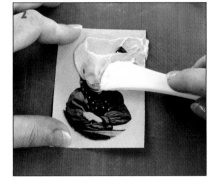

4 Remove the paper from the water. Rub off the paper backing. Let the gel transfer dry until it is once again clear.

You are left with a clear gel decal or skin. You can paint the back of the decal with acrylic paints if desired. Attach it to your project with a clear drying gel or decoupage medium.

T-shirt transfer paper isn't just for t-shirts anymore! This unique paper lets you turn any image into an image transfer with very few tools. An added benefit to using the t-shirt transfer paper is that you can take a brand new modern photo, and change the color values on your ink-jet or laser printer to give it a vintage feel. You may choose to distress it even further by scratching away bits of the transfer paper adding to the aged worn appeal.

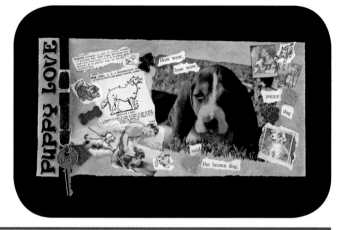

Supplies

- ✦ Iron-on transfer paper – Hewlett Packard
- ✦ Prewashed fabric
- ✦ Craft Iron – Clover
- ✦ Cotton pillowcase (100-percent cotton recommended)
- ✦ Hard work surface

Note: *It is important to purchase the correct type of transfer paper for your particular printer. They will be labeled for either ink-jet or laser printers. Also, keep in mind that regular t-shirt transfer paper is translucent while the "dark" t-shirt transfer paper has a white foundation.*

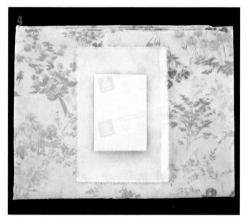

1. Print your image on the iron-on transfer paper. If you are incorporating text into the design, you will need to flip or print a mirror image.

2. Trim the excess paper from the design.

3. Preheat the iron on the cotton setting for at least 8 minutes.

4. Place the pillowcase on your work surface, making sure there are no wrinkles, and then lay the material face up. Position the printed transfer paper, image down, over the material.

5. Holding the transfer in place, press firmly, and slowly move the iron around one edge of the transfer paper for 1 minute. Continue ironing in sections until the entire transfer has been heated. Allow the transfer to cool for at least 5 minutes.

 Caution: Always keep the iron in motion while it is on the transfer paper. Leaving the iron in one spot for too long may ruin the transfer.

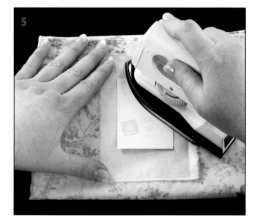

6 Peel the transfer paper away from the material in a diagonal direction. If the paper starts to tear while peeling, try peeling it from the opposite side of the image.

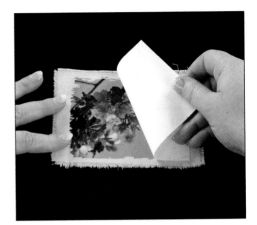

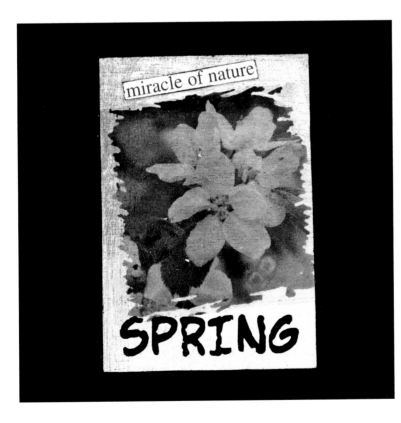

chapter 7

Altered Charms

Altered art projects aren't limited just to books, canvas, and cards. Try your hand at altered charms. From the very basic to more involved techniques, you can create charms to be used for earrings, bracelets, necklaces, and more! These charm techniques are so versatile that you might even consider using them as embellishments for altered books, canvases, and all the other collage and altered art projects you have in mind.

Memory Glass Charms

These are some of the easiest charms you can make. Use the handy Memory Glass, Memory Frames, and collage images to create a host of charms in mere minutes.

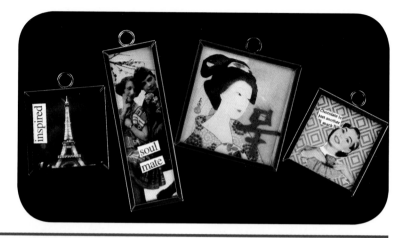

Supplies

- ✦ Memory Glass – Ranger Industries
- ✦ Pencil
- ✦ Memory Frames – Ranger Industries
- ✦ Collage sheet – Tuscan Rose, Southern Blackberry Designs, Altered Pages
- ✦ Scissors

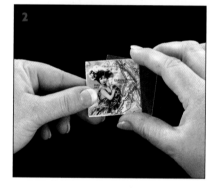

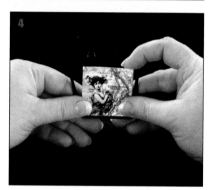

1. Place a piece of the Memory Glass over the desired image and trace around the edges using a pencil. Trim the image from the collage sheet. Erase any lines that may be left on the image.

 Note: *You need one image for a single-sided charm or two images for a double-sided charm. Consider pattern or specialty paper or ephemera pieces for the second side.*

2. Sandwich the collage image(s) between two pieces of Memory Glass.

3. Open the frame using the metal tab on the side. You do not need to unfold the frame entirely. Just open the frame far enough to allow you space to slide the Memory Glass in.

4. Slide the Memory Glass and collage images into the frame and close it. Slide the metal tab back into position and secure it.

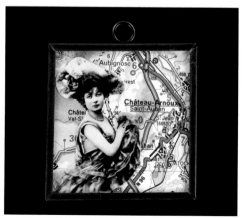

Since Memory Frames have presoldered jump rings, no further work is necessary. You are free to incorporate these charms into a variety of projects.

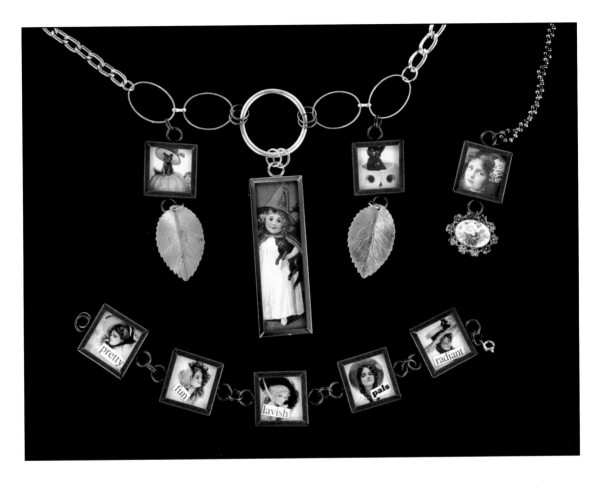

TIP

Ideas for use include a necklace, bracelet, earrings, pendant, magnet, or keychain fob, or as an embellishment in altered books, cards, scrapbook layouts, canvases, and so much more!

Acrylic Charms

Durable clear pieces of acrylic are a great alternative to glass charms. These pieces come in a large variety of shapes and sizes to match any need you might have.

Since acrylic is so tough and durable, these charms make an excellent addition to scrapbooking layouts and greeting cards without the worry of breakage as with glass charms.

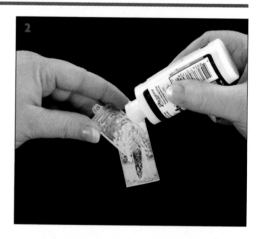

Make the Charm

Supplies

+ Acrylic charms – Tim Holtz Idea-ology
+ Glossy Accents – Ranger Industries
+ Collage sheet – Altered Pages, Southern Blackberry Designs
+ Scissors

❶ Trim the collage image from the sheet.

❷ Apply a layer of Glossy Accents on the back of the charm.

❸ Position the charm over the image. Press and slide the acrylic piece back and forth to ensure total coverage and complete contact with the image. Let the piece dry for 1–3 minutes.

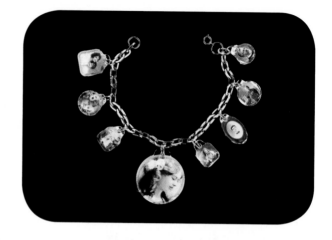

❹ Trim the excess paper from the charm.

Note: *Some charms do not have holes drilled in them. Keep this in mind if you will be using these pieces for necklaces or as dangles. You can drill a hole in the charm with a multispeed rotary tool prior to adding images.*

Additional Ideas

- Add color to the acrylic pieces by applying alcohol inks.
- Stamp an image onto the acrylic pieces using a solvent or archival type of ink. Make sure the ink is designed to be used on nonporous surfaces. Some inks do not dry on surfaces such as this.
- Instead of collage images, try using interesting vintage ephemera, dictionary pages, newsprint, or vintage advertisements.
- Apply a layer of adhesive to the back of the charm and cover with leafing flakes.
- Apply Krylon Leafing Pens along the edges for added detail.

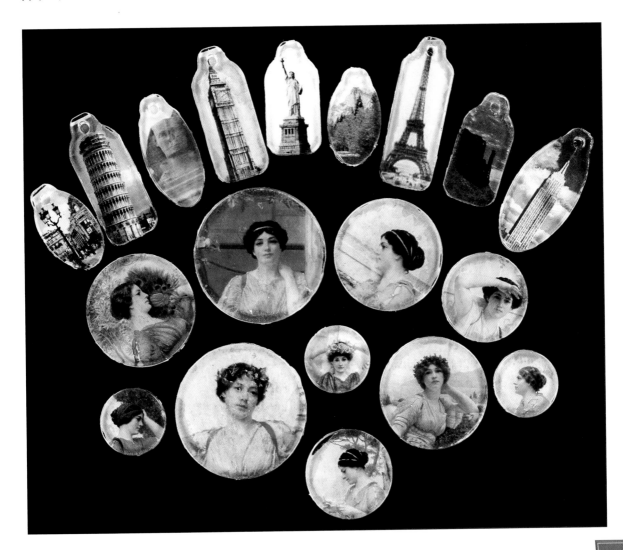

Glaze-Filled Charms and Pendants

Glaze-filled charms are another quick and easy way to create personalized charms in an instant. Use a high-gloss clear glaze in jewelry blanks for stunning, professional-looking results. These charms look just like the expensive store-bought charms but cost a fraction of the price.

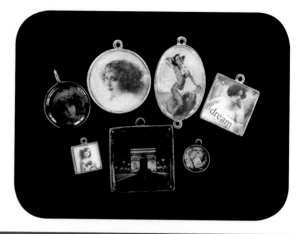

Supplies

- ✦ Patera findings – Nunn Designs
- ✦ Glaze medium (Diamond Glaze – JudiKins; or Glossy, Sepia, Crackle Accents – Ranger Industries)
- ✦ Collage images – Altered Pages, Southern Blackberry Designs
- ✦ Scissors or paper punches
- ✦ Micro beads, faux gemstones, etc.

1 Use a paper punch or scissors to cut a collage image to fit inside the charm link or pendant.

2 Cover the back of the image with the desired adhesive and glue the image to the bottom of the finding. It's very important that the image be totally secure; this will prevent the image from floating in the glaze in subsequent steps. Let the image dry for 2 or 3 minutes.

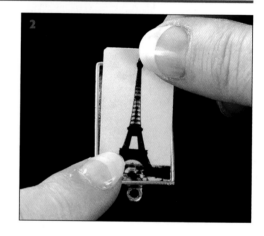

3 Fill the finding with the desired glaze medium.

Note: If there are bubbles in the glaze, you can pop them using a straight pin, although smaller bubbles add character to a finished piece.

4 **Optional:** You can sprinkle micro beads, faux gemstones, or other small embellishments into the wet glaze for added depth and texture. Let the glaze dry completely. Depending on temperature, humidity, and coat thickness, this may take up to 24 hours.

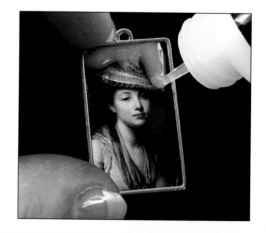

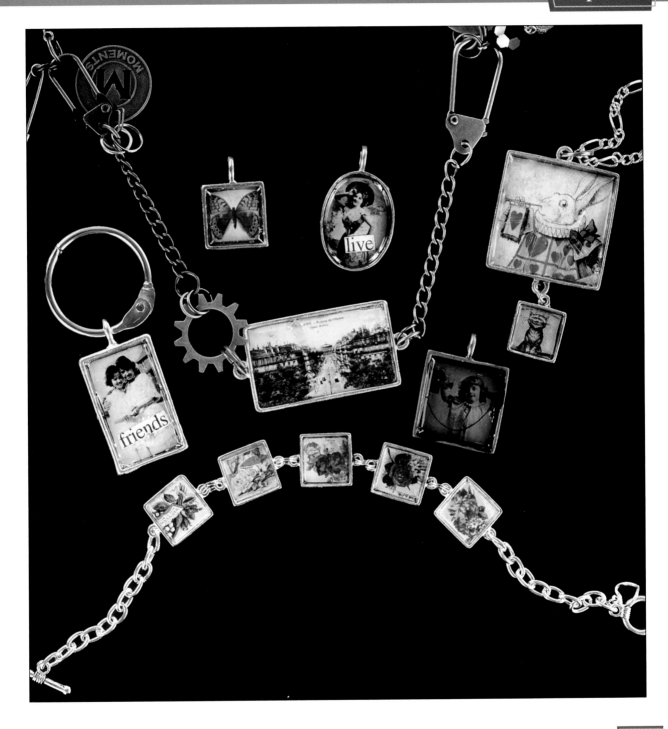

Bottle Cap Charms

Like glaze-filled charms and pendants, bottle caps can be turned into charms in the same fashion. Bottle caps will, however, need to be prepared before their charming transformation can take place.

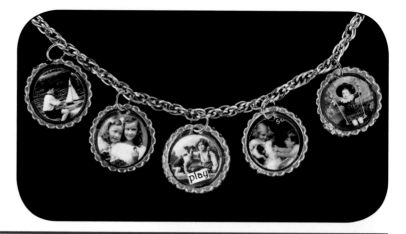

Supplies

- ✦ Bottle caps
- ✦ Crop-A-Dile (hole punch) – We R Memory Keepers
- ✦ Rubber mallet (optional)
- ✦ Collage images – Altered Pages, Southern Blackberry Designs
- ✦ Glossy accents – Ranger Industries

1 Punch a hole in the rim of the bottle cap using the Crop-A-Dile hole punch.

The bottle cap may be used at this time, but if you want a shallow, low-profile charm, continue with the rest of the steps.

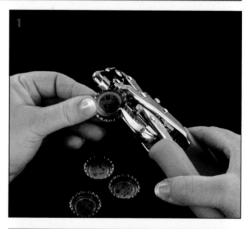

2 Place the bottle cap, ridges facing down, on a cement floor or other hard surface.

3 Firmly hit the center of the bottle cap once or twice with the rubber mallet. If your initial hit was off center, compensate by striking the opposite edge on your next swing to even it out.

Notice how the ruffled edge of the bottle cap has been doubled over, creating a nice finished look.

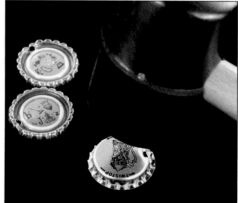

TIP

The Crop-A-Dile is the best tool I have found to punch holes or set eyelets in a wide variety of materials, including paper, chipboard, thin sheets of wood, metal, fabric, and more. Very little effort is needed for even the toughest of materials.

4 Insert the collage image or other embellishments following the same method that was used to create glaze-filled charms. Let the glaze dry completely before trying to attach it to your project. Depending on temperature, humidity, and amount of glaze used, it could take anywhere from 3–24 hours.

Note: *If the glaze runs out of the hole, clear the opening with a piece of wire or a paper piercer.*

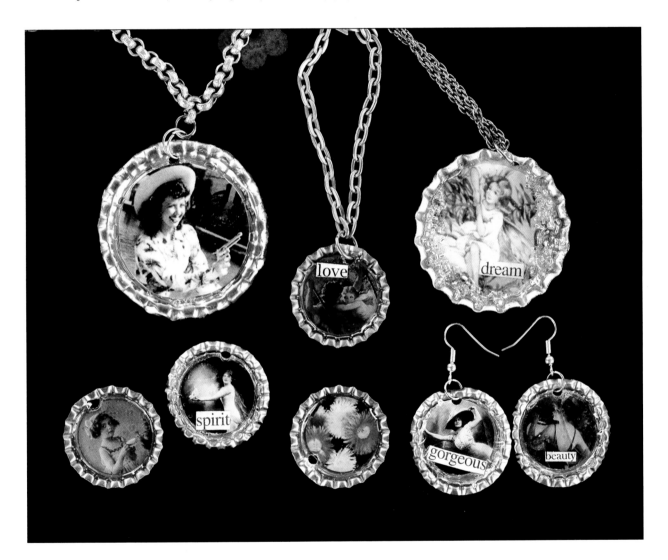

Button Charms

New or old, large or small, buttons come in all sorts of shapes, colors, and designs. They're the perfect accent or main attraction for any collage or altered art project. Both shank and hole-type buttons are easily converted into altered charms with a little bit of creativity.

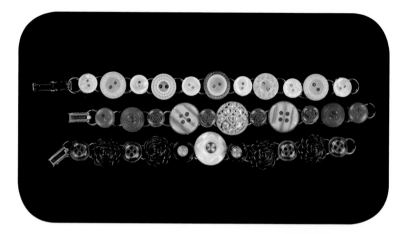

Shank Buttons

Shank buttons have metal or plastic nubs on the back side that take the place of holes. The shanks make it easy to turn these types of buttons into charms. You can use a jump ring to attach it to a necklace chain, earring, or bracelet. It can also be used as a dangle for nonjewelry projects.

These types of buttons may be threaded on a piece of wire, hemp, or jewelry cord.

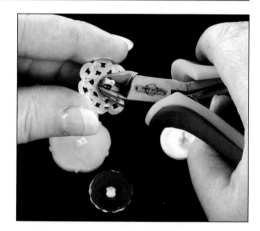

If a flat button is desired, clip off the protruding shank with a pair of side cutter- or wire cutter-type pliers. Exercise caution when cutting; you need to be sure to point the button down when snipping the shank off. The shank tends to travel a fair distance if you are not prepared.

File off any sharp, protruding metal or plastic edges with medium-grit sandpaper.

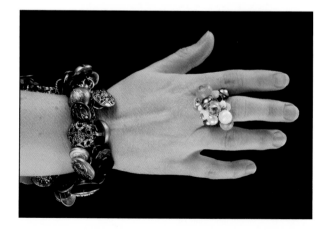

Two- and Four-Hole Buttons

Buttons that have holes instead of shanks can be turned into charms in a number of ways.

The easiest way to create a button charm is to use a very strong clear-drying adhesive and glue it to a jewelry bail or other finding. If you choose to glue the button, you must allow enough time for the adhesive to cure prior to use. If the glue has not had proper time to cure, the adhesive or the button charm may fall off.

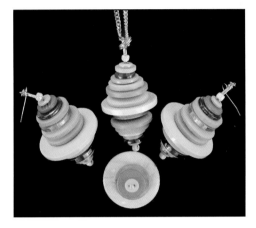

Another method is to thread a piece of wire or jewelry cord through the holes. For a finished look, when you pull the cord or wire through the top side of the button, slip a bead onto the cord or layer a smaller button on top of the first one; then finish stitching as normal.

Drilling additional holes with a multispeed rotary tool is another option available for turning buttons into charms. This allows you to use the buttons as links in a necklace or bracelet, and if desired, you may hang a smaller dangle from the button as well. Always use caution when drilling buttons, especially with older buttons that may have become brittle with age.

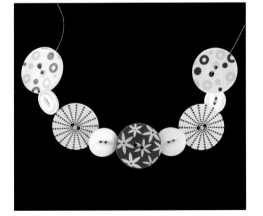

Checkers, dominoes, poker chips, dice, Scrabble tiles—what do they all have in common? Yes, they're all game pieces, but they can also be transformed into altered charms. Follow these simple steps to create festive charms for jewelry, embellishments, and more.

Since game pieces don't come predrilled, you will need to drill them yourself. Before you begin, think about what type of hole configuration you will need for your particular project.

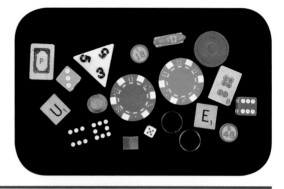

Supplies

- Game pieces
- Marker
- Multispeed rotary tool (with a small drill bit) – Dremel
- Spring clamp or C-clamp
- Scrap wood block
- Fine-grit sandpaper or emery board
- Masking tape (optional)

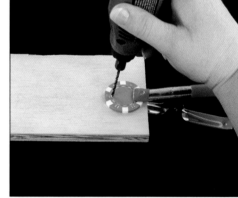

1. Determine where the holes should be, and place a dot using a marker. Double-check the placement to be certain that it's in the correct location. It's best to measure twice and drill once.

2. **Optional:** Once you have determined hole placement, you may put a small piece of masking tape where the hole will be drilled to avoid the drill bit from drifting when you start to drill the hole.

3. Clamp the game piece to a wood block using a spring clamp or C-clamp.

4. Insert a small drill bit into the multispeed rotary tool. Position the tip of the bit over the mark and begin drilling the hole. Start with a slower RPM (revolutions-per-minute) speed to avoid drift. Once the hole has been established, you may turn up the RPMs.

 Note: Game pieces are made from a variety of materials. It may take longer to drill through one material than another. Also, some plastics are brittle, and so you need to use a lower RPM speed when working with these types of materials.

5. Once the hole has been drilled, wipe away the dust and debris. If there are any rough spots along the front or back sides of the hole, file them off with sandpaper or an emery board.

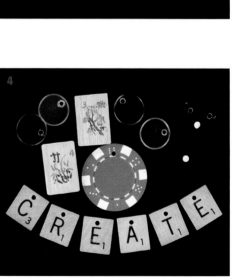

After you have drilled the necessary holes in your game pieces, you're ready to create game piece charms. There are many collage and altered art techniques that can be incorporated into creating game piece charms; it's just a matter of the application.

FLAT GAME PIECES

Game pieces with a flat area are ideal and can be altered using most collage techniques. Size is the determining factor where changes may be required since most game pieces are 2 inches or smaller. Most take paper, paints, ink, or other mediums very well; rubber stamps, collage sheets, specialty papers, and image transfers are excellent for adding imagery. If the finished charm will be handled or moved frequently, it is best to seal it with an acrylic spray or brush on a topcoat.

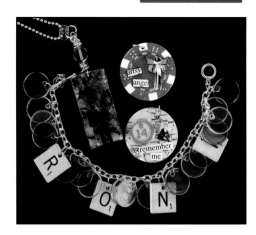

TEXTURED AND DIMENSIONAL GAME PIECES

Checkers, dice, chess, and other dimensional game pieces with textured surfaces can pose a problem when altering. These types of surfaces may limit the variety of techniques, require additional adhesive, or require modifications to achieve the desired effect.

For example, when incorporating stamped images onto highly textured surfaces such as the checker bracelet, you may need to stamp on tissue paper instead of directly onto the checker. The stamped tissue paper should then be applied to the surface using a decoupage or glaze medium. Additional adhesive was used to attach the collage images.

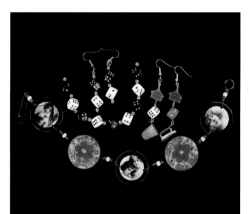

A hollow piece such as a Tri-Omino game piece can be turned into a miniature collage. Queen's Dresser Drawers; Altered Pages and Southern Blackberry Designs make several mini image sheets perfect for these pint-sized collage applications.

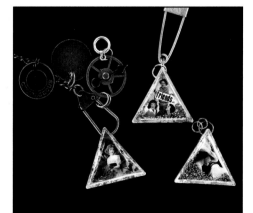

Found Object Charms

Charms can be made from everyday objects found everywhere in your daily life: pencils, washers, mini glass vials, keys, small toys, springs, beads, broken jewelry, tokens, and more. Add a finding and you've got yourself the makings for a unique, fun, and funky one-of-a-kind charm collection.

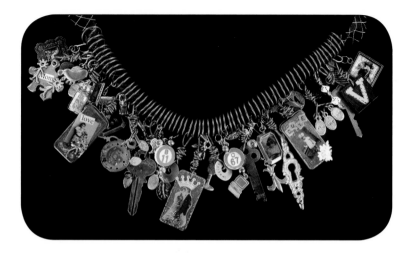

Collect Found Objects

Initially you will need to collect charm material. Large, small, and everything in between, it's all fair game.

- Maybe you or someone you know has old, leftover, broken, or unfashionable jewelry lying around that can be salvaged, taken apart, and reused in part or whole.

- Rummage around in a junk drawer. Look wherever you have leftover or forgotten everyday items; this is where you'll want to start. Maybe you've got trinkets left over from childhood stashed away in a shoebox just waiting to be reborn.

- If you don't have good charm fodder to sort through, try looking at garage sales, flea markets, secondhand stores, online auctions, or Etsy for miscellaneous lots of forgotten treasures.

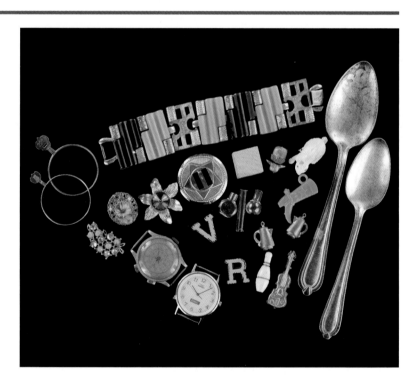

Attach a Finding

After you have amassed a collection of potential charms, you will need to determine the best way to add a jewelry finding that will enable you to attach the charm to your project. You can use a number of options to attach findings. Begin by asking yourself the following questions:

- Does it have an existing hole where a jump ring can be attached? It doesn't necessarily have to be a hole that was intended to be used as a connection; it could just be part of a design to work.

 If so, these types of objects can be easily attached with a pair of needle-nose pliers and a jump ring. Open the ring just far enough to slip the ring through the hole and then close it back up.

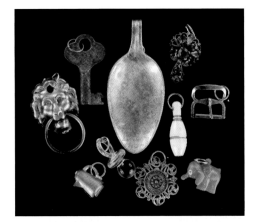

- Can you punch or drill a hole around the edge or through its center? If you can, then use a hole punch or a multispeed rotary tool to drill a small hole where you are able. Most plastic, wood, metal, or composite items can be punched or drilled if care is taken.

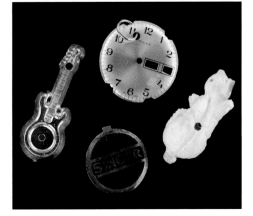

- Will this item melt under extreme heat? If not, soldering a jump ring to the item might be an option. (See the "Soldered Charms" section in this chapter for complete instructions.)

CONTINUED ON NEXT PAGE

TIP

Here's a little trick to ensure the jump ring is secure: Apply a dot of clear glaze such as Glossy Accents or Diamond Glaze over the jump ring joint and let it dry.

- Is there an area on the back of the piece to glue a bail or other jewelry finding? An excellent glue for attaching all sorts of jewelry findings is E-6000. Be sure to let the glue cure completely prior to use.

- If all else fails, wrap it in wire. Sometimes there's just no good way to attach a jewelry finding to an object. In these cases, you can simply wrap it in wire by creating a small loop, wrapping the object, and finishing it off with a neat little knot of some sort. You could get fancy and add a bead or two while you're wrapping the charm, but plain old wire works great.

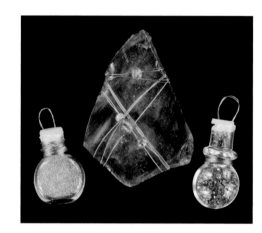

Now that you've attached the various findings to your found objects, it's time to incorporate them into your art. They can be used in collages, altered art pieces, or wearable art.

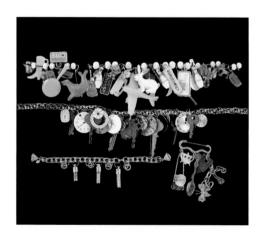

Label Holder Charms

Label holders are normally used to hold mundane data about drawer contents or other bits of necessary yet dull information. Well, not anymore! In a few simple steps, you can turn that unexciting label holder into an awesome altered charm.

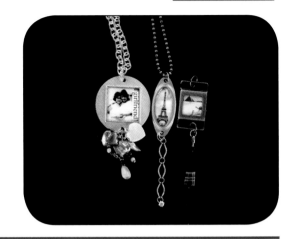

Supplies

+ Label holder
+ Glossy Accents – Ranger Industries
+ Collage image – Altered Pages, Southern Blackberry Designs
+ Jump rings
+ Charms or other embellishments

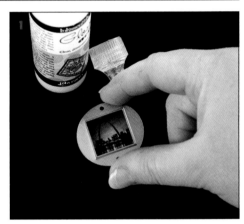

1 Apply a layer of Glossy Accents around the edge of the label holder. Position it over the collage image and let it dry.

2 Embellish the label holder by placing words or pieces of text, charms, or other desired items over the photo inside the label holder. Fill the label holder with Glossy Accents and let it dry.

Note: *This may take 12–24 hours to dry completely, depending on temperature, humidity, and layer thickness.*

3 Attach jump rings or other jewelry findings to the dry label holder and connect it to your project.

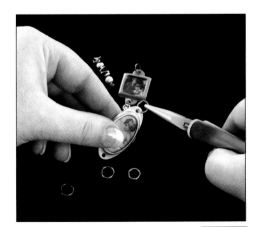

Mica Charms

Mica, a delicate-looking yet amazingly tough mineral, is perfect for creating one-of-a-kind altered charms.

You can do so because mica is a mineral that is formed in sheets. These individual layers can be separated and peeled apart enabling you to create several charms from only one piece of mica.

Keep in mind that mica becomes more transparent as you remove each additional layer. Also, mica is a naturally occurring mineral and may contain color variations as well as flecks of minerals and debris formed during its creation, which only adds to its unique qualities.

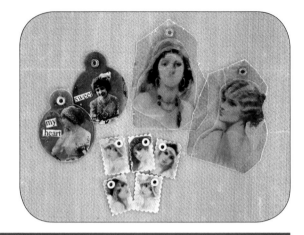

Supplies

- Mica – USArtQuest
- GlueFilm – Streuter Technologies
- Collage sheets – Alpha Stamps, Southern Blackberry Designs
- Craft iron – Clover
- Eyelets – Making Memories
- Crop-A-Dile Eyelet Setting Tool – We R Memory Keepers

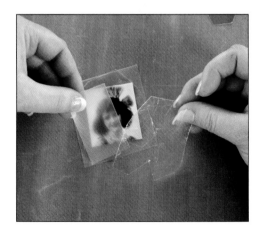

1 Peel off the desired sizes of mica to be used. You need two sheets of mica for each charm—front and back.

2 Trim the desired collage image or other ephemera to be used in the charm. If you want a double-sided charm, you need two images. Cut three pieces of GlueFilm the same size.

3 Assemble the charm by placing one sheet of the mica on your work surface. Next add the following in order: a layer of GlueFilm, a collage image facing down, the second piece of GlueFilm, the second collage image facing up, the final piece of GlueFilm, and the front piece of mica.

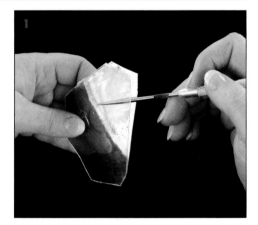

4 Once you have assembled all the layers, place the craft iron on top of the pile to melt all the layers together. Let the charm cool completely.

Note: *Do not run the iron back and forth. After the glue is molten, the various layers have a tendency to slide.*

5 Punch a hole at the top of the charm. Insert and set the eyelet.

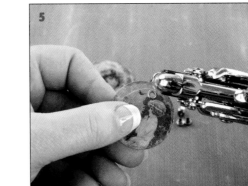

Thin layers of mica, while being very durable, still allow you to trim the edges with decorative scissors adding to the overall design. For a finishing touch the edges may be enhanced using a metallic leafing pen, acrylic paint, or other metallic mediums.

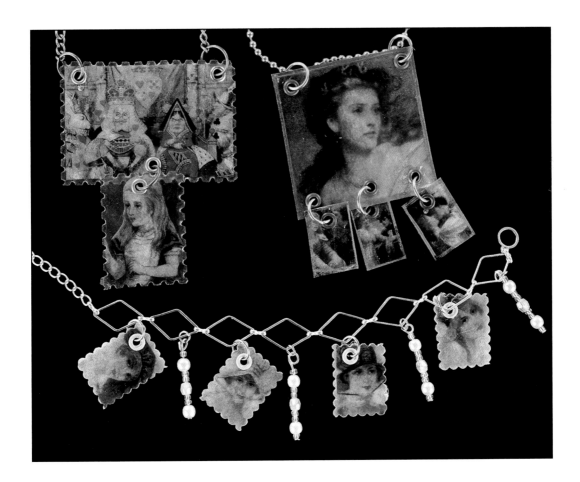

Paper and Polymer Clay Charms

Charms made from paper or polymer clay are an excellent option when you're working on specific themes or hard-to-find items. Both types of clay can be shaped, molded, and stamped to create exactly what is needed to finish your project.

MOLDED CLAY CHARMS

Push molds created specifically for the polymer clay market are available in a wide array of styles and themes. Molds intended for candles, candy, or ice cubes work just as well. If you can't find exactly what you're looking for, you can create your own mold with a two-part silicone putty. Use the following steps to create a molded clay charm.

1 Condition the clay by kneading and rolling it in your hands until it is soft and pliable.

2 Tear off enough clay to fill the desired mold and roll it into a ball.

3 Press the ball of clay into the center or deepest section of the mold. Work the clay toward the edges, filling in the entire mold as you go.

4 Gently peel the clay out of the mold. If you are using polymer clay, it should be baked according to the manufacturer's instructions. If you are using paper clay, you can leave it to dry naturally, turning it periodically, or you can bake it.

5 Paint and add the necessary findings if desired.

FREEFORM CHARMS

Freeform is just that: pieces of paper or polymer clay that have been formed without the aid of molds, stamps, or other tools. You are limited only by your imagination when creating these types of charms.

Freeform charm ideas include geometric shapes, simple flowers, leaf shapes, animals, insects, fruits, or vegetables. The sky is the limit!

STAMPED CLAY CHARMS

Stamping in clay is a great way to make personalized and unique charms.

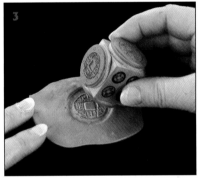

1 Condition the clay by kneading and rolling it in your hands until it is soft and pliable.

2 Roll out the clay until it is ¼-inch to ⅛-inch thick.

3 Press a rubber stamp into the clay using firm, even pressure. Remove the stamp to reveal the image.

4 Trim the desired section of the image. If you wish to hang the charm with a jump ring, poke a hole in the clay prior to baking.

5 Bake the clay according to the manufacturer's instructions or, if using paper clay, let it dry naturally.

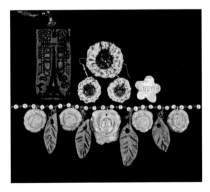

 TIP

Always follow the manufacturer's instructions when baking polymer clay. Time and temperatures may vary depending on the variety and color.

Extra Idea! Use mini cookie cutters to cut out stamped clay charms.

Soldered charms look quite difficult, but after you make one or two, you will realize just how easy they are to create. Charms are just the beginning. Once you know the basics, you'll be able to apply that knowledge to make soldered ornaments and other art.

The process of making soldered charms can be broken down into three main tasks: applying copper foil, soldering, and soldering attachments.

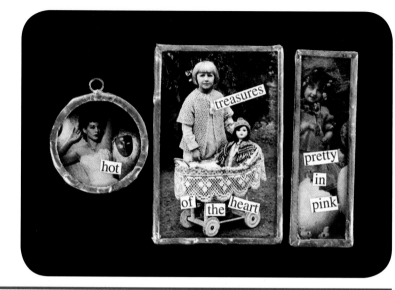

Supplies

- ✦ Soldering iron and stand – Simply Swank
- ✦ Glass pieces – Simply Swank
- ✦ Collage images – Tuscan Rose, Hannah Grey, Alpha Stamps
- ✦ ⁵⁄₁₆-inch copper tape – Simply Swank

- ✦ Acid-free flux – Simply Swank
- ✦ Lead-free solder – Simply Swank
- ✦ Jump rings – Simply Swank
- ✦ Clamps – Simply Swank
- ✦ Safety glasses
- ✦ Bone folder – Ranger Industries

- ✦ Non-Stick Craft Sheet – Ranger Industries
- ✦ Finish mediums (optional) – solder polish, acrylic paint, alcohol ink

Note: *Always work in a well-ventilated area over a heat-protected work surface. Soldering does produce nontoxic fumes; if you are sensitive, you may want to wear a protective face mask.*

SEASONING A NEW SOLDER IRON

When using a new iron, you need to "season" it just as you do with a new cast-iron skillet. To season an iron, melt solder onto both sides of the tip, and then wipe it off on a wet sponge. Repeat this process two or three times.

To ensure maximum heat at the tip surface, continually wipe the tip on the water-soaked sponge in the iron stand during use. This removes any impurities that the tip accumulates while in use.

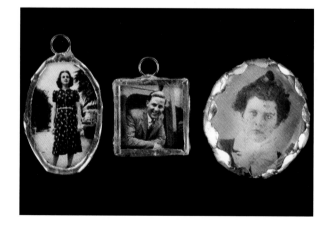

COPPER FOILING

Copper foil is the base for your solder project. The solder does not attach to plain glass, only the areas that have been foiled. Keep in mind that you can only solder metal to metal; it won't work any other way.

1 Place your collage image between two pieces of glass.

2 Hold the glass in one hand; with the other hand, center and stick the copper foil tape to the bottom of the glass "sandwich."

3 Wrap the foil around the entire piece. Overlap the foil ¼ inch at the bottom to ensure a proper bond.

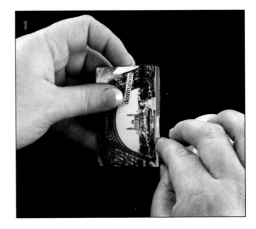

4 Fold in the side edges of the tape over the glass on the front and back sides.

5 Tuck all the corners under just as you would if you were wrapping a gift.

6 Fold the ends over; use a bone folder to burnish the foil to the glass to remove any wrinkles or air bubbles. This also helps ensure proper adhesion.

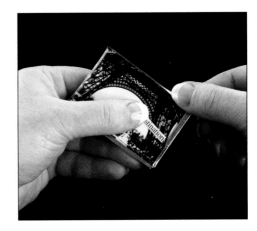

7 Trim any uneven edges with a craft knife.

Note: *Copper tape also comes in a pre-cut wavy-edge design or plain-edged copper tapes may be trimmed using decorative scissors prior to applying them to the glass.*

CONTINUED ON NEXT PAGE

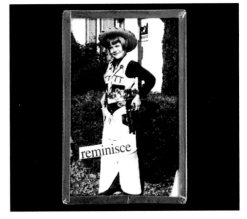

SOLDERING

The three main components of the soldering process are:

- **Flux:** A chemical compound used to promote the bonding of metals, flux helps make the solder flow and creates a smooth appearance.

- **Lead-free solder:** This is a composite metal made from tin, copper, and silver. This is the material that is melted and covers the copper foil tape. When melted, solder becomes extremely hot. *Never* touch hot solder. Always use clamps when handling the item being soldered to avoid burns from heat that's transferred during the soldering process.

- **Soldering iron:** This is the main heat source for melting and applying solder.

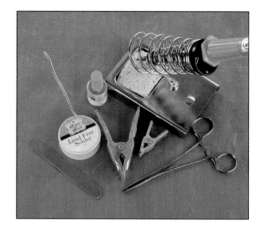

1 Plug in the soldering iron and let it warm up for a few minutes. Soak the sponge in the soldering iron stand with water. Use this sponge to clean the tip of the iron prior to use and periodically while you are soldering.

2 Use a clip to stabilize the foiled project.

3 Paint the flux onto a small section of the foil. Work in small sections, as the flux will evaporate with heat.

4 Holding the soldering iron in one hand and the solder in the other, touch the solder to the iron tip. The solder starts to melt and run down the tip. Touch the tip to the copper foil to get the solder to start flowing onto the foil.

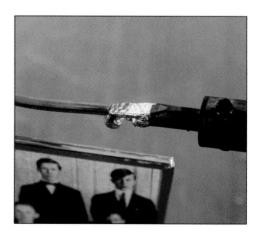

5 Slightly lift the tip off the copper foil, creating a "bridge" of solder between the tip and the foil. Pull the solder along, "painting" it onto the foil in a slow, steady motion. Pull the solder away from the tip to keep from adding too much solder at one time.

Note: Never rest the iron tip directly onto the copper foil; it may burn a hole through the foil.

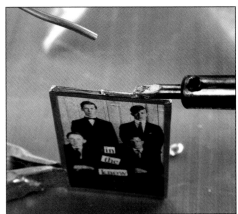

6 Continue melting and coating the solder over all the edges, turning the pieces as needed. Less solder is better for beginners; you can add more solder later.

To smooth out lumps or add solder, paint flux on and add solder as needed. Don't rework areas more than two or three times, as this may burn a hole though the foil tape or cause the tape to lift off the glass. Tape that has lifted can be crimped back into place.

7 When you are finished soldering, feel around all the edges for rough spots. These rough areas or other lumps or bumps that you do not want can be easily removed by sanding them off with a file, fine-grit sandpaper, or a rotary tool.

CONTINUED ON NEXT PAGE

TIP

Follow these tips to help keep the iron tip silver:

- Don't leave the iron plugged in when not in use.
- Clean the tip of the iron by wiping on a damp synthetic sponge when you notice any discoloration.
- Do not use a higher temperature than necessary to melt the solder.

SOLDERING JUMP RINGS

After you have soldered your charm, you need to add a jewelry finding. You can add metal embellishments in the same fashion by first "tinning" the object to be added and then melting the embellishment to the existing solder.

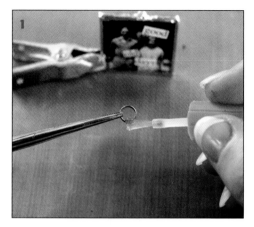

1 Hold the jump ring with a pair of needle-nose pliers, and paint the area where solder will be added with flux. If soldering a jump ring, it's best to do so at the opening to hide the seam.

2 Add a small drop of solder to the jump ring where you painted the flux. The jump ring has now been "tinned," or prepared for soldering to the charm.

3 Do not add flux to the charm. You do not want the solder to flow at this point. Add a small mound of solder to the edge by melting a small amount of solder and pulling the tip up and off the surface.

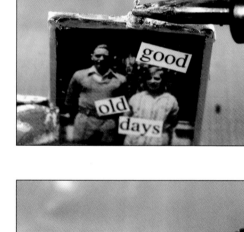

4 Hold the fluxed jump ring firmly in place on the mound of solder. Bring the tip of the solder iron in from the back or side, and touch it to the mound of solder until it starts to melt. Push the jump ring into the melted solder and pull the tip of the solder iron away. Hold the jump ring in place until the solder has set.

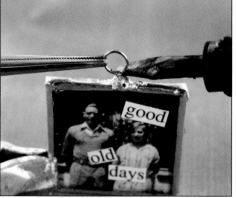

5 When the project is complete, wipe off all the flux residue with a damp cloth. Never submerge charms or place them under running water. The tape and solder are like a casing and are not waterproof. If water seeps under the glass, it can ruin the art between the glass pieces.

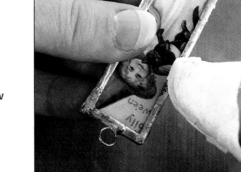

6 **Optional:** You may choose to apply various finishes to the soldered areas:

- Apply a solder finishing wax or metal polish for a high sheen.

- Patinas can be used to create a blackened or coppered finish. (Follow the manufacturer's instructions for proper application.)

- Acrylic paints can be applied. However, if the item will be handled frequently, the paint may wear off.

- Alcohol inks are an excellent idea for adding color. (Apply according to the manufacturer's suggestions.)

- Scratch the surface of the solder with an emery board to create a "brushed" finish.

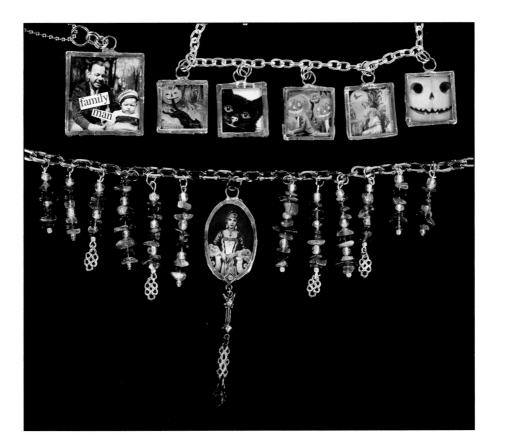

chapter 8

Fabrics, Fibers, and Trim

Textile collage is a unique and varied craft. Projects range from simple, clean designs to those that incorporate complicated stitches and beading, and take many hours to construct. We'll start out with the basics and touch on a variety of techniques to build your fabric foundation.

this is the stuff

that memories
are made of...

SILLY

childhood

me

Fusible Web "Fiber Lace" Paper

This is a quick and easy technique that allows you to create your own fiber lace paper to incorporate into any collage or altered art project. It is the perfect way to use up all of those leftover bits and pieces of fiber from other projects.

Supplies

- Assortment of fancy fibers and embroidery floss
- Fusible web – Therm-O Web
- Craft Iron – Clover
- Non-Stick Craft Sheet – Ranger Industries

MAKING FIBER LACE PAPER

1. Layer assorted fibers in varying lengths on the nonstick craft mat. You need to be sure that the fibers cross over each other in an even layer.

 Note: Fancy, eyelash-type fibers and metallic embroidery floss are excellent for this technique.

2. Once you are satisfied with the fibers, place a section of fusible web (adhesive side down) over the fibers.

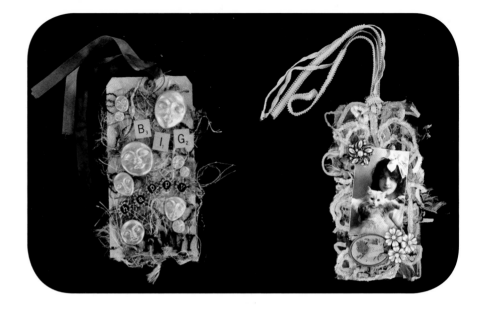

③ Iron the webbing, working in small sections. Iron each section for 15–20 seconds until you have ironed the entire piece of webbing. Let the webbing and fibers cool completely.

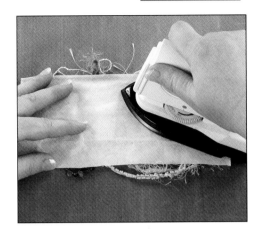

④ Peel the fibers off of the craft mat; peel off the white backing paper from the fusible web. You now have a unique piece of lace paper.

Note: *Keep the backing paper for later steps in this project.*

⑤ Trim excess fibers and snip areas where there are loops.

The fiber lace paper is now ready to be applied to virtually any collage or altered art project.

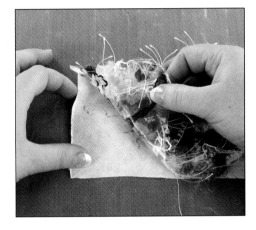

USING FIBER LACE PAPER

① Position the fiber lace paper with the adhesive side down on the project where it is to be used.

② Cover the fiber lace paper with the backing paper, shiny side down, and iron it.

③ Let the adhesive cool; remove the backing paper.

Note: *Add color to the background of your collage prior to adding the fiber lace paper, as the fusible web material will resist many types of color media.*

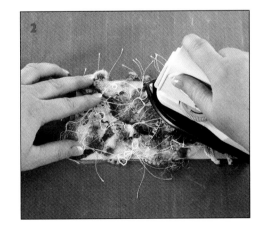

Create Fabric Paper

Many people feel more comfortable and prefer to work with paper instead of fabrics. If you're one of those people, here is a solution that will allow you to incorporate fabrics while affording you the comfort of working with paper.

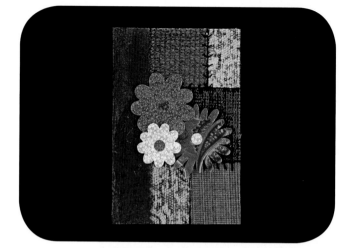

Supplies

+ Fabric
+ GlueFilm – Streuter Technologies
+ Cardstock
+ Craft Iron – Clover
+ Non-Stick Craft Sheet – Ranger Industries

① Place the cardstock on the craft mat; stack a sheet of GlueFilm and a piece of fabric with the pattern facing up onto the cardstock.

② Iron the pile of media, paying special attention to the edges. When you are sure the entire piece of fabric has been fully ironed, let the material cool.

The fabric paper is now ready to be used. It can be cut, shaped, and manipulated just like paper, but it has the added look, texture, and dimension of fabric.

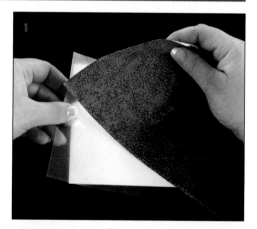

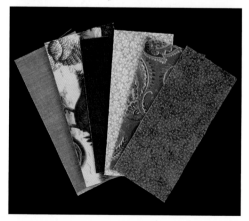

Here are some additional ideas for using fabric paper: incorporate the fabric paper on cards or collage projects, make a fabric banner or gift cone (below center), create unique napkin rings (below left and right), or make a stitched heart pocket.

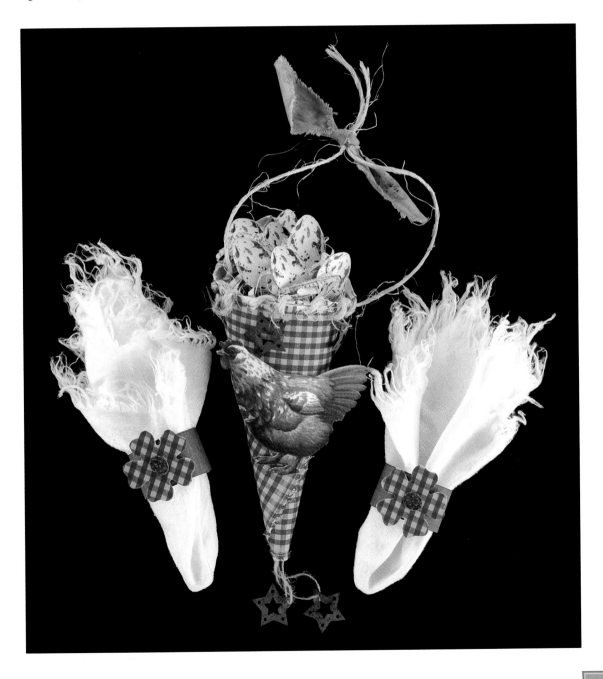

Painted Fabrics

Painting on fabric opens up a new avenue for creativity. Once you understand the basics, you are free to create without limitations. These techniques work equally well for wearable pieces of art, canvas, and fabrics that will be incorporated into collage or altered art projects.

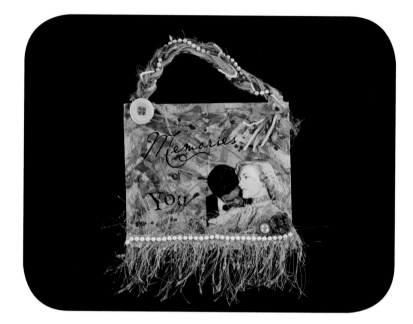

The Basics

Fabrics: Paint works well on virtually any fabric you choose. The fabric weave will, however, be a factor that determines what techniques you will be able to use. For example, highly detailed, painted designs won't work well on loose-weave material. Cotton and muslin are great fabrics for beginners because those fabrics are easy to use and are inexpensive.

Prewashing: It isn't necessary to prewash the fabrics that you will be painting. With some fabrics, such as silks, you are advised not to prewash.

Paints: There are a number of fabric paints on the market. There are also textile mediums that can be mixed with everyday acrylic craft paints, which work quite well.

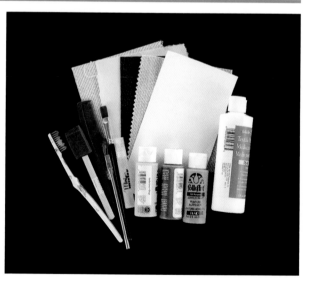

Paint applicators: There are no limits on the ways you can apply paint to fabrics. A few of the basic tools include brushes in various sizes, natural sponges, brayers, and squirt bottles. Experimentation is the key to finding a tool that you enjoy working with.

Preparing to paint: You should always place the fabric you will be painting on a piece of cardboard or other stiff board that has been covered in waxed paper, parchment paper, or plastic wrap. If you are painting a shirt, skirt, or other wearable item, the wrapped cardboard should be placed under the area being painted. This protects the garment from errant paint drips and stains.

Paint Techniques

Since there are such a wide variety of methods used to apply paint to fabric, we'll begin with some general techniques for you to build from.

Freestyle or random painting: Dampen the fabric to be painted and place it on the wrapped cardboard. Randomly drip paint onto the fabric; if desired, scrape the paint drops with a palette knife. Continue layering paints as desired. Let the fabric dry completely, and then iron as suggested.

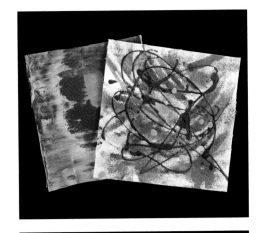

Speckled paint: Dampen the fabric and place it on the wrapped cardboard. Apply paint as desired using a bristle or foam brush. Sprinkle sea salt over the wet paint and let it dry completely. Wipe away the sea salt prior to ironing.

Brayer painting: This technique works well on both wet and dry fabrics. Roll the brayer several times to coat it with paint. Immediately roll the paint onto the fabric. Continue building layers of color by applying additional paint. Add an interesting texture by wrapping the brayer with rubber bands, string, fibers, bubble wrap, or other items.

Layered Fabric Collage

Quilting is a beautiful, yet time-consuming, form of fabric art. Many people find the complicated stitches a daunting task to undertake. An easy solution is a layered fabric collage—no sewing necessary!

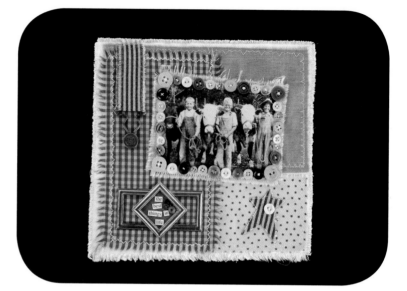

Supplies

- Fabric remnants
- GlueFilm – Streuter Technologies
- Foundation (Basic Grey Chipboard Album)
- Rotary cutter, decorative edge shears or other cutting implement
- Craft Iron – Clover
- Non-Stick Craft Sheet – Ranger Industries
- Collage image – Tuscan Rose
- Embellishments – Hannah Grey
- Aleene's Fast Grab Tacky Glue – Duncan Enterprises

① Gather the fabric remnants to be used on the collage. Decide what look you want for the edges of the fabric. Here are some suggestions:

- Trim the edges with regular scissors for a crisp edge.
- Cut the material with pinking shears, creating a zigzag edge.
- Use a rotary knife with one or a variety of decorative blades to trim each piece.
- If a distressed finish is desired, tear the material and leave the threads hanging. Pull out loose threads to create additional fringe.

② Cut corresponding pieces of GlueFilm for each piece of fabric to be used in the collage.

Note: GlueFilm is an excellent choice when working with fabric. Traditional liquid adhesives seep through the material and leave hard, rough spots where the glues have been applied. Then there is time spent waiting for the adhesives to dry. You will have none of that with GlueFilm. Iron, cool and you're set to go!

③ Determine where each piece of fabric should be placed. Once you have a satisfactory design, if you are able, snap a quick digital photo or make a rough sketch where each piece should be on the final collage. By doing so, you will ensure the final collage turns out just as you envisioned it.

④ Iron each piece of the collage to the foundation.

⑤ Add photos and text, and embellish as desired.

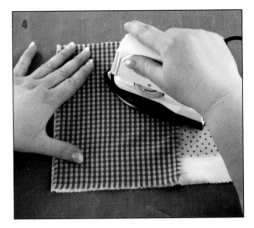

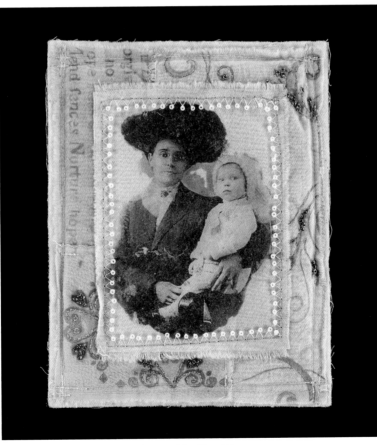

Created by Lisa Dixon

Basic Appliqué Stitches

Many pieces of fabric art include a variety of hand and machine stitches. This easy-to-follow guide illustrates the most popular appliqué stitches.

ALGERIAN EYE (OR STAR STITCH)

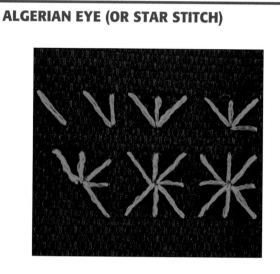

BACK STITCH

BLANKET STITCH

BUTTERFLY CHAIN STITCH

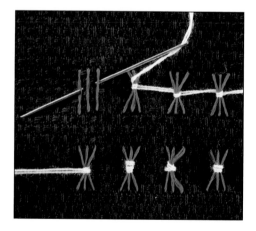

CHAIN STITCH

CROSS STITCH

FEATHER STITCH

FERN STITCH

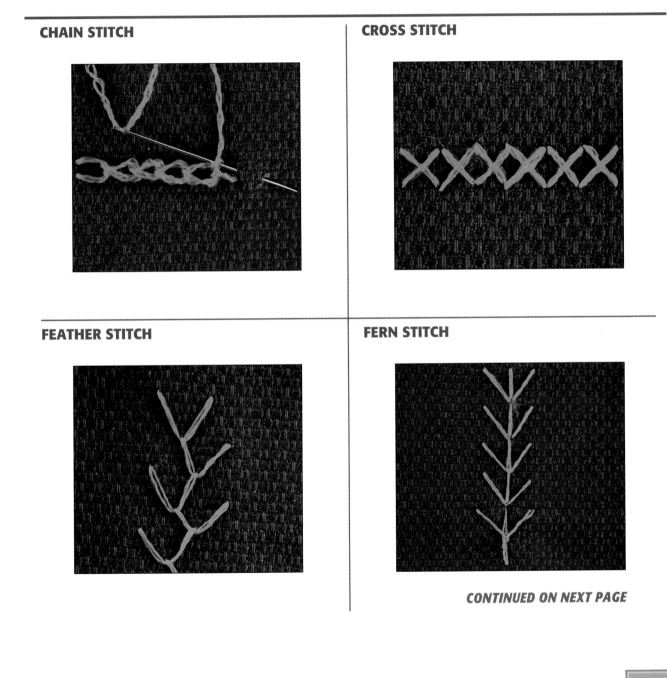

CONTINUED ON NEXT PAGE

HERRINGBONE STITCH

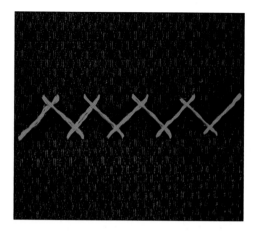

ROSETTE OF THORNS

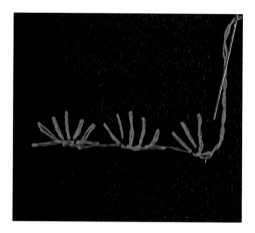

RUNNING STITCH

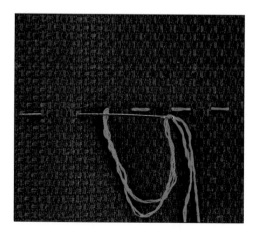

ZIGZAG STITCH

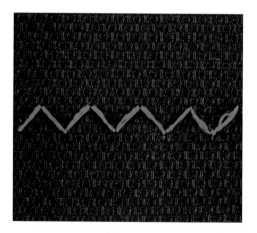

Soft Collage

Cast away the paper and glue, and pick up a needle and thread! Often called "soft collage," fabric arts just wouldn't be complete without making at least one quilt block collage.

Soft collage incorporates the same design elements and principles of traditional paper collage.

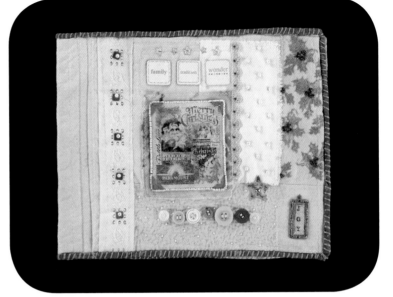

Created by Lisa Dixon

Supplies

- ✦ Fabric remnants (dyed with Glimmer Mist, stamped, painted)
- ✦ Foundation material (cotton or muslin)
- ✦ Low loft batting
- ✦ Thread or embroidery floss
- ✦ Needle
- ✦ Sewing machine (optional)
- ✦ T-shirt image transfer
- ✦ Assorted fancy fibers, buttons, and charms

① Mix and match the various pieces of fabric until you find a pleasing arrangement. Stitch these pieces together by hand or with a sewing machine.

② Assemble the quilt block by spreading the foundation material on your work surface. Next, place the stitched quilt block face down onto the foundation; cover it with a layer of low loft batting. Pin all three of the layers together. Stitch around three sides, leaving the bottom open.

Note: *Batting is the padding added to give the finished collage body; low loft batting is a very thin, light variation.*

CONTINUED ON NEXT PAGE

3 Turn the collage right side out, and stitch the bottom closed. Iron any wrinkles that may have been created during the process.

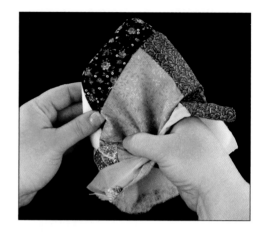

4 Employ a variety of appliqué stitches along each of the seams on the quilt block. For added texture and interest, use fancy fibers, metallic threads, and colored floss as desired.

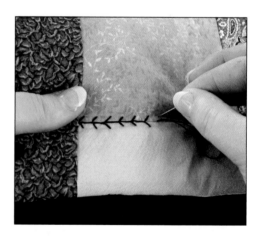

5 Add the image transfer and embellish the collage with charms, buttons, or other bits of ephemera.

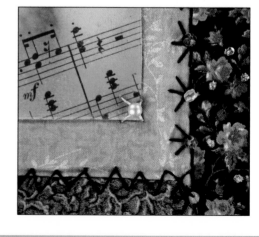

TIP

Alternatives to sewing these pieces of fabric together: Fusible web, fabric glues, Streuter GlueFilm, spray adhesives.

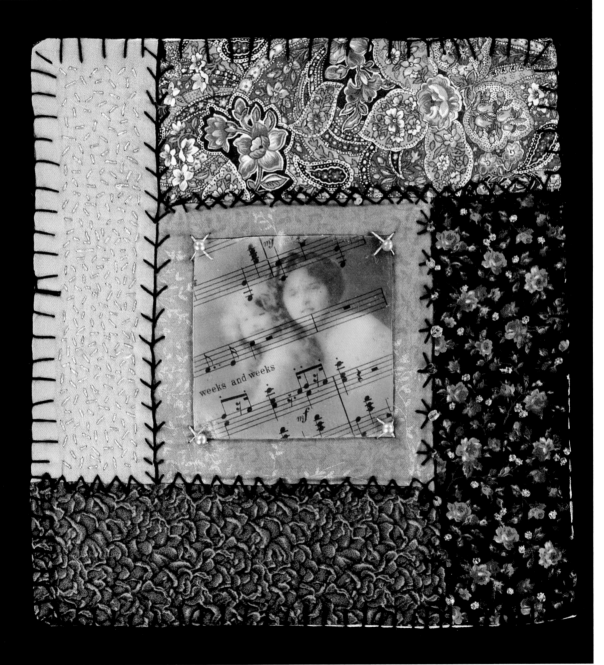

Assemblage Art

A major sector of the collage and altered art genre centers around found objects—items that started life off with a purpose but somewhere along the way became unused, unloved, or destined for the trash heap. Glass bottles, tin cans, boxes, bottle caps, rusty springs, odd pieces and parts…all fall into this realm. Rescue these items from the bin, breathe new life into them, and create amazing works of art along the way. When it all falls together, it is referred to as *assemblage art*.

Captured Fairies

These are whimsical creations featuring darling little imps and fairies captured in their natural surroundings for you to enjoy and admire. Let your imagination run wild as you create their surroundings with recycled found objects, junk jewelry, and more.

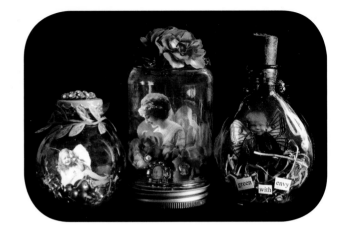

Glass Bottle Collage

Supplies

- Drinking glass, Mason jar, bottle, or other glass container
- Collage image – Hannah Grey, Tuscan Rose
- Cardstock, chipboard
- Paper or other material (for the fairy wings)
- Tweezers
- Aleene's Fast Grab Tacky Glue – Duncan Enterprises
- Ribbons, fibers, beads, buttons, charms, jewelry bits, flowers, and other natural elements, or other embellishments and found objects

1. Trim the image from the collage sheet. Create wings for your fairy by using paper or another type of material. Glue them to the back of the collage image.

2. Mount your fairy onto cardstock. This gives the image body and aids in placement.

Note: If you are using a jar with a small opening and a stand would be impossible to use, disregard Steps 3 and 4 and move on to Step 5.

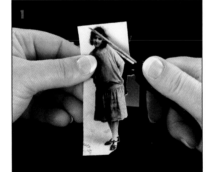

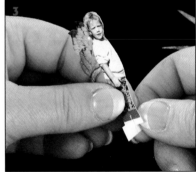

3. Cut a small strip of cardstock or chipboard; it will serve as a stand for the fairy. The size of this stand will be determined by your glass vessel as well as the size of your fairy. Usually $1/2 \times 1 1/2$ inches is a good starting point. Cut a slit in the center of the stand using scissors. This slit should extend to the center of the piece of chipboard as shown in the photo. Cut a corresponding slit in the bottom of the fairy image.

④ Apply a generous dollop of glue to the stand and fairy; place the fairy into the glass container. Let the fairy dry in place.

⑤ **Optional:** If your jar has a small opening and a stand will not work, pour a small mound of glue in through the opening. Roll the image, and insert it using a pair of tweezers. When the image is in the jar, the image will unroll by itself. If the image doesn't stand properly in the jar, prop it in place with a cotton ball placed on either side of the image; these cotton balls can be removed once the glue has set.

⑥ Embellish the jar both inside and out, and add text as desired.

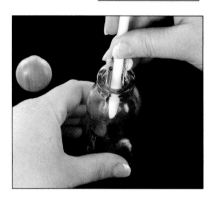

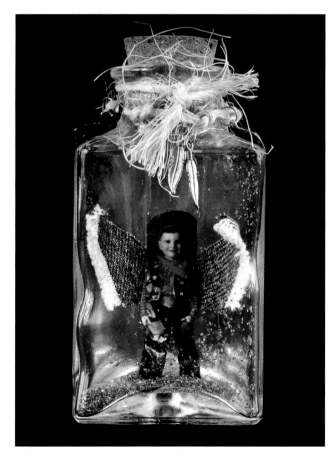

Tin, steel, brass, copper, silver, and gold—metals touch our daily lives in a variety of ways. While metal pieces are extremely durable, these items are still vulnerable to wear and tear, thus rendering them useless. Before pitching those old, worn-out metal parts into the recycle bin, think about resurrecting some life back into them by incorporating them into a collage.

Preparation Possibilities

Everyone approaches art differently. Some people like clean, sleek lines, while others relish years of wear. The following are a few ideas on how to handle a variety of metals, and you may wish to incorporate one or two into your collage.

- Rusty metal pieces may be used as is, or for a smoother finish, sandpaper can be used to clean up the metal. Remember, as layers of rust are removed, work with finer grits until the desired finish is achieved.

- Metal primers may be applied to prevent rust and provide a "tooth" for other mediums to adhere to. This tooth allows complete coverage with fewer coats.

- If you want to add age to a metal piece, there are various one- or two-part solutions to add patinas and/or rust. Be sure to follow the manufacturer's instructions due to the harsh chemicals used in this process. A mixture of salt and vinegar may also be used to add a patina to metal. Be very wary of alternate home mixtures because mixing a variety of chemicals will create toxic fumes and may cause severe illness.

- Wire or strong adhesives such as E-6000 or Gorilla Glue are great for securing metals to your project.

- Use a mild dishwashing detergent and warm water to remove any dirt, grease, oil, or dust deposits from the tins prior to use. Rinse with clean water and allow it to dry thoroughly. A proper cleaning will ensure good adhesion of all mediums and adhesives used during altering.

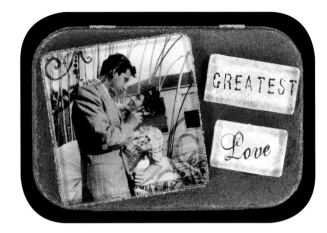

Here's a quick and easy project for any mint tins you might have lying around your house.

Create a lovely little gift box, keepsake tin, party favor, or remembrance box in a matter of minutes. Personalize these boxes by using various mementos and embellishments.

Supplies

- ✦ Mint tin
- ✦ Fine- or medium-grit sandpaper
- ✦ Dust cloth or rag
- ✦ Embellishments – natural elements, collage images, vintage jewelry, beads, charms, ribbons, fibers, ephemera, or other found objects.

- ✦ Sealer – Krylon Crystal Clear, Patricia Nimocks Clear Acrylic Sealer – Plaid
- ✦ Adirondack Acrylic Dabber Paint – Ranger Industries
- ✦ Perfect Pearls Pigment Powder – Ranger Industries
- ✦ Perfect Pearls Paint Brush – Ranger Industries

1. Sand the entire tin using a fine- or medium-grit sandpaper. Wipe off all dust and debris using a soft cloth.

2. Begin dabbing paint directly from the bottle onto the lid of the tin. This layer of paint should be fairly thick and should cover the entire top of the tin.

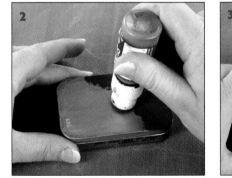

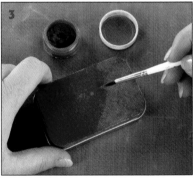

3. Immediately, before the paint dries, apply a generous coating of the Perfect Pearls powder to the wet paint. Let this area dry completely.

 Note: If you are using a large tin, work in small sections, altering between applying paint and powder.

4. Repeat Steps 1 and 2 until the entire tin has been covered. Let the paint and Perfect Pearls powder dry completely before moving to the next step.

5. Once the tin is completely dry, dust off any excess powder using a dry brush. Spray one or two coats of acrylic sealer to the entire tin and let it dry.

6. Embellish the tin as desired.

Miniatures—Pint-Size Collage

Don't have the time to pull out your supplies? Think you don't have enough time or money to give it a try? Well, these pint-size collage ideas are exactly what you need. Create miniature pieces of art quickly and easily with found objects around your home.

Many people who are limited on time, space, or money have resorted to creating in miniature. The following are a few tips and ideas to get you started.

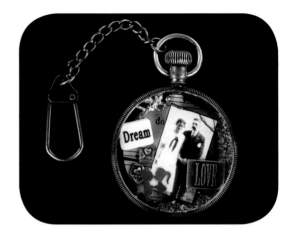

Supplies and Materials

FOUNDATIONS

The foundation for a miniature collage can be found virtually anywhere. Canning jar tops, juice can lids, tuna cans, old pocket watch casings, small gelatin molds, and bottle caps all make an excellent starting point for a mini collage.

MINIATURE FOUND ELEMENTS

Most full-size elements won't work in miniature collage. But if you take a minute and look around, you will find that there are tiny bits and pieces everywhere. Compact versions of large appliances, travel games, action figures, jewelry charms, and findings all offer a variety of mini parts.

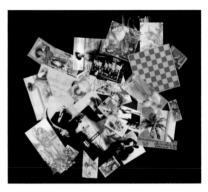

TINY COLLAGE IMAGES AND EPHEMERA

Of course, you can use full-size images and ephemera in your mini collage works by using a fraction of those elements. However, there are some companies that cater to small-scale designs. Queen's Dresser Drawers, Altered Pages, and Southern Blackberry Designs all offer collage sheets, which include miniature photos, vintage images, ephemera, and more.

Learn how to create a miniature collage using a Mason jar lid as the foundation.

Caution: Glass glitter is made from tiny shards of colored glass. This glitter is extremely sharp. Mylar glitter may be substituted but will not create the same dimensional effect.

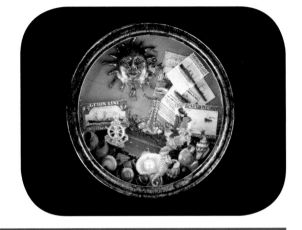

Supplies

+ Mason jar lid and ring
+ Mini collage images – Southern Blackberry Designs, Altered Pages
+ Small embellishments (miniature collage images, beads, buttons, vintage jewelry, flowers or other natural elements, coins, small toys, Cracker Jack-type charms, etc.)
+ Ephemera – Found Elements

+ Adirondack alcohol inks – Ranger Industries
+ Glass glitter – German Corner Store or Mylar glitter
+ Transparency sheet
+ Double stick foam tape (½ inch, 9 inches for a regular size ring, 11 inches for a wide mouth ring)

+ Aleene's Fast Grab Tacky Glue – Duncan Enterprises, E-6000 Adhesive
+ Picture hanger hinge
+ Safety glasses and gloves

1. Apply alcohol ink to the Mason jar lid and ring, and let them dry.

2. Trace the lid on the transparency sheet and cut it out. This will become the window to protect the finished collage.

3. Add a few dots of Fast Grab Tacky Glue to the inside lip of the ring, place the transparency window into the ring, and press it into place.

4. Cut a length of double stick tape for the inside of the ring as noted in the supplies list. Insert the transparency sheet and press the tape on the inside of the Mason jar ring.

5. Remove the liner from the double stick tape. Cover the adhesive with glass glitter. Carefully press the glitter into the tape. Set the ring aside for later use.

CONTINUED ON NEXT PAGE

6 Assemble the collage on the Mason jar lid, leaving a ⅛-inch space around the rim of the lid to allow for the foam tape and mounting.

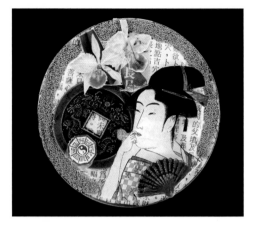

7 Place the Mason jar ring so the back side of the ring is facing up. Apply a bead of glue around the entire edge of the double stick tape.

8 Immediately position the collaged lid inside the ring so that it is resting on the glued tape edge. Let the lid dry in that position.

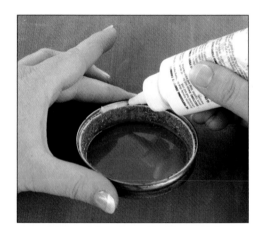

9 After the collage has dried to the ring, squeeze a generous mound of E-6000 to the upper edge of the back of the collage. Press the picture hanger into the E-6000; allow the adhesive to cure for 18–72 hours before hanging.

Note: *Cure time may vary, depending on temperature, humidity, and the amount of glue applied. Excess glue may be trimmed away with a craft knife.*

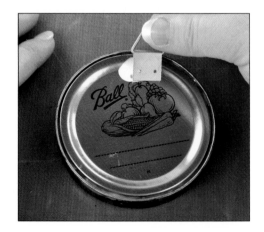

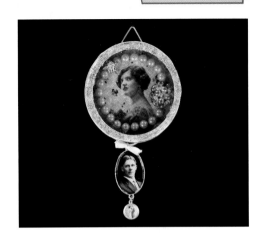

10 Cover the back of the collage with the desired cardstock or fabric, and embellish the front of the ring as desired. Wrap a ribbon around the ring and secure it.

The Mason jar ring collage is just one pint-sized collage of many possibilities. Keep these little gems in mind when you're short on time but still need to fill that creative urge.

This is just a sampling of the fun miniature collages you can create using a variety of foundations, collage images, and tiny ephemera found around the house.

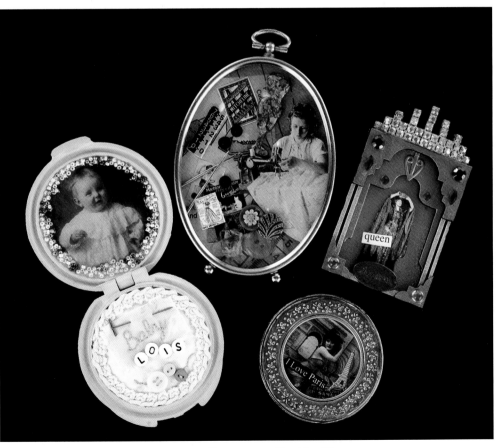

Compact collage created by Lisa Dixon

In Chapter 7, you learned about creating an altered charm using a bottle cap. Now take using bottle caps one step further by incorporating them into your collage and altered art projects.

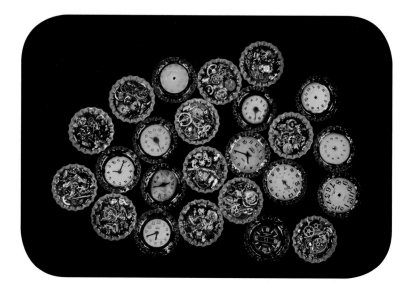

Bottle Cap Checkers

Supplies

- Bottle caps (24) – Brewers Art Supply
- FolkArt Acrylic Paint – Plaid
- Paintbrush
- Fluid Acrylics – Golden

- Adirondack Acrylic Dabber – Ranger Industries
- Vintage watch parts and faces
- Clock rubber stamp – Lasting Impressions with Panache

- Sealer – Krylon Crystal Clear
- Glossy Accents and Sepia Accents – Ranger Industries
- Wood checkerboard – Albert Vance
- Straight pin (optional)

1. Paint the interior and exterior of 12 bottle caps with red acrylic paint and the other 12 bottle caps with black acrylic paint. Let them dry completely.

2. Add watch parts to the 12 red bottle caps. Place one watch face in each of the black bottle caps.

3 Fill the black bottle caps with Sepia Accents; fill the red caps with Glossy Accents. If any bubbles form in the wet glaze, pop them with a straight pin. Let the bottle caps dry overnight.

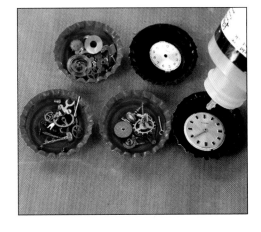

4 Paint and decorate the checkerboard to match the theme of your game. Stamp the squares using Adirondack Acrylic Dabber.

5 **Optional:** If desired, stitch a small bag to hold the altered checkers. Embellish the bag to match the theme.

Checkerboard created by Albert Vance

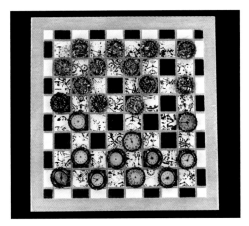

Shrines are typically a container or receptacle used to store sacred items. In the world of assemblage art, altered shrines and shadow boxes pay homage to a particular theme—any subject or idea held dear by the artist. These types of projects come in all shapes, sizes, and colors. There simply are no limits to the boundaries of altered shrines or shadow boxes.

ALTERED SHRINES

Shrines, by definition, are boxes or containers that hold and conceal precious relics. In turn, altered shrines are also boxes or other containers that house the artist's precious thoughts, ideas, or relics.

Generally, most shrines have two main parts: the outside of the container and the inside of the container. The container itself, or "house," is decorated in a chosen theme. The container opens in some fashion to reveal the *inner sanctum,* the area inside the container where the theme is carried out to its fullest extent.

Some examples of a shrine container would be a movie reel can (shown in the photo above), a mint or cookie tin, a lunchbox, a cigar box, or even something as small as a matchbox.

SHADOW BOXES

Shadow boxes, on the other hand, are usually shallow open-framed boxes that may contain several compartments to be filled with various found objects relating to the overall design.

Ideas for shadow boxes include small compartmental drawers; wood, paper-mâché, or chipboard boxes with or without built-in dividers; empty tins without lids; and shaped boxes, to name a few.

In recent years, collage, altered art, and assemblage art have become quite popular. Some manufacturers now offer shadow box frames in standard sizes with a variety of finishes.

Soft collage incorporates the same design elements and principles of traditional paper collage. Create a fun and sassy shadow box by incorporating a variety of collage images, found objects and vintage ephemera. Use unexpected items for backgrounds such as a jean label, watch parts or sea shells. Add emphasis on particular items by using double stick foam to bring some items to the foreground while moving others to the background to add depth and dimension to your shadow box collage.

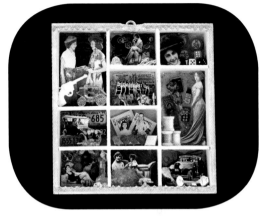

Supplies

+ Sectioned drawer
+ Collage images – Hannah Grey; Queen's Dresser Drawers
+ Mini collage embellishments – Hannah Grey
+ Decorative brads – Making Memories
+ Adirondack Acrylic Dabber Paints, Glossy Accents, Pop-It Shapes, Alcohol Ink – Ranger Industries
+ Dresden Trim – German Corner Store
+ Glossy Accents – Ranger Industries
+ Double stick foam

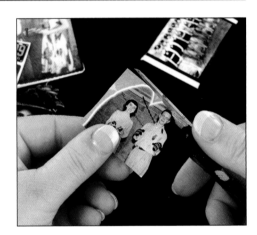

1. Trim the desired images from the collage sheets, and gather the desired embellishments.

2. Paint the box with acrylic paint and let it dry.

3. Glue the background elements to the back of each section and let them dry completely.

4. While the background elements are drying, add one or more layers of double stick foam to each collage image. Each layer you add pushes the image farther off the background, adding depth to the finished collage.

 Note: Varying the space of each element from the background adds depth, creates interest, and produces an eye-pleasing arrangement.

5. Finish off the collage by adding mini collage embellishments, and add trim around the top and bottom edges.

Triptych Basics

Broken down, the Greek word *triptych* translates as *tri* or three and *ptyche* or fold, which refers to a common form of artwork popular in ancient Greece. Today, the word triptych has come to embody any three-panel artwork, which may or may not be hinged.

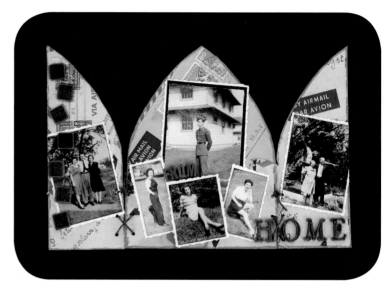

Triptych Base

Many companies offer preassembled triptych units, which are usually primed and ready to be altered. Creating a triptych foundation from scratch isn't difficult, and the basic construction techniques may be applied to several projects.

Since most triptychs are made to be hung on the wall or created as standing pieces of art, the panels of the triptych must be sturdy enough to support the weight of the artwork. Many bases are created using wood or canvas as the foundation material. Other base choices that work well are chipboard, foam core board, game boards, mica, and sheet acrylic.

If smaller, more lightweight artist trading cards or Gothic Arch triptychs are desired, reinforced cardstock is also suitable.

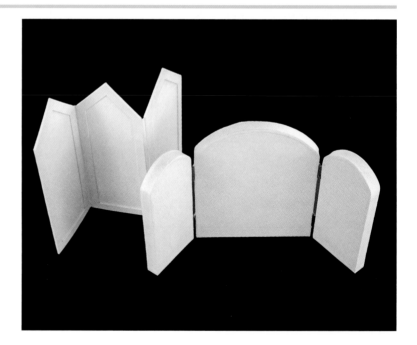

Triptych Hinges

It is common for triptych panels to be joined together in some fashion. There is a wide variety of connections that may be incorporated into the design. The following are some of the most popular choices:

Metal hinges: Very secure and easily attached with brads or screws, metal hinges are the most common type of hardware used to join the panels.

Book rings: These are hinged metal rings with steel teeth that lock together for a secure closure. Book rings are an inexpensive and easily removed type of closure.

Twisted wire: This is as secure as a hinge but has its advantages and disadvantages. Highly decorative knots and designs can be created with wire, but it doesn't offer much flexibility or stand up to excess movement (opening and closing of panels).

Leather or Grungeboard: Leather hinges have been used since ancient times. They offer years of service and can be hand- or die-cut for a variety of looks. They can also be dyed to match an existing design. Although it isn't leather, Grungeboard holds many of the same qualities and can be used in much the same fashion.

Torn fabric, fibers, or ribbon: These types of hinges are flexible and offer warmth and a versatility not afforded by the first two choices. Color and texture can be adjusted to fit the overall design perfectly.

Mica is such an interesting material to work with. Transparent yet incredibly strong, it is the perfect foundation to create a triptych.

The unique transparent qualities affords you the opportunity to incorporate images, text, and design elements to both the front and back sides of the triptych adding depth and dimension not normally attainable with most foundations.

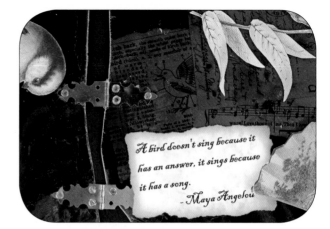

Supplies

- XL Mica Sheets – USArtQuest
- GlueFilm – Streuter Technologies
- Collage images – PaperArts.com
- Ephemera – Found Elements, Hannah Grey
- Found objects – personal collection
- Hinges – hardware store
- Mini Brads – Making Memories
- Crop-A-Dile Hole Punch/ Eyelet Setter – We R Memory Keepers

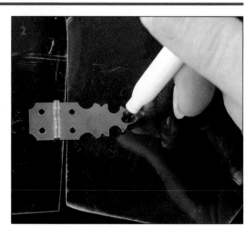

1. Select three sheets of mica to be used for the collage. If this collage is to be a tabletop variety, keep in mind that the bottom may need to be trimmed.

2. Determine the placement of the hinges by placing them on the mica panels. Place a dot where each hole will need to be punched on all three panels. Use the Crop-A-Dile to punch the necessary holes in each panel.

 Note: It is important to determine hole placement prior to adding images, ephemera, or found objects to avoid overlapping.

3. Iron the desired images to the mica using GlueFilm. Let the images cool 20–30 seconds before handling.

4. Apply accents to the panels by incorporating a variety of found objects and ephemera to both the front and back sides of the mica.

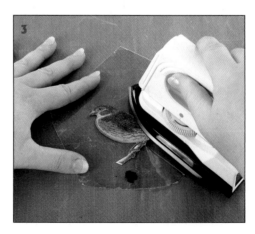

5 Mount the hinges to each panel using brads. **Optional:** Hit each brad with the texture hammer several times to produce dents and dings.

TIP

- Give yourself additional work space and dimension by adding bits of your design between the many layers of mica before attaching the hinges.
- Add color to your mica triptych by applying one or more colors of alcohol inks to the back or center layers of the mica.
- Edge the mica panels with a metallic leafing pen, acrylic paint, or other medium.
- Sandwich leafing flakes in between the layers of mica as an interesting addition to your design.

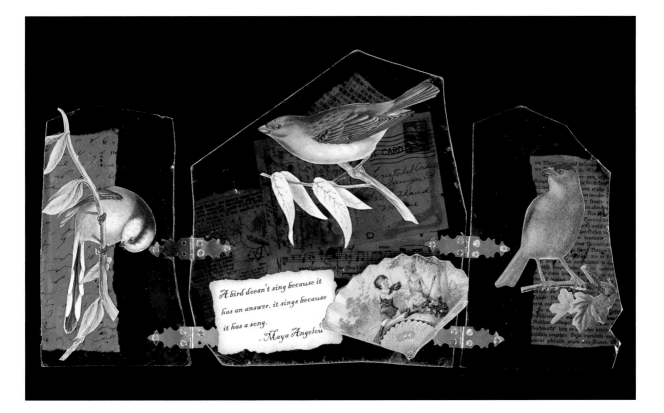

Altered Books

Altered books are essentially discarded books recycled into art. The pages of the book are used as the artist canvas by combining a variety of techniques, images, and text. This type of art can be based on random thoughts and ideas or centered on a specific theme. Every altered book is a personal expression of the artist who created it so no two books will ever be the same. The following techniques may be combined in any number of ways allowing you to create an altered book all your own.

Basics of Altered Books

Starting a new project is always more enjoyable when you understand the basics. Learn how to choose the correct book, book preparations, and other information to get you started off right.

Choose the Right Book

The first step in altering a book is choosing the correct book for the job. There are two major types of bindings found in mass produced books: *sewn* and *glued*. Books that have a sewn binding are very durable and withstand extensive handling, which is a must for altered books. Glued bindings, on the other hand, tend to have brittle spines and frequently loose pages in very short order.

Determine how the book was made by standing the book on end and open it slightly. If the cover arches away from the binding of the book, it's a very good indication of a sewn binding.

Look for a distinct scallop pattern along the spine of the book; each scallop indicates a *signature* or section which has been individually assembled. Most glued books have very precise, sharp edges near the binding.

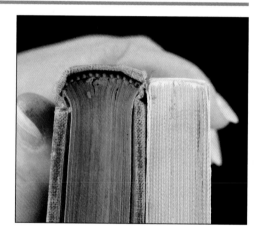

If you are still unsure of how a book has been assembled, open the book and look at the spine. If stitch holes or threads are visible, you know it is a sewn binding. There will be no holes or thread visible in a glued binding; you may also hear cracking if the book has been opened too far.

Remove the Pages

It is a good idea to remove several pages from the book prior to altering. This extra space allows a variety of techniques to be incorporated while still maintaining the integrity of the spine.

Remove the excess pages by placing a straightedge ¼–1 inch away from the spine and tearing out the page. Repeat this procedure every few pages. If several bulky techniques or embellishments will be used, remove every other page.

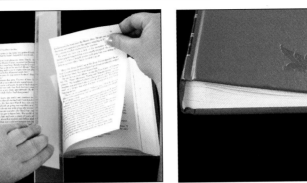

If the extra pages are not removed, you will end up with a book that can't close properly. This may damage or ruin the spine.

It is not necessary to remove any pages where a window or niche will be added to the book (see pages 176 and 178). These types of techniques will require a solid block of pages.

CONTINUED ON NEXT PAGE

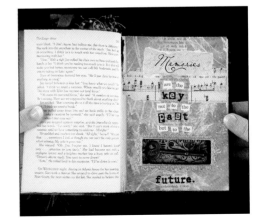

Reinforce the Pages

In most cases, the pages in an average book are not substantial enough to withstand altering techniques. Remedy this situation by gluing several pages together for a strong and rigid work surface.

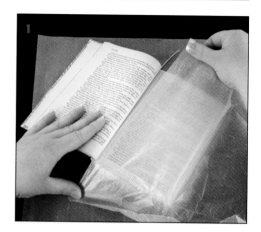

Supplies

- Book (to be altered)
- PH Neutral PVA Glue – Lineco
- Waxed paper
- Foam brush or scraper
- Heavy books (for weight)

1 Cut two pieces of waxed paper. Tuck one sheet in front of the pages to be glued and one behind.

Note: Waxed paper is an essential form of protection when altering pages in a book. It should be used when gluing pages together or adding tip-ins (see page 173) or fold outs (see page 174). Also use waxed paper when working on potentially messy techniques.

2 Work in the natural direction the book wants to close (for example, left to right or right to left). Apply the PH Neutral PVA glue in a thin, even layer working from the spine to the outside edges of the page.

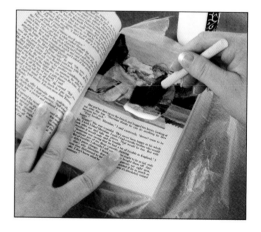

3 Carefully join the two pages together and smooth. Make sure there are no creases or winkles in either page. You may roll a brayer over these pages to remove possible air bubbles if desired.

Note: Do not use a glue stick for gluing in or adding pages. Glue stick adhesive will eventually break down and the pages will come apart.

4 If more than two pages are to be joined together repeat Steps 1 and 2.

⑤ After you have glued the desired number of pages together, close the book and add weight to press down the pages. Let the pages dry overnight.

Once the pages have dried, you will have strong, durable pages that will stand up to virtually any altered book technique.

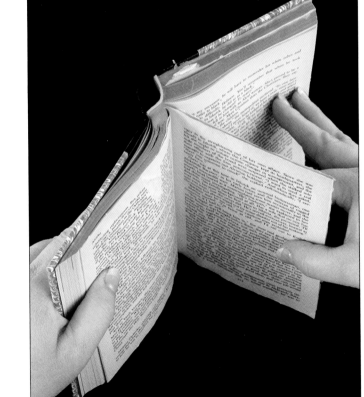

Story on the Page

If you like word games then you are going to love this altered book technique. It combines the hunt of a word search and the joy of storytelling all rolled into one.

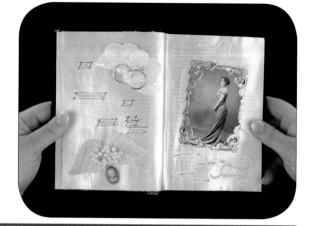

Supplies

- ✦ Book (to be altered)
- ✦ Pencil
- ✦ Acrylic paint – Ranger Industries
- ✦ Paintbrush
- ✦ Embellishments

1. Read through the text on your two-page spread. If you see words or phrases that you find interesting underline them with the pencil as you go.

2. Read through the marked words. Create a story or quote using these words. Circle the chosen words for your quote as you go.

 Note: The words in your story or quote should follow a logical sequence so the reader doesn't have to skip around the page to understand the meaning you are trying to convey.

3. Paint over all of the text except the words relevant to your quote or story. Let this paint dry completely.

4. Finally, add embellishments and photos to the page spread that will enhance the story or quote.

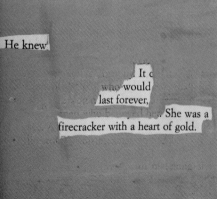

A *tip-in* is a themed page or set of pages that have been created outside of the book. These tip-in pages can be easily added to an altered book whenever or wherever you choose. Many times these types of pages are traded among groups of altered artists.

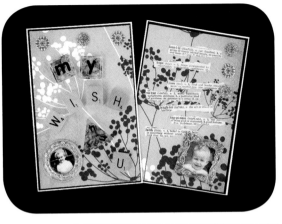

Supplies

- ✦ Heavy duty cardstock or tag board
- ✦ Waxed paper
- ✦ PH Neutral PVA Glue – Lineco
- ✦ Ruler
- ✦ Paper trimmer or rotary cutter
- ✦ Embellishments, images, and text

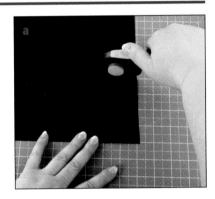

1 Determine the size of the tip-in to be created. Many times if you are swapping pages with other artists, the book and page size will be predetermined.

2 Using the ruler and paper cutter, cut the foundation material for the tip-in from heavy duty cardstock or tag board (a). This will help ensure that the page(s) will withstand being transported and handled without falling apart. If you are making a two-page spread, you may either cut one large piece of cardstock with a center fold or cut two separate sheets—one for each side of the spread (b).

3 Create the page just as you would a normal altered book page by adding text and images. Keep in mind that these pages will eventually be added to a book so bulky items should be left clear of the center line enabling the book to close properly.

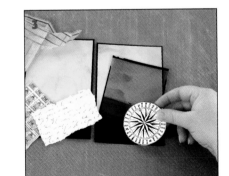

4 Attach the tip-in to your altered book by first tucking two sheets of waxed paper behind the pages where the tip-ins are to be added. Apply a thin layer of PVA glue to the book pages, and tuck the tip-in as close as possible to the spine. Close the book and allow the tip-in to dry completely.

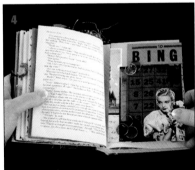

Fold Outs

When two pages just aren't enough, triple your work area by adding fold out pages. Fold out pages look like a regular page spread but they open to reveal four inner pages for a total of six pages of work area.

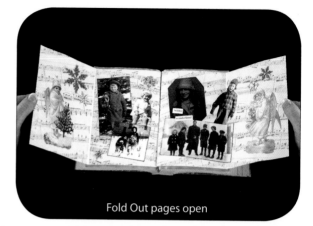

Fold Out pages open

Supplies

- ✦ Heavy duty cardstock or tag board
- ✦ Ruler
- ✦ Paper trimmer
- ✦ PH Neutral PVA Glue – Lineco
- ✦ Embellishments, images, text, etc.
- ✦ Waxed paper
- ✦ Heavy books (for weight)

1 Measure the book height and width to determine the size of the fold-out pages. For example if the book to be altered is 6 × 8 inches you will need to cut two pages 12 × 8 inches.

2 Cut the fold-out pages to the necessary size.

3 Fold and crease the pages in half.

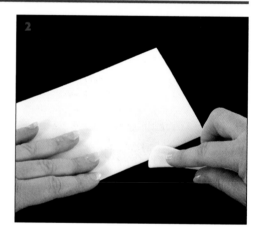

4 Glue the fold out pages to the reinforced pages in the altered book (see page 170). Weight the book and let them dry overnight.

5 After the fold out has dried, there are now six pages where once there were only two. Decorate and embellish as desired.

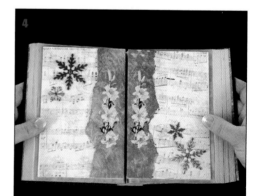

Fold Out pages closed

Pockets are a great place to tuck photos, clippings, and other memorabilia in an altered book. Use these handy techniques to create quick and easy pockets for your altered book.

Vertical pockets can be created using eight pages in a book. Begin by leaving the first two pages intact. Then tear a ½-inch to a 2-inch strip from the next two pages. Tear a 1½-inch to a 2½-inch strip from the third set of pages, and tear a 2-inch to 3-inch strip of paper from the last two pages.

Note: The width of the torn strips can be varied depending on the initial page size. Additional pockets may be added at varying depths.

Once all pages have been torn, attach all of the pages together at the top and bottom using glue, eyelets, brads, or other types of fasteners.

Horizontal pocket pages may be created using the same basic technique for vertical pockets as described above. However, larger portions of the pages may need to be removed in order for the pockets to be of use.

Folded pages are another option for creating numerous sizes and shapes of pockets in your altered book. Simply fold two pages and secure using brads or eyelets.

TIP

There are several premade pockets that may also be used. Attach these types of pockets to the book using glues or other fasteners.

Create a
Window or Door

Open up a whole new world of possibilities by adding a window or door to your altered book. You never know what you might find on the other side.

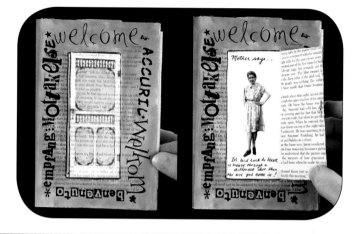

Supplies

- ✦ Altered book
- ✦ Waxed paper
- ✦ Ruler
- ✦ Pencil
- ✦ Craft knife
- ✦ PH Neutral PVA Glue – Lineco

- ✦ Sheet of glass or self healing cutting mat
- ✦ Door (B-Line Designs) or Window (100 Proof Press) rubber stamps (optional)
- ✦ Archival Ink – Ranger Industries

- ✦ Heavy books (optional for weight)
- ✦ Embellishments (Twinkling H2O's – LuminArte, Rub-ons – Making Memories, Gesso – Ranger Industries, Collage Image – personal collection)

1. Decide how thick you would like your door or window page to be. If only a few pages are needed, glue these pages together using the instructions in the section "Reinforce the Pages" on page 170.

 Note: *If several pages are needed, position the waxed paper as usual—one sheet before and one sheet after the pages to be glued. Instead of gluing each page, apply a generous amount of glue around the outer edges of the set of pages. Close the book, add weight the pages down and let them dry over night.*

2. Measure the area where the window or door should be. Draw the cut lines onto the pages.

3 Place the sheet of glass or cutting mat under the pages to be cut. If desired, hold a ruler along the cut lines, and use the craft knife to begin removing the excess paper from the window. If you are creating a door, only cut three sides and leave the fourth side intact.

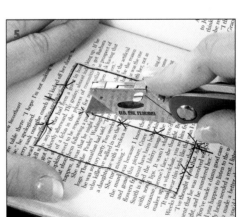

4 After all of the pages have been cut from the window or door area, apply a layer of glue along the inside edges of the cut pages. Let the glue dry overnight.

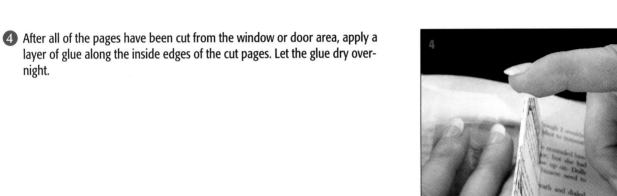

5 **Optional:** A flap may be added to either a door or window by gluing two or three additional pages to the front or back side of the opening.

6 After the extra pages have dried, cut along three edges of the opening leaving one side intact, which will act as the "hinge" for the window or door flap.

7 Decorate and embellish the pages as desired.

Create a Niche

Unlike windows or doors, which are used to view one area from another, niches are charming little cubby holes created for hiding all sorts of small trinkets and treasures.

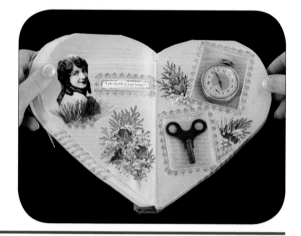

Supplies

- Altered book
- Waxed paper
- Ruler
- Pencil
- Craft knife
- PH Neutral PVA Glue (Lineco) or Aleene's Fast Grab Tacky Glue (Duncan Enterprises)
- Sheet of glass or self-healing cutting mat

- Heavy books (for weight)
- Found Objects – pocket watch, key – personal collection
- Pearl Ex Pigment Powder – Jacquard
- Fluid Acrylics – Golden
- Collage Image, Dresden Trim – Hannah Grey
- Pressed Flowers – Nature's Pressed

1. Hold the object to be hidden in the niche up to the side of the book. Gauge how many pages will be needed to create the niche. The niche should be deep enough that the object will be completely submerged once placed inside the hole.

2. Place a sheet of waxed paper before and after the set of pages needed for the niche. Hold the pages together in one hand and apply a generous coating of glue to the edges.

3. Close the book, and apply weight. Let the pages dry overnight.

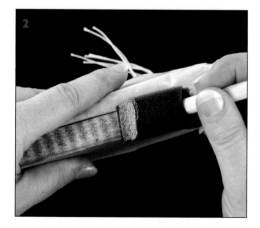

Altered Books chapter **10**

 Place the item to be encased in the niche on the set of glued pages. Decide where the niche should be positioned, and roughly sketch an outline of the size and shape of the niche. Remove the item and go back over the sketch lines with a pencil and ruler.

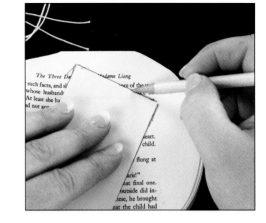

⑤ Place the sheet of glass or cutting mat under the niche. With a craft knife, cut and remove a few sheets at a time until the desired depth has been reached.

⑥ **Optional:** Apply glue around the inside edges of the niche if desired, and let the glue dry overnight.

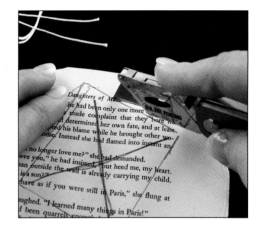

⑦ Paint or paper the interior of the niche, insert the desired object into the niche and finish decorating the surrounding page spread.

Note: The object may be glued into the niche or simply tucked down into the hole.

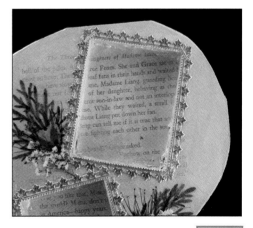

179

Add a Drawer

Just like niches, drawers are excellent little hiding places for all sorts of fun little surprises. Metal tins or matchboxes work equally well for the drawer.

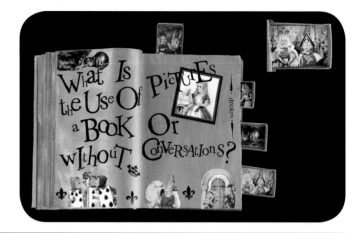

Supplies

- ✦ Altered book
- ✦ Waxed paper
- ✦ Ruler
- ✦ Pencil
- ✦ Craft knife
- ✦ PH Neutral PVA Glue – Lineco

- ✦ Aleene's Fast Grab Tacky Glue – Duncan
- ✦ Sheet of glass or self-healing cutting mat
- ✦ Small tin or matchboxes (as the drawer)
- ✦ Heavy books (for weight)

- ✦ Embellishments (collage images – Tuscan Rose, Southern Blackberry Designs, Altered Pages; Golden Fluid Acrylics; decorative tissue paper; rub-on letters – Making Memories, FolkArt acrylic paint – Plaid; found objects, coins, keys)

1. Hold the drawer up to the side of the book, and determine how thick the set of pages should be.

2. Place a sheet of waxed paper before and after the set of pages needed for the drawer. Hold the pages together in one hand, and apply a generous coating of glue to the edges.

3. Close the book, apply the weight, and let dry the pages overnight.

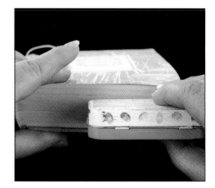

④ Establish where the drawer should be positioned. If a matchbox will be used (a), trace around the edges of the box for snug placement; if a tin is to be used (b), you must allow for additional space to slide the entire tin in and out of the opening. Make adjustments to allow for this movement.

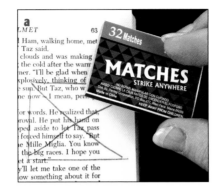

⑤ Use the craft knife to cut the paper from the drawer opening. Test-fit the tin or matchbox at this time to ensure a proper fit. If adjustments are necessary, do so at this time.

⑥ If a tin is being used, skip this step and move on to step 7. Glue the matchbox into the opening, using Aleene's Fast Grab Tacky Glue.

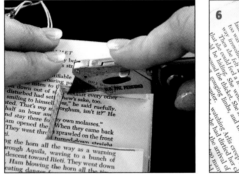

⑦ Glue 5–15 pages to the chunk of drawer pages to conceal the opening. Use the reinforcing pages method on page 170. Let the glue dry overnight.

⑧ To make a handle for the drawer, glue a small knob or wire a bead to the pull-out drawer.

⑨ Decorate the book as desired. Fill the drawer(s) with ephemera, found objects, etc.

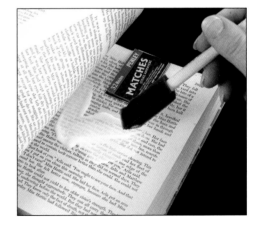

This is a great example of how two drawers were added to the altered book, "World Traveler." It allows the owner to store bits and pieces collected from his/her journey abroad. Now imagine this same idea applied to a variety of other themes.

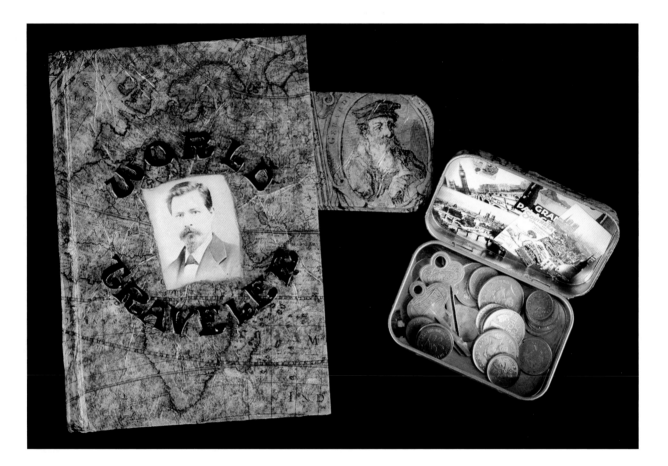

Give your altered book movement and sound by incorporating a shaker. What is a shaker? It's basically a niche filled with small objects, which move about freely when the book is moved. You can also add the shaker to the middle of the book and create a double-sided shaker by adding a transparency sheet to the back side of the shaker as well.

Supplies

- ✦ Altered book
- ✦ Waxed paper
- ✦ Ruler
- ✦ Pencil
- ✦ Craft knife
- ✦ PH Neutral PVA Glue – Lineco
- ✦ Transparency
- ✦ Small embellishments (shells, beads, buttons, gemstones, Cracker Jack toys, seeds, keys, watch parts, sequins, glitter, confetti, etc.)

1. Create a niche where you would like the shaker to reside by following the directions in the section titled "Create a Niche" on page 178.

2. Fill the niche with various small items.

3. Cover the top of the filled niche with a transparency sheet; this clear sheet enables viewers to see as well as hear the objects in the niche.

4. Finish decorating the page as desired.

Altered Board Books

Children's board books are an excellent foundation to alter; the sturdy pages and interesting array of shapes add up to hours of altered fun.

Since most board books have a glossy surface, it's necessary to prepare the book prior to use.

Board Book Preparation

Supplies

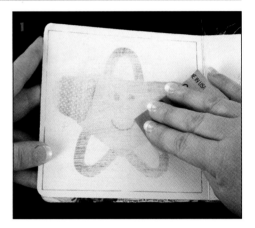

- ✦ Board book
- ✦ Sand paper
- ✦ Gesso – Ranger Industries
- ✦ Foam brush or scraper

1 Sand the surface of each page including the front and back covers. This step creates a "tooth" for the gesso to stick to.

2 Paint each page with the gesso for a "fresh canvas" for you to alter. Let each page dry completely. If additional coats are necessary to cover existing text or images, reapply the gesso as needed.

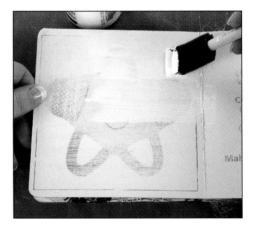

3 After the gesso has dried the board book is ready to be altered, use virtually any collage or altered book technique mentioned in this book to adorn the pages.

Note: Keep in mind that dimensional elements or techniques will make the book difficult if not impossible to close.

TIP

Gesso spray may be used as an alternative to the traditional variety to eliminate brush strokes. Apply thin coats and allow at least 30 seconds of dry time between each coat. No sanding is required, and clean-up is a breeze!

Create a collage by layering ephemera, collage images, and embellishments.

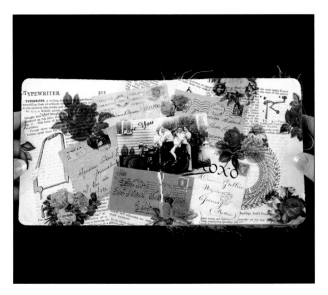

Windows or doors may be added.

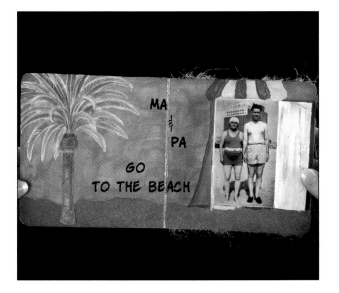

Board books may be painted, inked, or stamped.

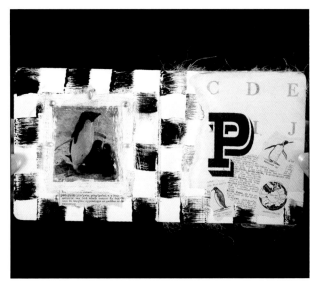

Board books can also withstand many collage techniques that regular altered books can't handle.

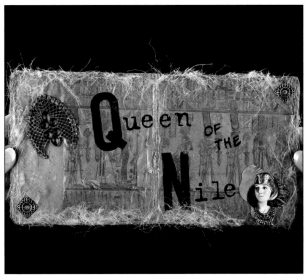

Gesso Texturing

Gesso is not only great for covering existing images or text on a board book, but it is a quick and easy way to create texture on sturdy pages. Once dry, gesso may be painted, stained, or inked.

Texturing Techniques

VEINING

Spread a generous layer of gesso over an entire page. Close the book, and open the pages quickly. This should result in multiple veins across both pages. You may open and close the pages repeatedly until the desired effect has been achieved.

GESSO AND MESH

Place a sheet of cheese cloth or other mesh material on the board book. Spread an uneven layer of gesso over the mesh. Quickly lift the mesh straight up and off of the board book. This will create an interesting textural contrast between the high and low areas of the gesso.

GESSO AND TEXTURE COMBS

Spread an even layer of gesso over the page or pages. Drag a comb, stylus, or other tool through the wet gesso layer to create an interesting texture. Let the gesso dry completely.

Deconstructed Board Books

As previously mentioned, board books aren't compatible with dimensional embellishments or techniques. To solve this problem you can deconstruct a board book, and reassemble it to fit your needs.

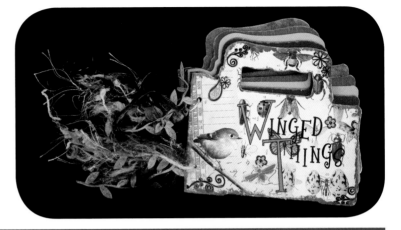

Supplies

- ✦ Prepared board book
- ✦ Craft knife
- ✦ Ruler

- ✦ Sheet of glass or self-healing cutting mat
- ✦ Crop-A-Dile – We R Memory Keepers

- ✦ Book rings (two or three depending on the size of your book)

1 Place the opened board book on a sheet of glass or cutting mat. Use the ruler as a straightedge, and cut each page from the book using the craft knife.

2 Using the Crop-A-Dile, punch holes in each page of the book.

3 Thread the book pages onto the book rings, and lock the book rings into place.

The board book is now ready to be altered using both flat and dimensional techniques alike.

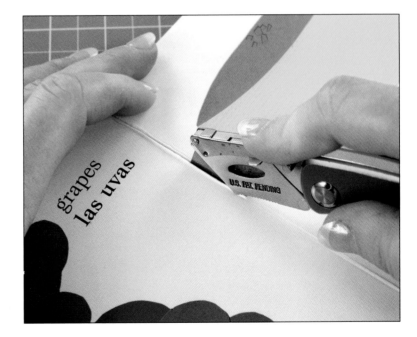

Inspiration Gallery

The following projects incorporate a variety of techniques shared in the book. Let them excite and inspire you along your artful journey.

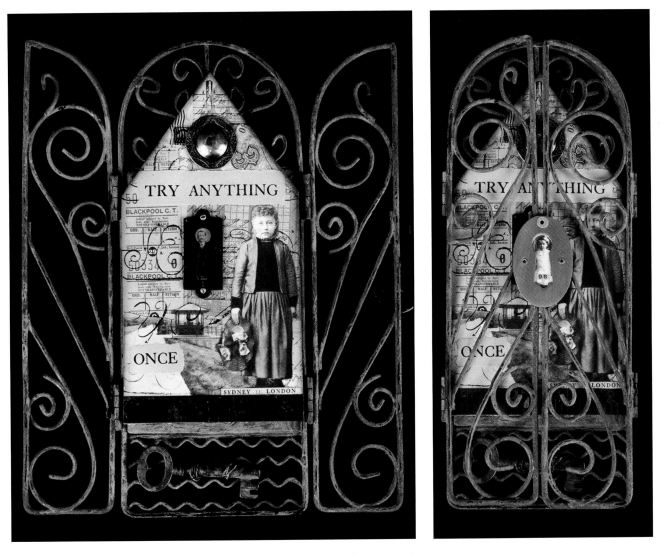

Gated Triptych – Artist: Jen Crossley
Chapter 9: Found objects, triptychs

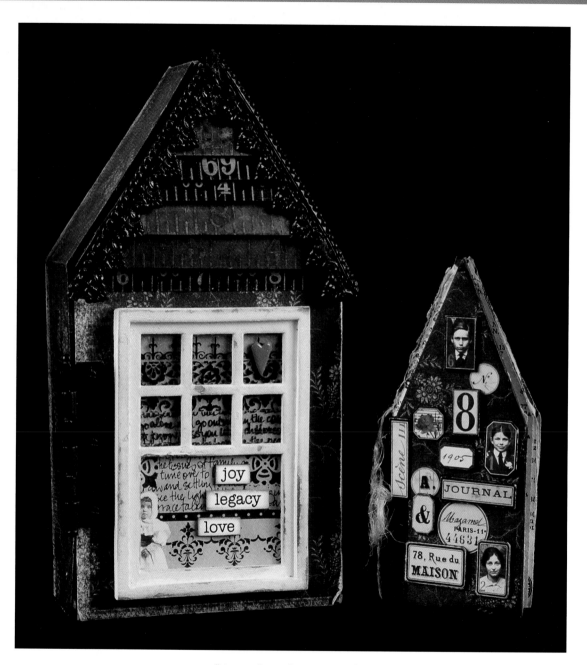

"Houses" – *Artist: Jen Crossley*
Chapter 9: Shadow boxes

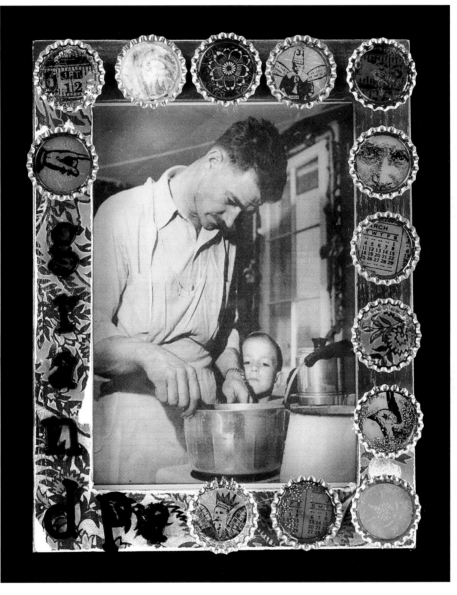

"Grandpa" – Artist: Roni Johnson
Chapter 3: Distressing by Hand, Chapter 6: Acetone Transfer, Chapter 7: Bottle Cap Charms

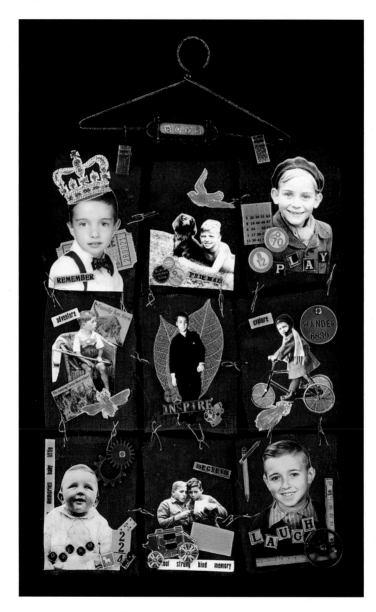

"Boys" – Artist: Roni Johnson
Chapter 1: Collage Basics, Chapter 9: Assemblage Art

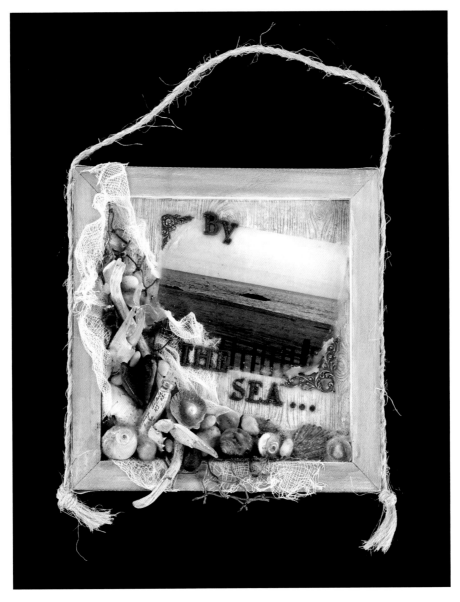

"By the Sea" – Artist: Roni Johnson
Chapter 3: Paint Patina, Chapter 4: Beeswax Collage, Chapter 6: Tranz-It Image Transfer

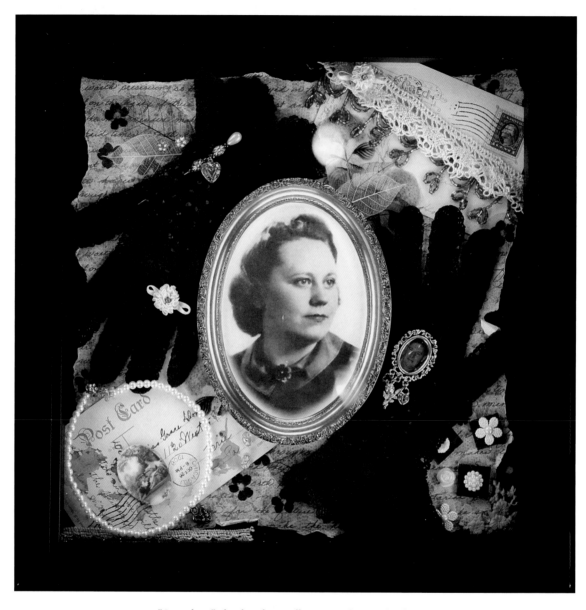

"Grandma" shadow box collage – Artist: Roni Johnson
Chapter 7: Glaze Filled Charms and Pendants, Found Object Charms;
Chapter 9: Bottle Cap Art, Altered Shrines, and Shadow Boxes

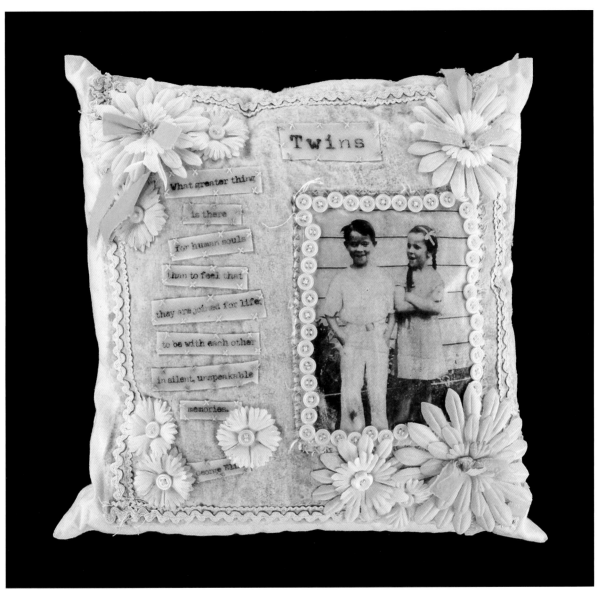

"Twins" altered pillow – Artist: Lisa Dixon
Chapter 6: Gel Medium Image Transfer, Chapter 8: Soft Collage

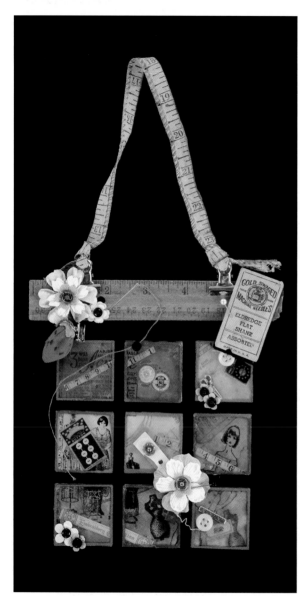

"Stitch in Time" Memory Glass collage –
Artist: Roni Johnson
Chapter 3: Walnut Ink Distressing,
Chapter 7: Memory Glass Charms

"Flutter by Butterflies" canvas – Artist: Roni Johnson
Chapter 3: Crackle Paint

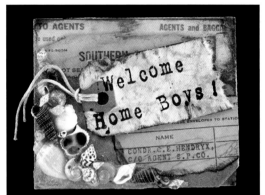

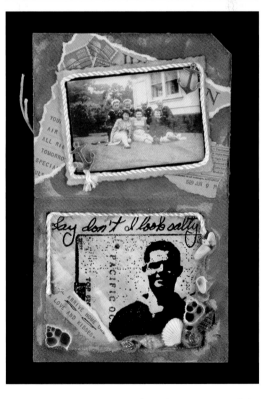

"Health, Beauty, Friendship"
beeswax tag –
Artist: Roni Johnson
Chapter 3: Metallic Rub-ons,
Chapter 4: Beeswax Collage

"Welcome Home Boys" altered microscope slide
mailer – Artist: Roni Johnson
Chapter 3: Distress Inks, Glaze; Chapter 4: Mixed
Paper Collage; Chapter 6: Gel Medium Image
Transfer; Chapter 9: Miniatures, Pint-Sized
Collage

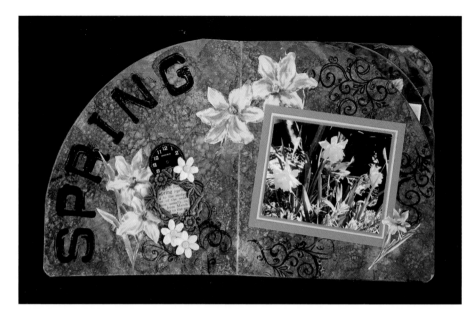

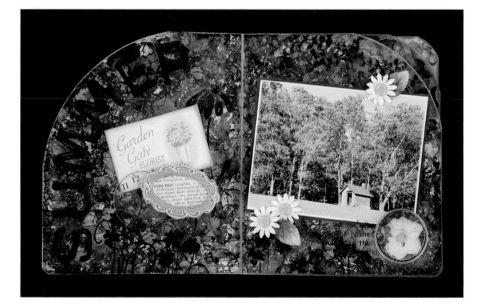

"Spring and Summer" altered board book layouts – Artist: Roni Johnson
Chapter 7: Glaze Filled Charms, Chapter 10: Altered Board Books

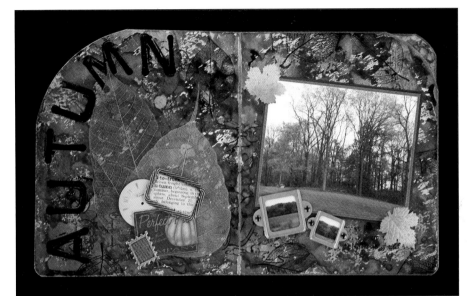

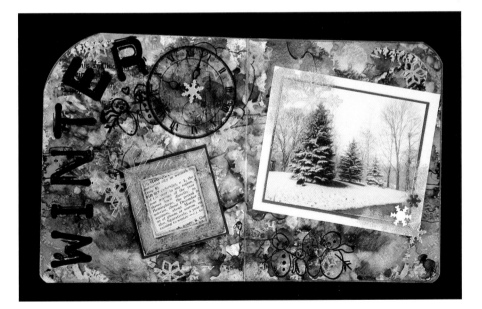

"Autumn and Winter" altered board book layouts – Artist: Roni Johnson
Chapter 7: Glaze Filled Charms, Label Holder Charms; Chapter 10: Altered Board Books

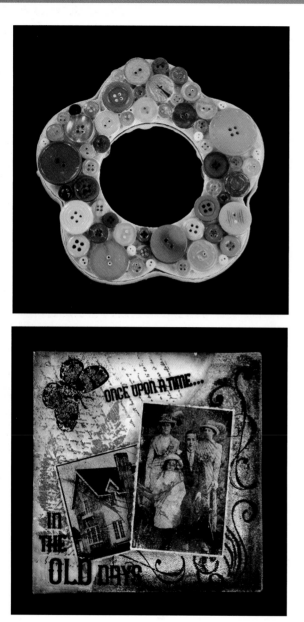

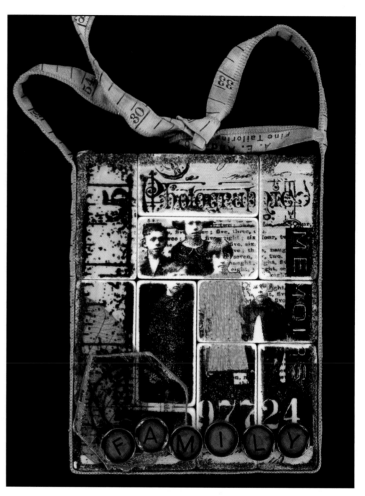

Top left: "Button Mirror" faux mosaic – Artist: Roni Johnson
Chapter 4: Faux Mosaic

Bottom left: "In the Old Days" canvas – Artist: Roni Johnson
Chapter 3: Distressing by Hand, Distress Inks, Crackle Alternatives

Right: "Family" domino collage – Artist: Roni Johnson
Chapter 9: Game Pieces

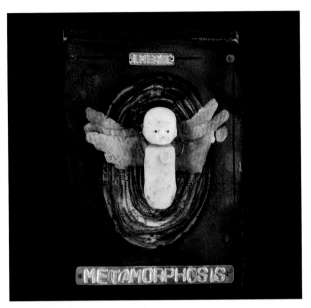

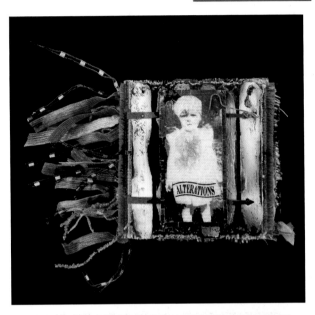

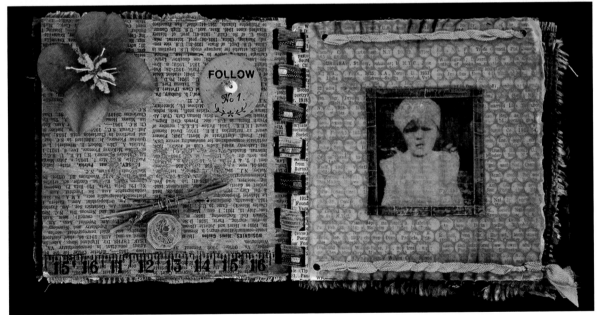

Top left: "Metamorphosis" altered book – Artist: Tracy Tatro
Chapter 3: Glaze, Chapter 9: Metal Art, Chapter 10: Create a Niche

Top right and bottom: "Alterations" altered book – Artist: Tracy Tatro
Chapter 3: Paint Patina, Glaze; Chapter 6: Transparency Image Transfer; Chapter 8: Layered Fabric Collage;
Chapter 10: Altered Book

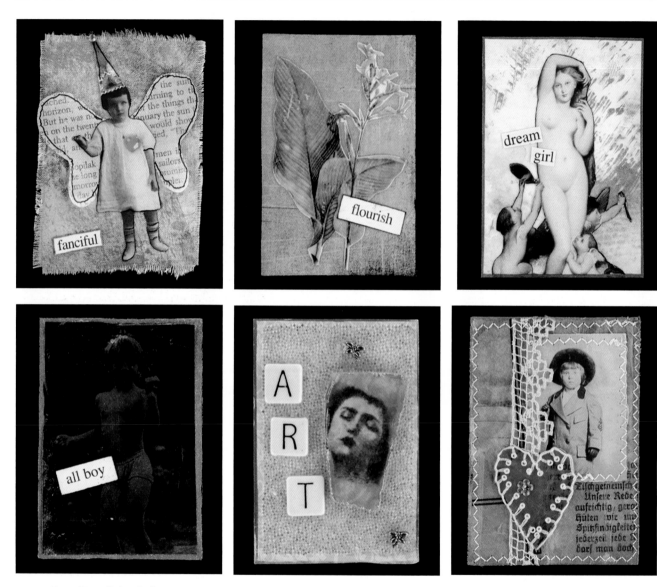

Top: "Fanciful Fairy" ATC –
Artist: Roni Johnson
Chapter 8: Painted Fabric

Bottom: "All Boy" ATC –
Artist: Roni Johnson
Chapter 6: GlueFOIL Faux Tin Type

Top: "Flourish" ATC –
Artist: Roni Johnson
Chapter 6: Tranz-It Image Transfer

Bottom: "ART" ATC –
Artist: Betty Oliver
Chapter 7: Found Object Charms

Top: "Dream Girl" ATC –
Artist: Roni Johnson
Chapter 5: Monoprinting,
Chapter 6: Waterslide Decal

Bottom: "Stitched Heart" ATC –
Artist: Lisa Dixon
Chapter 8: Basic Appliqué Stitches

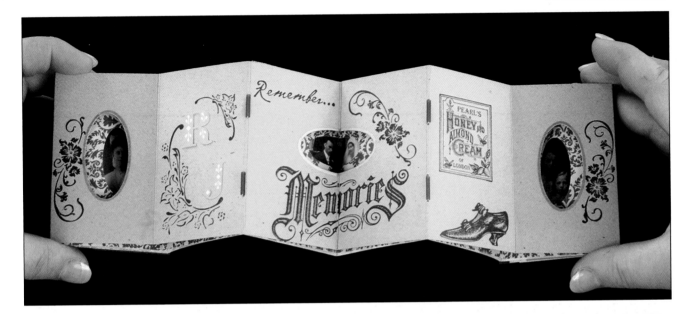

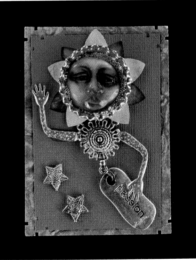

Top: "Memories" fold-out ATC – Artist: Betty Oliver
Chapter 3: Distressing

Left: "Elizabeth" ATC – Artist: Dawn Miller
Chapter 3: Distress Inks

Center: "Cameo" ATC – Artist: Bonnie Brock
Chapter 8: Fabric Paper

Right: "Passion" ATC – Artist: Betty Oliver
Chapter 7: Bottle Cap Charms, Chapter 9: Bottle Cap Art

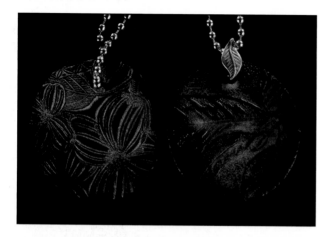

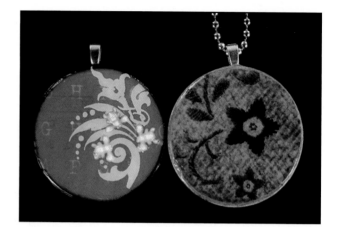

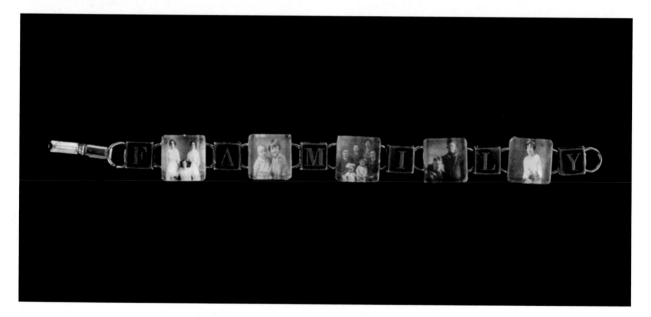

Top left: Clay Charms – Artist: Mindy Lai
Chapter 7: Paper and Polymer Clay Charms

Top right: Wooden Nickel Glazed Charms – Artist: Mindy Lai
Chapter 7: Glaze Filled Charms

Bottom: "Family" bracelet – Artist: Roni Johnson
Chapter 7: Acrylic Charms

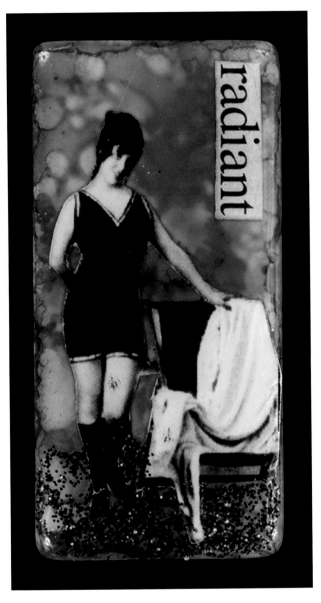

"Radiant" altered domino charm – Artist: Roni Johnson
Chapter 7: Game Piece Charms

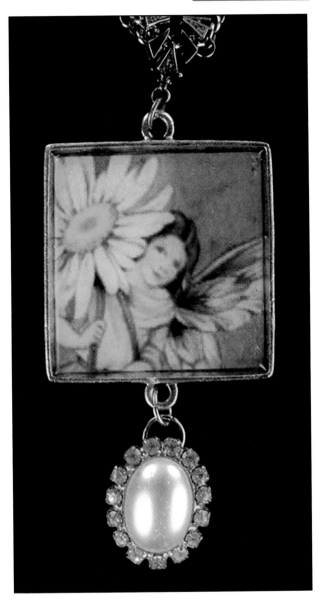

"Daisy Fairy" charm – Artist: Roni Johnson
Chapter 7: Glaze Filled Charms and Pendants

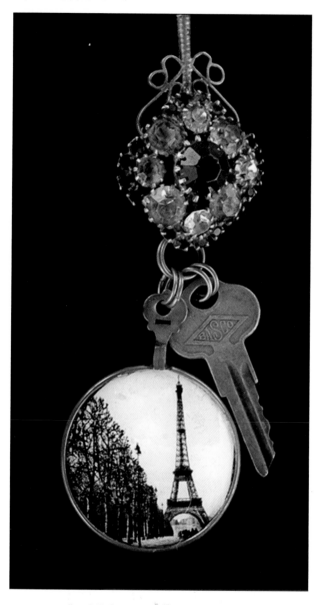

"Paris" charm – Artist: Roni Johnson
Chapter 7: Found Object Charms

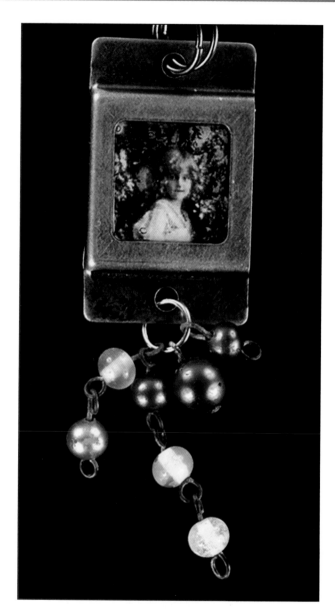

"Sweet Little Girl" label holder charm –
Artist: Roni Johnson
Chapter 7: Label Holder Charms

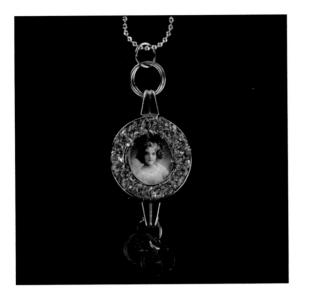

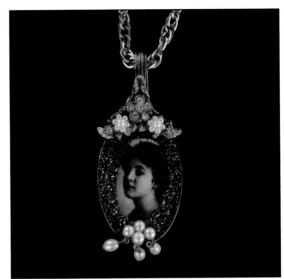

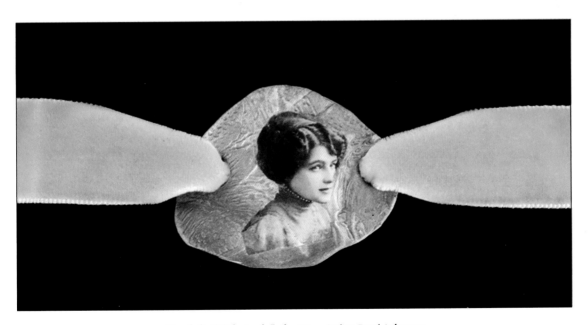

Top left: "Little Lady" charm – Artist: Roni Johnson
Chapter 7: Found Object Charms

Top right: Spoon charm – Artist: Roni Johnson
Chapter 7: Found Object Charms

Bottom: Clay Choker charm – Artist: Roni Johnson
Chapter 7: Paper and Polymer Clay Charms

CONTRIBUTING COLLAGE MANUFACTURERS

Special thanks to the following companies for their generous donations, which helped make this book possible:

100 Proof Press – rubber stamps
www.100proofpress.com

Alluring Impressions – rubber stamps
www.alluringimpressions.com

Alpha Stamps – rubber stamps, collage sheets
www.alphastamps.com

Altered Pages – collage sheets
www.alteredpages.com

B-Line Designs – rubber stamps, collage sheets
www.blinedesigns.com

Basic Grey – pattern paper, fibers, buttons, board books
www.basicgrey.com

Beadalon – jewelry tools, jewelry wire, jewelry findings
www.beadalon.com

Books by Hand – PH Neutral PVA Glue
www.booksbyhand.com

Canvas Concepts – art canvas
www.canvasconcepts.com

Clover – craft iron
www.clover-usa.com

Craft-T Products – metallic and luster rub-ons, chalk
www.craf-tproducts.com

Creative Paper Clay – paper clay
www.paperclay.com

Dremel USA – Dremel rotary tool
www.dremel.com

Duncan Enterprises – glue, collage medium
www.ilovetocreate.com

Enchanted Gallery – rubber stamps
www.theenchantedgallery.com

Found Elements – ephemera, found objects
www.foundelements.com

Golden – art paints, mediums
www.goldenpaints.com

Hannah Grey – ephemera; found objects; collage supplies
www.hannahgrey.com

Jacquard – paints, ink, pigment powders
www.jacquardproducts.com

JudiKins – rubber stamps, MatteKote paper, Eclipse Tape, Tranz-It medium
www.judikins.com

Krylon – paint, sealers, specialty finishes, metal leafing pens
www.krylon.com

Lost Coast Designs – rubber stamps
www.lost-coast-designs.com

LuminArte – pigment powders, spray dyes
www.luminarteinc.com

Mad About Molds – push molds
www.geocities.com/madaboutmolds/

Nature's Pressed – preserved natural elements
www.naturespressed.com

Nunn Design – metal charms, metal embellishments, Patera charms and findings
www.nunndesign.com

PaperArts – specialty papers
www.paperarts.com

Plaid – paints, sealers, specialty mediums
www.plaidonline.com

Ranger Industries – ink, paint, embossing, beeswax, UTEE, stamping supplies
www.rangerink.com

Retro Café Art – collage sheets, shrine and altered art supplies
www.retrocafeart.com

Sepp Leaf Products – metal leaf flakes
www.seppleaf.com

Simply Swank – soldering iron and supplies
www.simplyswank.net

Southern Blackberry Designs – collage and decoupage sheets, Trans Maxx transfer medium
www.blackberrydesings.com

Streuter Technologies – GlueFilm, GlueFOIL
www.streuter.com

Tattered Angels – Glimmer Mist
www.mytatteredangels.com

Tim Holtz – tools; masks, embellishments
www.timholtz.com

Tsukineko – ink, walnut inks and crystals
www.tsukineko.com

Tuscan Rose – collage sheets
www.tuscanrose.com

USArtQuest – adhesives, mica, glaze, paints, pigments
www.usartquest.com

Index